THE AMERICAN TEXT-BOOKS

OF ART EDUCATION.

REVISED EDITION.

TEACHERS' MANUAL

FOR

THE PRIMARY COURSE OF INSTRUCTION IN DRAWING.

Copyright © 2013 Read Books Ltd.
This book is copyright and may not be
reproduced or copied in any way without
the express permission of the publisher in writing

British Library Cataloguing-in-Publication Data
A catalogue record for this book is available from the
British Library

Drawing and Illustration

Drawing is a form of visual art that can make use of any number of drawing instruments, including graphite pencils, pen and ink, inked brushes, wax colour pencils, crayons, charcoal, chalk, pastels and various kinds of erasers, markers, styluses, metals (such as silverpoint) and even electronic drawing. As a medium, it has been one of the most popular and fundamental means of public expression throughout human history – as one of the simplest and most efficient means of communicating visual ideas.

Drawing itself long predates other forms of human communication, with evidence for its existence preceding that of the written word – demonstrated in cave paintings of around 40,000 years ago. These drawings, known as pictograms, depicted objects and abstract concepts including animals, human hands and generalised patterns. Over time, these sketches and paintings were stylised and simplified, leading to the development of the written language as we know it today. This form of drawing can truly be considered art in its purest sense – the basic forms on which all others build.

Whilst the term 'to draw' derives from the Old English *dragan* (meaning 'to drag, draw or protract'), the word 'illustrate' derives from the Latin word *illustratio*, meaning 'enlighten' or 'irradiate'. This process of 'enlightenment' is central to drawing and illustration as we know it today. Medieval codices' illustrations were often called 'illuminations', designed to highlight and further explain

important aspects of biblical texts. This was the most general form of illustration; hand-created, individual and unique. This changed in the fifteenth century however, when books began to be illustrated with woodcuts – most notably in Germany, by Albrecht Dürer.

The first creative impulses of a painter or sculptor are commonly expressed in drawings, and architects and photographers are commonly trained to draw, if for no other reason than to train their perceptual skills and develop their creative potential. Initially, artists used and re-used wooden tablets for the production of their drawings, however following the widespread availability of paper in the fourteenth century, the use of drawing in the arts increased. During the Renaissance (a period of massive flourishing of human intellectual endeavours and creativity), drawings exhibiting realistic and representational qualities emerged. Notable draftsmen included Leonardo da Vinci, Michelangelo and Raphael. They were inspired by the concurrent developments in geometry and philosophy, exhibiting a true synthesis of these branches – a combination somewhat lost in the modern day.

Figure drawing became a recognised subsection of artistic drawing in this period, despite its long history stretching back to prehistoric descriptions. An anecdote by the Roman author and philosopher Pliny, describes how Zeuxis (a painter who flourished during the 5th century BCE) reviewed the young women of Agrigentum naked before selecting five whose features he would combine in order to paint an ideal image. The use of nude models in the medieval artist's workshop is further implied in the writings

of Cennino Cennini (an Italian painter), and a manuscript of Villard de Honnecourt confirms that sketching from life was an established practice by the thirteenth century. The Carracci, who opened their *Accademia degli Incamminati* (one of the first art academies in Italy) in Bologna in the 1580s, set the pattern for later art schools by making life drawing the central discipline. The course of training began with the copying of engravings, then proceeded to drawing from plaster casts, after which the students were trained in drawing from the live model.

The main processes for reproduction of drawings and illustrations in the sixteenth and seventeenth centuries were engraving and etching, and by the end of the eighteenth century, lithography (a method of printing originally based on the immiscibility of oil and water) allowed even better illustrations to be reproduced. In the later seventeenth and eighteenth centuries, the previous combination of the arts and sciences in drawing gave way to a more romantic and even classical style, epitomised by draftsmen such as Poussin, Rembrandt, Rubens, Tiepolo and Antoine Watteau. Mastery in drawing was considered a prerequisite to painting, and students in Jacques-Louis David's Studio (a famed eighteenth century French painter of the neo-classical style), were required to draw for six hours a day, from a model who remained in the same pose for an entire week!

During this period, an increasingly large gap started to emerge between 'fine artists' on the one hand, and 'draftsmen' / 'illustrators' on the other. This difference became further complicated with the 'Golden Age of Illustration'; a period customarily defined as lasting from the

latter quarter of the nineteenth century until just after the First World War. In this period of no more than fifty years the popularity, abundance and most importantly the unprecedented upsurge in quality of illustrated works marked an astounding change in the way that publishers, artists and the general public came to view artistic drawing. Arthur Rackham, Walter Crane, John Tenniel and William Blake are some of its most famous names. Until the latter part of the nineteenth century, the work of illustrators was largely proffered anonymously, and in England it was only after Thomas Bewick's pioneering technical advances in wood engraving that it became common to acknowledge the artistic and technical expertise of illustrators. Such draftsmen also frequently used their drawings in preparation for paintings, further obfuscating the distinction between drawing/painting, high/low art.

The artists involved in the Arts and Crafts Movement (with a strong emphasis on stylised drawing, and a powerful influence on the 'Golden Age of Illustration') also attempted to counter the ever intruding Industrial Revolution, by bringing the values of beautiful and inventive craftsmanship back into the sphere of everyday life. This helped to counter the main challenge which emerged around this time – photography. The invention of the first widely available form of photography (with flexible photographic film role marketed in 1885) led to a shift in the use of drawing in the arts. This new technology took over from drawing as a superior method of accurately representing the visual world, and many artists abandoned their painstaking drawing practices. As a result of these developments however, modernism in the arts emerged – encouraging 'imaginative

originality' in drawing and abstract formulations. Drawing was once again at the forefront of the arts.

There are many different categories of drawing, including figure drawing, cartooning, doodling and shading. There are also many drawing methods, such as line drawing, stippling, shading, hatching, crosshatching, creating textures and tracing – and the artist must be aware of complex problems such as form, proportion and perspective (portrayed in either linear methods, or depth through tone and texture). Today, there are also many computer-aided drawing tools, which are utilised in design, architecture, engineering, as well as the fine arts. It is often exploratory, with considerable emphasis on observation, problem-solving and composition, and as such, remains an unceasingly useful tool in the artists repertoire.

The processes of drawing is a fascinating artistic practice, enabling a beautiful array of effects and creative expression. As is evident from this short introduction, it also has an incredibly old history, moving from decorations on cave walls to the most advanced, realistic and imaginative drawings possible in the present day. It is hoped that the current reader enjoys this book on the subject.

CONTENTS.

	PAGE
INTRODUCTION	5
GENERAL DIRECTIONS FOR TEACHERS.	
Preliminary Study	9
Use of the Manual. — Methods	10
PLAN OF THE COURSE.	
Geometric Name or Term	11
Reduction and Enlargement	12
Use of the Blackboard	13
Memory Exercises	14
Drawing from Dictation	14
Drawing from Objects	15
Busy Work	16
Design	17
PARTICULAR METHODS.	
Drill Work	17
Time Drawing. — Test Exercises. — Cultivation of the Observation. — Class Analysis of Forms	18
Mechanical Aids in Drawing. — Judging Distances	19
GENERAL RULES FOR CLASS WORK.	
Length of Class Lessons. — Class Instruction. — Technical Terms	20
Manual Execution. — Care of Drawing-Materials	21
GENERAL DIRECTIONS FOR PUPILS' WORK	21

PART I.

FIRST PRIMARY YEAR.

SCHEME	24, 25
ORDER OF WORK	26

CHAPTER I.

FORM LESSONS FROM SOLIDS. — A SPHERE. — A CUBE. — A CYLINDER. — A SURFACE. — ONE SURFACE; MANY SURFACES. — A HEMISPHERE. — A CURVED SURFACE. — A PLANE SURFACE. — A FACE. — AN EDGE; A LINE. — A STRAIGHT EDGE; A STRAIGHT LINE. — A POINT . . . 28

CHAPTER II.

VERTICAL LINES. — HORIZONTAL LINES. — OBLIQUE LINES. — SQUARE . . 39

CONTENTS.

CHAPTER III.
CURVED SURFACE. — CURVED LINE. — FROM THE SOLID **PAGE** 54

CHAPTER IV.
STRAIGHT AND CURVED LINES. — DIVISION OF LINES. — PARALLEL LINES. — CIRCLE 56

CHAPTER V.
LINES PERPENDICULAR TO EACH OTHER. — ANGLES; RIGHT ANGLES. — ACUTE ANGLES. — OBTUSE ANGLES. — DIVISION OF LINES INTO THREE EQUAL PARTS. — REVIEW OF LINES AND ANGLES 68

CHAPTER VI.
LIGHT LINES. — SQUARE WITH LIGHT LINES. — TRIANGLE. — RIGHT-ANGLED TRIANGLE. — LIGHT LINES TRISECTED. — CIRCLE WITH LIGHT LINES . 86

PART II.
SECOND PRIMARY YEAR.

SCHEME 102, 103
ORDER OF WORK 104
THE CARDS 105

CHAPTER I.
STRAIGHT LINES. — ANGLES. — TRIANGLES: RIGHT-ANGLED, ISOSCELES, RIGHT-ANGLED ISOSCELES, AND EQUILATERAL 107

CHAPTER II.
SQUARE AND ITS DIAGONALS. — SQUARE AND ITS DIAMETERS. — LINES TRISECTED. — SQUARE ON ITS DIAMETERS. — SQUARE ON ITS DIAGONALS. — OBLONG 138

CHAPTER III.
CIRCLE AND ITS DIAMETERS. — CIRCLE INSCRIBED IN A SQUARE. — UNION OF LINES. — ELLIPSES. — ELLIPSES AND CIRCLES. — OVALS 167

CHAPTER IV.
AXIS OF SYMMETRY. — AXES OF SYMMETRY. — REVERSED CURVES. — UNITS OF DESIGN. — CONVENTIONALIZATION OF LEAVES. — CONVENTIONALIZED FORMS IN DESIGN 199

INTRODUCTION.

ART EDUCATION is a subject so broad in itself, of such great importance in all practical life, and so valuable educationally, that instruction in it should begin contemporaneously with education in language and in number. The Kindergartner begins it even earlier, a lesson in form being among the very first lessons given. Art Education in its elementary stages is an education in the variations, modifications, and applications of form.

The simple elements of form should be taught in every primary school. The education of the eye in seeing form, and of the hand in expressing it, must precede and lead to the education of the mind in comprehending the principles which govern its representation and application. It will be noted, by looking over the schemes for the work of the two primary years, that no geometric form is given technically until children have been made familiar with it by observation and imitation. "First see, then do, then know."

OBJECT OF PRIMARY ART EDUCATION.

Art Education should be introduced into primary schools as a means of leading children to see, and to represent what they see; and also of leading them to give attention, to remember, to imagine, to create, and finally to think by exercise of the observation, memory, and judgment.

NATURE OF THE PRIMARY COURSE.

This Primary Course in drawing begins with lessons in form from the solid, which lead through surface, face, edge, and line, to a point.

Books, mere words, and even good instruction, are not sufficient for teaching little children. Perception must first be cultivated. Actual objects must be presented. Therefore the first lessons in form are from the simple geometric solids, — the simplest objects which can be found.

These solids should be in the hands of every teacher who attempts this course of instruction. It should be well understood, however, that primary lessons in drawing should not introduce the representation of more than one face of any of these solids in a single drawing. Children should learn

the *facts* of the forms of the solids by handling and by observing them, and by representing them by drawing and in other ways. In the case of solids, and objects with rounding surfaces, as cylinders, vases, etc., children may be taught to look for two dimensions, the height and the width. No attempt to teach the laws of perspective should be made, as they involve too many difficulties.

If children are thus led to discover the surfaces, corners, and edges of the solids, and if they learn to see that the edges are lines, they will learn to represent objects by drawn lines with comparative ease; for they will be able to see the lines in the objects. The ordinary method of teaching drawing, only from lines drawn on the blackboard or printed on paper, leads children very naturally to think that lines are to be seen only on a flat surface.

A line is simply length: a line is represented as nearly as it is possible to represent it by a drawn line. The line drawn upon the board, upon the slate, or upon paper, is really only a representation of a line. The edge of a solid also represents a line.

If children learn at the outset to see the lines in objects, as well as those drawn on any surface, their way of looking at and of seeing an object will be materially changed; and they will soon learn to discover the forms of objects which they would not have seen without this instruction.

These preliminary form lessons having been given, the regular work in drawing then begins, and is carried from the point through the line to simple geometric figures, and to elementary design and object-drawing based on the simple geometric figures. The teacher, however, should understand fully at the outset that nothing but childish work can be expected from primary children, and therefore should not aim at great excellence of manual execution, but should rather seek to develop ideas of form in a simple, natural way.

In this course very little technical instruction is to be given, and the work should be largely imitative. Children are "to see and to do;" thus becoming acquainted with the various figures, rather by seeing and by drawing than by means of technical explanations. Curved lines are introduced early in the course, but they are to be merely imitated. In the second year the first year's work is reviewed, the characteristics of the figures are to be more carefully explained, and some simple principles of design are to be taught. The variety so necessary in work for children is attained by a constant change in the manner of giving the lesson; observation, judgment, memory, and attention being specially appealed to by turn. The course has been very carefully graded, so that the exercises given shall awaken and direct mental activity in a simple and natural manner.

LESSONS SHOULD BE GIVEN BY REGULAR TEACHERS.

The lessons should be given by the regular teachers under competent supervision. One who understands the general principles of teaching does not need special artistic gifts for this work. Thousands of persons teach

arithmetic successfully who possess no special mathematical gifts; and the principles of elementary Art Education are no more difficult to master than those of arithmetic.

MOULDING IN CLAY.

Moulding in clay is an important auxiliary in the teaching of form; and its use should be contemporaneous with, and complementary to, the use of solids as objects. Moulding is such simple work, and such a delight to the children, and withal can be introduced into the schools so readily and so cheaply when the teacher knows how to conduct the exercise, that it is earnestly to be hoped that the time will soon come when this most important feature will be introduced into every primary school.

TEACHERS' PRIMARY MANUAL.

GENERAL DIRECTIONS FOR TEACHERS.

PRELIMINARY STUDY.

In every study, even the earliest instruction should be given with reference to all that is to follow, and also with reference to its bearing upon other branches of knowledge. The teacher who fails to look beyond the work of the day must ever fail to give the best instruction. Art Education in Primary Schools must be considered first as one of the means of promoting mental growth, then as a means of developing simple ideas of form and the power of expressing such ideas graphically. The teacher desirous of success should be self-informed of the value of Art Education; that is, this information should be obtained, as far as possible, from independent investigation into its practical aspects and uses, and its educational action on the various mental faculties, rather than from statements made by others. The question, What is Art Education good for? should be answered by every teacher before beginning to give even the elements of Art Education to pupils. The answer, however, must not be given at random, but must be conscientious; that is, it must be based on careful thought and study. If this question cannot be answered by the teacher, if the value of Art Education is not understood, the object of instruction in its various subjects and features cannot be clearly defined in the mind of the teacher; and the teaching, being aimless, will be vague and without result.

Art Education, even for little children, means something more than instruction in drawing. It comprehends the cultivation of the eye, that it may perceive form; of the hand, that it may represent form graphically (drawing); of the mind, that it may receive and express ideas in regard to form. It would seem appropriate, then, that these lessons should be called form lessons. Teachers should consider them as such, and should direct their teaching to creating in the minds of their pupils a correct conception of simple forms, rather than to giving instruction merely in drawing.

The connection of these form lessons with the other primary studies, language and number, should also be noted. The connection between form and language lessons is very close. Children may be required to consider

the exact force and limitation of words earlier, perhaps, in form lessons than in any other study; for the terms used are illustrated at once to the eye. See, therefore, that your pupils in the outset acquire, if possible, a habit of critical verbal discrimination, that will be of great value to them in all studies. Moreover, the exact knowledge of many of the terms employed will be of constant use.

In number, the repetition of forms gives pleasing exercises. A good teacher can hardly fail to make a lesson in form a lesson in language, and can many times make it a lesson in number also.

USE OF THE MANUAL.

"A good teacher always prepares every lesson beforehand."

With the general object of Art Education in public schools understood, and the particular object of the Primary Course in mind, the teacher is ready to prepare for the daily lessons by studying the Manual. The General Directions for Teachers and the General Directions for Pupils' Work should first be thoroughly mastered by the teacher. Then the daily lessons may be taken up; but these should be considered by the subject rather than by the single lesson. If the subject be vertical lines, for instance, the Manual should be carefully studied, not only on the subject of vertical lines, but on the subjects immediately preceding and following it. The work of the week, and the result desired, should be considered as a whole; and each lesson of the week should take its place in the teacher's mind as being made to contribute to that result. With this preparation, the teacher should draw upon the board the work of the teacher for that day, and upon the slate the work of the pupil; determining the details of position, size, repetition, etc., in order to be perfectly familiar with the work, both of teacher and pupil.

The Manual should not be considered, then, as in any way furnishing an equivalent to preparation by the teacher, but rather as a guide in that preparation. Instruction, to be really efficacious, must proceed from the thought and effort of the teacher.

METHODS.

The methods presented in the Manual are based upon ripe experience, and have been proved to be good. It is not claimed, however, that these should be rigidly followed in all their details. Every good teacher will, in a measure, originate details, and adapt the teaching to the circumstances surrounding it, which must necessarily change with every class. But, while venturing upon changes in details, the teacher must not fall into the grave error of considering only the particular result to be attained in the lesson of the day, but must keep steadily in view the broad, general results aimed at in the whole course of form lessons.

PLAN OF THE COURSE.

It is intended that the Primary Course shall begin with lessons in form from the model or object, to be followed by exercises in drawing and design.

In the course for each half-year, work for twelve weeks has been laid out. Each week has its particular subject, upon which all the lessons of the week are based. Work for only twelve weeks in each half-year has been given, that there may be opportunity to dwell longer than a week on any subject if the needs of the class demand it. If the twelve weeks' work is carried through without break, according to the plan, the remainder of the half-year should be occupied with a review, varied as much as possible.

It is the plan of this course, in treating each subject for weekly work in drawing in the first primary year, —

1. To present a geometric form or line *first* in a model or object, and to make the child familiar with the form or line by requiring him (*a*) to observe it in the model or object, and (*b*) to draw it imitatively.

2. To give a representation of the form upon the blackboard or upon paper for reproduction by the child.

3. To require the reproduction of the form from memory by the child.

4. To require the reproduction of the form by the child from dictation by the teacher.

5. To require the reproduction of the form by the child from an object.

6. To give daily independent practice in making and drawing forms.

These different kinds of work have been assigned as follows: —

1. *Monday.* — The geometric name or term from the object.
2. *Tuesday.* — Reduction from the blackboard.
3. *Wednesday.* — Reproduction from memory.
4. *Thursday.* — Drawing from dictation.
5. *Friday.* — Drawing from an object.
6. *Every day.* — "Busy work" in form.

The work in the second primary year is a development of that of the first year, together with the presentation of some simple principles in design. The manner of treating each subject is the same as that of the first year, with the addition of enlargement from cards, and of exercises in original design.

GEOMETRIC NAME OR TERM.

In teaching a geometric form or line, the order should be as follows: —

1. Present the form or line in a model or object.
2. Lead the children to discover the characteristics of the form or line in the object.
3. Give the name.
4. Lead them to statements concerning its characteristics.

5. Ask them to find it in other objects; and, having found it, require them always to name it, and state its characteristics.

6. Let the children draw it imitatively.

The definitions given in the Manual are not intended for the use of pupils. Children should first be led to discover for themselves the characteristics of a form from the form itself, thus getting a correct idea of it. If they are then led to express this idea from the form, they have a true conception of the form, which the mere words of a definition would fail to give.

Children should also be able to "draw the geometrical definitions," and to name forms readily.

Every Primary School should possess at least the following carefully made models: a sphere, a cube, a cylinder, a hemisphere, a triangular prism, a square prism.

In addition to the above, these are necessary: —

1. Thirty balls of different sizes and materials, — wood, rubber, etc.
2. Thirty cubes, — blocks of wood, clay, etc.
3. Thirty cylinders of different sizes and proportions, — pieces of broom-handles, ribbon-blocks, etc.
4. A few spheres that can be divided into hemispheres.
5. Thirty square prisms, — oblong blocks of wood, clay, etc.
6. Thirty triangular prisms, — blocks of wood, clay, etc.
7. A quantity of clay.
8. Thirty squares.
9. Thirty circles, thirty semicircles.
10. Thirty right-angled triangles, — fifteen isosceles, fifteen scalene.
11. Thirty acute-angled triangles, — ten equilateral, ten isosceles, ten scalene.
12. Thirty obtuse-angled triangles, — fifteen isosceles, fifteen scalene.
13. Thirty oblongs, thirty rhombuses, thirty rhomboids.
14. Thirty ellipses, thirty ovals.

REDUCTION AND ENLARGEMENT.

Pupils should make some of their drawings of the same size as the copies, others larger, others smaller. When the teacher desires to give pupils practice in making drawings smaller than the copy, — when, indeed, reduction is the main thing to be taught, as in the second lesson of the week, — then the blackboard can be properly used. In this case the drawings should be simple, so that they may be readily and quickly placed on the blackboard, and such that they will suffer as little as possible from bad execution, and from being viewed obliquely by the pupils. They should also have definite proportions, that the pupils, even when viewing them from the other side of the room, may be able to draw them accurately from the description of the teacher.

Again, pupils should have frequent practice at the board. A certain number of the pupils should be sent to the board at each lesson, and should

draw upon it, on as large a scale as convenient, the same exercise that the rest of the class is drawing. Pupils will thus be exercised in Enlargement, and also in the freest kind of freehand drawing.

The second lesson of the week, during the first year, is to be Reduction. The figures for these lessons should be drawn on the blackboard by the teacher. They should be carefully placed, and should be of large size: the longest lines of a figure should not be less than two feet. Pupils are to copy these figures on their slates, learning to make them of definite size. This will teach Reduction.

The second lesson of the week during the second year is to be Enlargement. For this purpose cards are to be used. The figures on the cards are to be copied by the pupils from the cards; but the teacher should indicate the proportions or scale, and should give detailed directions. This will teach the pupils Enlargement.

USE OF THE BLACKBOARD.

The necessity for the frequent use of the blackboard by the teacher in giving instruction will be readily recognized. A few suggestions as to the best means of acquiring command over it will be of value. It is best, when drawing a vertical line on the blackboard, to stand directly in front of where the line is to be drawn, with the right side partially turned towards the board, and far enough away to let the hand, when the arm is extended, fall easily, carrying the crayon down. Never draw a line with a jerky movement, but always with a uniform motion, and slow enough for the eye to follow.

Horizontal lines are drawn most easily when, a firm point having been made at the left, the arm and body are moved with the hand from left to right, thus steadying the hand, and keeping its position with relation to the body unchanged. In drawing curved lines, it is well to pass the chalk once or twice over the place where the curve is to be drawn, without marking; or to make a few points to serve as a guide in drawing the curve. Lines on the left should be drawn first. It is better to draw with the whole arm than from the elbow or wrist, and to stand at least two feet from the board. The centre of a blackboard drawing should always be taken on a level with the eye of the draughtsman: otherwise the drawing must be viewed obliquely. For the proper examination of any drawing, the eye must be so far removed that it can easily take in the whole at once. The distance of the eye should not be less than three times the breadth of the drawing. No attempt should be made to draw lines much higher than the head nor much lower than the elbow. Teachers' work upon the blackboard for class illustration should be carefully but not too slowly done.

In giving a blackboard lesson (the second lesson of the week), one of two general methods may be followed by the teacher.

DIRECTIONS. — *First*, Draw the whole figure on the blackboard prior to the lesson, that the class may see what they are to do before they begin.

Then direct them, line by line, how to proceed, causing the whole class to do the same thing at the same time. Occasionally leave the pupils to execute the drawing without any directions whatever, each relying on his own judgment for the proportions and mode of procedure.

The advantage here is, that the teacher is enabled to spend the time among the pupils, assisting those who need assistance, and noting the manner of working of the class, while pupils are compelled to think for themselves.

Second, Clearly state what is to be first done; then do it yourself on the blackboard. Having allowed the class sufficient time to do it also, proceed in the same way with the next step. This method has some special advantages. The pupils must work steadily, and give strict attention, while they are kept in a perpetual state of expectation as to what is coming next, and of surprise when it does come. When you employ this method, draw all the lines faintly at first, requiring your pupils to draw theirs in the same manner. Having made the sketch, line in. After you have done your part of such a lesson, allow your pupils a little time for completing their drawings.

MEMORY EXERCISES.

Pupils should be frequently required to produce, from memory, figures which they have previously drawn. These exercises show the teacher how much of previous instruction is retained, while they are valuable as a means for developing the power of memory. Therefore a regular place has been given to memory exercises in this course, and they have been made the third lesson of the week. In the early part of the course, perhaps through the first year, the exercise in drawing from memory should be the exercise of the previous day; but this may be gradually changed, and the exercise given for memory drawing may be one that has been drawn more than one day previous.

DRAWING FROM DICTATION.

Dictation exercises constitute an important feature in this course. They are assigned to the fourth day in the week.

The teacher gives only a verbal description of the figure to be drawn, while the pupils translate the spoken words into lines. After a while, quite elaborate drawings can be made in this way.

The educational value of this exercise is very great for both teacher and pupils. The teacher must use language with the utmost precision; while the pupils must give the closest attention to the spoken words, first making a mental picture of what is required, and then drawing it. If it is found necessary to repeat any part of the description, the language, unless it was wrong, should not be changed, but should be given exactly as it was given at first. To draw from dictation, pupils must know the exact force of all the terms employed. There is no possible escape. Hence a dictation exercise is, in some respects, an excellent one for review.

Dictation lessons may be given in two ways, according to circumstances and to the capacity of pupils: —

DIRECTIONS. — *First,* Dictate a line to be drawn. Having waited a sufficient time for the class to draw it, draw the same on the blackboard, that each pupil may see whether he has it right or not. This will prevent mistakes, as each pupil is enabled to verify his work line by line. Thus proceed with each step of the exercise.

Second, After the whole figure has been slowly dictated, and drawn by the pupils, draw it on the blackboard in the order dictated. The pupils can then verify their work by comparison with the figure on the board. It will be seen that this method is more difficult than the first, since the pupils cannot verify their work until the whole figure is completed; but good attention is insured, and time is saved to the teacher, which may be devoted to giving individual assistance.

As pupils progress, the manner of dictation should change, details should be omitted, and the dictation should be of forms as much as possible.

DRAWING FROM OBJECTS.

Drawing from objects is an important means to the ends aimed at in this Primary Course in Art Education, — that is, primarily, to promote mental growth; secondarily, to develop simple ideas of form, and the power of expressing them by words and by drawing.

Much has been done in teaching form in public schools: but lessons in form have been mainly lessons in seeing; and the knowledge gained has been that gained by seeing, and not that gained by doing. Moreover, these lessons have generally stopped at geometric solids and plane figures; and much of the value of these lessons has been lost from the fact, that, as geometric solids and plane figures were the only subjects given for observation, children failed to look farther, and their development in that direction ceased.

Much, also, has been done in the past few years to establish drawing as a regular study in the public schools; but the drawing introduced has been mainly either imitative from copies, or decorative. It has been generally conceded that this work is suited to the average capacity and ability of the pupils of the public schools, and is beneficial in its results: but there has been a vague, undefined, perhaps unacknowledged, idea that drawing from objects is beyond the reach of children in general; that it can be successfully practised only by those specially gifted; that only the eye of genius can see the forms of objects so as to represent them as they appear; and that, consequently, ordinary children cannot be taught to draw from objects. Some so-called object-drawing has been done, it is true: but it has been done from the flat; that is, from a flat copy. This has its proper place in form lessons; but it is second-hand object-drawing, and cannot take the place of drawing from the object.

Real drawing from objects is, moreover, a proper subject for even primary

children. It is true that there are grave difficulties in the way of teaching drawing from objects, if complicated objects are selelected, and placed in such positions that their appearances are very different from their facts of form; but drawing from objects may be systematized. Objects should be selected so simple in form that they will present but one stage of difficulty at a time. Care must be taken that each difficulty is mastered — that is, so well understood that it is no longer a difficulty — before any fresh problem is offered.

If simple solids are first given for study, and lines are found in the edges of those solids, pupils will easily trace lines in the edges of all solids, and will soon see them in objects. They will learn by training to distinguish the form of an object, then to see the lines which make that form. If they are able to see those lines, they will have no difficulty in representing them in a childish way; which is all that should be desired of a primary pupil. Excellence of manual execution is not the end sought for here. If pupils find that a face of a cube has four straight edges that are equal (and very little children can find this out with judicious leading), it will not be hard for them to draw those edges. If a triangle made of wire is given as an object for drawing, they will see that they can represent the wire by lines. If a triangle made of slender sticks or wires and softened peas is given as an object, they will make the triangle with circles at the vertices of the angles. If a triangle of bright paper is given, and they study its form, they will see that they can represent the form by drawing lines for its edges.

Drawing from objects is not difficult to teach, but it must be taught according to the mental power or comprehension of pupils. It is as important educationally and practically as constructive or decorative drawing, and no scheme of Art Education can be called comprehensive which does not include it. It should be made a leading subject for training in Primary Schools. Great care should be taken, however, not to complicate it by attempting perspective views, or light and shade.

Drawing from objects in class work should not embrace more than two dimensions. If an object has plane surfaces, but one face should be attempted by children; while the representation of objects with rounding surfaces should include only the height and width, the width at top and bottom being represented by straight lines.

The fifth lesson in the week is made a lesson in drawing from a model or object.

BUSY WORK.

In addition to the work done in the lessons, it is expected that some "silent work" in form will be assigned every day. It is essential that a habit of work be formed, and that children should be trained from their entrance into school to work quietly, earnestly, and faithfully at some task for an allotted length of time. This "silent work" must alternate with class work. With primary children this work cannot be study: it must be some work with the fingers. The work assigned for such times is called by some "silent work," by some "Busy Work." It is used in language by assigning

some letter or sentence to be copied repeatedly; in number, by giving various objects to be arranged in groups. In form, the variations that may be devised for this work are almost numberless. Lines and forms may be drawn in groups of twos, threes, fours, etc. The numbers in the groups may be the same or alternating; the forms repeated may be the same or alternating. Pegs, splints, and other small objects used in number, may be arranged in forms. Simple objects may be given to be drawn and repeated. In work of this kind the child becomes very familiar with the forms given, and gains readiness with the pencil in expressing those forms.

This Busy Work is not only an occupation for the children, but is also, when properly conducted, a profitable occupation; for the children are taught not only to be busy, but also to do their work well. Their busy work should always be inspected, and their efforts encouraged.

DESIGN.

In the last half of the second primary year some simple terms and principles in design are introduced, and are made respectively the subjects of a week's work. When children have reached this stage in the course, they will have become acquainted with the arrangements which these terms and principles imply, by having met with them frequently in previous exercises. The principles of symmetry and repetition will be found exemplified in all the decorative exercises of the course. It will not be difficult, even for young children to understand the principles given. A knowledge of these principles will give an additional charm to drawing. It will enable the pupils to begin at once, and intelligently to make original designs.

PARTICULAR METHODS.

There are certain methods of work besides those assigned to the different days in the week in the general plan, which should be used as occasion demands. Sometimes drill is needed; sometimes the class lags, and time-drawing should be introduced; sometimes test exercises are desirable; and sometimes a particular stage of progress calls for class analysis. These various methods must be used according to the needs of the class.

DRILL WORK.

"Brief and definite orders, and prompt and uninterrupted work according to them, regulated by keeping time, will accomplish an infinite amount of good in acquiring any kind of manual skill where practice is the thing required." Drill exercises in drawing may be upon straight or curved lines. One kind of line, however, should be made the subject of at least five minutes' drill before another kind is taken up. If the execution of a class is poor (judged not by an absolute standard, but by the standard of what might naturally be expected from little children), drill exercises will not only improve the execution of the pupils, but will interest them anew. They might be introduced profitably for a few minutes just at the close of any form lesson.

TIME DRAWING.

Throughout this course of instruction great importance is attached to rapid execution, provided always that it is intelligent. The habit of drawing rapidly should be early formed, and persistently cultivated. It is desirable that in drawing the hand should obey the mind as readily as possible; that it should obey as in writing, or as the vocal organs obey the mind in speech. For securing this habit of ready execution, time exercises are very valuable. A certain time should be fixed in which a figure is to be completed. These exercises in the Primary Course should be very brief. They cannot be introduced with special advantage until the second year; that is, until drill and practice have given some control of the hand. A short time exercise can be introduced just at the close of any form lesson in the second year. All work should begin and end at the word of the teacher.

TEST EXERCISES.

It is well to test the progress of pupils. It is perhaps better to do this occasionally through the term than to make the pupils' standing dependent on one test, an examination at the end of the term. Any regular form lesson may be made a test exercise, and the results of each pupil's work carefully noted. Pupils need not be informed that it is a test exercise, and thus the nervousness too often incident to an examination will be avoided. Of course it would not be just to make a dictation exercise alone a test of the pupils' progress in a knowledge of form; but exercises should be selected from all the kinds of work given, and an estimate made from all the test exercises.

CULTIVATION OF THE OBSERVATION.

Since intelligent drawing is always an expression of knowledge, every opportunity must be taken to cultivate the observation. Pupils must be trained to discover the features of whatever they are to draw before they begin their work. To take a simple illustration: when the pupils have learned the names of the different straight lines and angles, the square may be given as an exercise. The teacher should draw it on the blackboard, requiring the pupils to name each line as drawn, and, when the figure is completed, to give the number and names of the angles it contains. After the diameters and diagonals have been drawn, the pupils should be required to state the effect of these lines upon the original angles, and to give the number and names of the new angles. Other exercises may be treated in a similar manner.

CLASS ANALYSIS OF FORMS.

In the second year, when the cards are used, the analysis of forms may be commenced.

Teach pupils that they should always analyze a form before beginning to draw it: otherwise they cannot proceed intelligently. Just as young pupils

are apt to begin to work a problem in arithmetic before they have fairly read it, so they are apt to begin to draw a figure before examining it to learn what it means, and how best to begin. This is the haste that makes waste. While pupils should aim to draw rapidly, they should, nevertheless, always draw deliberately. From time to time class analysis of forms should be given. The form chosen for analysis may be a design, a drawing of an object, or an object itself. Pupils should be taught to find, first, the general geometric form upon which the figure is based; second, the construction lines which could be drawn, upon which to construct the details of the form; third, the division of these lines, etc.

MECHANICAL AIDS IN DRAWING.

In the second primary year, ruling and measuring may be introduced to advantage. There is a good deal of hesitation among teachers about the use of a rule and a measure; but they forget that these are legitimate drawing instruments, and that children should have an opportunity for practice in their use. It needs practice to use a rule well, and instruction to use a measure properly. A simple rule and measure accompanies each set of cards. These may be distributed at the discretion of the teacher, to use in any of the form lessons; but they should not be used in more than one-fourth of the exercises. There are two ways of using a measure. One is, to set off upon any line any definite distance, as two inches, directly from the measure; the other is, to set off a distance, as two inches, according to judgment, and then test it by the measure to see if the distance taken is correct. The first method may be used in design: only the second method, that of testing, should be used in other primary form lessons.

JUDGING DISTANCES.

An important accessory to the knowledge of form is correct judgment of distances.

Distances may be judged —

1. From a standard measure (*a*) by sight.
 (*b*) from memory.

2. From comparison
 (*a*) by division into equal parts.
 (*b*) by setting off a distance equal to a given distance (1) in the same direction.
 (2) in a different direction.

Special exercises in judging distances in these various ways should be short but frequent, and may be given at the close of any form lesson.

GENERAL RULES FOR CLASS-WORK.

There are many details of instruction in Primary Art Education, concerning which a definite plan of action can be laid out. Some of these involve general principles applicable in the various lessons; others involve particular methods to be used as circumstances require.

Among the former are, —
The Length of Lessons.
Class Instruction.
The Use of Technical Terms.
Manual Execution.
Care of Drawing Materials.

LENGTH OF LESSONS.

Short lessons often repeated are better for young pupils than long ones at greater intervals. The drawing-lesson should be a daily lesson in the primary grade. During the first half of the first school-year the lesson should not be more than ten minutes long; in the second half of the year it might be fifteen minutes long; and in the second and third years, twenty minutes.

CLASS INSTRUCTION.

It has been a prevalent opinion that instruction in drawing must be individual; but experience has proved, that, when lessons in form and in drawing are properly graded, class instruction produces better results. The lessons should be given from the platform, and children should be required as a general thing to work together. Better work is produced by primary pupils when the work is given line by line, than when each child is left to execute a figure without such detailed direction. At the same time a habit of working promptly and readily is thus formed, — a habit the value of which can hardly be over-estimated. Again, if a figure is dictated line by line, only time enough being given to draw the line, the bad habit of erasing, so seductive to children, is not formed; for there is no opportunity to acquire it.

TECHNICAL TERMS.

The use of words is best learned by using them: therefore, make no attempt to avoid the use of technical words when they would be appropriate. Do not, for example, use "level" for "horizontal," "upright" for "vertical," with the thought that your pupils will more readily comprehend what they are doing if it is described by the former words instead of the latter. Repeated use will make the latter and all technical terms just as expressive as any possible substitutes, just as instantaneously suggestive to the child-mind, while they commonly have the advantage of meaning one thing only. Expect of your pupils at all times correct usage of terms.

The two principal objections that will be made, if any are made, against carefully teaching the technical terms, are these:—

(*a*) *They are hard to understand.* This objection will be founded on the erroneous belief that the length of a word, or the infrequency of its use, makes its meaning hard to be understood, — a thing which depends wholly on the meaning itself, as it is not a question of mouth, but of mind. Thus the meaning of the word "wheelbarrow," with all its length, is as easily comprehended as the meaning of the word "cart;" while it is incomparably more difficult for a child to understand the meaning of the word "verb," because it is a mere abstraction, than of the word "circumference," which can be fully exemplified by ocular illustration.

(*b*) *These terms will not often be used, even if understood; more popular, though less exact, words being substituted for them.* This is a good reason why they should be thoroughly taught in school; since there are many occasions out of school as well as in, when their employment becomes absolutely essential.

MANUAL EXECUTION.

First of all, the eye is to be educated to distinguish form. The correct manual rendering of the form will come by practice. In the early lessons, teachers should lay more stress upon developing observation and understanding than upon mere dexterity in execution. It is rare, almost accidental, for young pupils to draw clear, unbroken lines; while lines varying in thickness must be expected from them for a long time. The teacher should rarely correct the work of pupils, but should rather lead pupils to draw correctly by example and precept, and by giving abundant opportunity for practice in work that will interest. Encourage to good work by freely commending that which is good. Consider the form before the lines.

CARE OF DRAWING-MATERIALS.

Slates must be clean. A separate set of pencils should be kept for the drawing-lesson. These should be long, soft, and well pointed. The duty of keeping the pencils sharpened can be assigned to some of the older pupils.

Drawing upon the blackboard should be a regular part of the work. The boards, being carefully cleaned, may be marked off in spaces at least two feet wide for each pupil; and crayon should be ready for each place.

A set of cards should be provided for each pupil in the second year. These should be kept by the teacher, and distributed when desirable. They may be used in the "silent work" as well as in the regular Tuesday's lesson.

GENERAL DIRECTIONS FOR PUPILS' WORK.

It is expected that these general directions will be given to the pupils, not all at once, but as required, and that they will be repeated until the pupils have learned to follow them from habit; for, when a certain way of

thinking or doing has become a habit, then, and only then, is it thoroughly mastered. Be very watchful of your pupils when they begin to draw, and keep them, if possible, from acquiring any bad habit which they must afterwards unlearn. To unlearn is the hardest kind of learning.

There is no one way in which it is always best to sit, to place the hand, to hold the pencil, and to keep the slate. Whatever the position of the body, it should always be easy and healthy, and the eye never any nearer the paper than is essential for a clear view of the lines. A few useful general directions for position and for manner of drawing may be given.

Sit *facing* the desk, *not* with the side toward the desk, and do not bend forward unnecessarily.

When drawing straight lines, keep the slate in one position, having its edge parallel to the edge of the desk.

When drawing curved lines, turn the slate so that the curve will be concave to the hand.

Hold the pencil lightly, and so that the fingers will not obstruct the view of the line to be drawn, from half an inch to an inch from the point, inclining to the paper at an angle of 45°, — at right angles to the line when drawing a straight line, and within the curve when drawing a curved line.

Do not bear heavily on the slate in drawing.

Let the eye precede the pencil in movement.

When drawing a line, do not keep the eye fixed on the point of the pencil.

When drawing a line to a given point, look at the space the line is to cross, and at the point to be reached.

When drawing a line without reference to a point, look at the whole line as it is drawn, and the space which it is to cross.

When drawing a line parallel to another, look at the given line, the line as it is drawn parallel, and the space which it is to cross.

Draw the left side of an exercise first. Work rather from the left toward the right, than from the right toward the left, unless you draw with the left hand, when the reverse would be better; and work rather from the top toward the bottom, than from the bottom toward the top.

Draw the shortest lines with a movement of the fingers alone; the next longer, with a movement of the hand at the wrist; the next, with a movement of the forearm at the elbow.

In drawing a vertical line, hold the hand at the right of the line, with the thumb on the upper side of the pencil; throw the elbow out somewhat from the side, sit upright, and draw towards the body.

In drawing a horizontal line, hold the hand below the line, bring the thumb nearer to the paper, and the elbow closer to the side than in drawing a vertical line, and draw from the wrist.

For some special directions for blackboard work, see p. 13.

PART I.

FIRST PRIMARY YEAR.

FIRST YEAR.—FIRST HALF.

SPHERE, CUBE, CYLINDER.

Surface—Curved, Plane.
Face—Plane.
Two Plane Faces meet.
Straight Edge, Straight Line, Point.
Square.

Nature and Order of Lessons	MONDAY.	TUESDAY.	WED'SDAY.	THURSDAY.	FRIDAY.
	Geometric.	Reduction	Memory.	Dictation	Object.
Vertical lines.			Lesson of Tuesday.		Lines in wainscoting, windows, doors, etc.
Horizontal lines.			Lesson of Tuesday.		Lines as above, also in blackboard, table, etc.
Oblique lines.			Lesson of Tuesday.		Lines in the room, picture-rod, wall paper.
Square.			Lesson of Tuesday.		Object with square, square of bright paper.

SPHERE, CUBE, CYLINDER.

Surface—Curved, Plane.
Face—Plane.
Plane Face and Curved Face meet.
Curved Edge, Curved Line.
Circle.

Nature and Order of Lessons	MONDAY.	TUESDAY.	WED'SDAY.	THURSDAY.	FRIDAY.
	Geometric.	Reduction	Memory.	Dictation	Object.
Straight and curved lines.			Lesson of Tuesday.		Bow of wood or whalebone.
Division of lines into two equal parts.			Lesson of Tuesday.		Cover of a long book.
Parallel lines.			Lesson of Tuesday.		Ruler, paper-cutter.
Circle.			Lesson of Tuesday.		Plate.

FIRST YEAR.—SECOND HALF.

SPHERE, CUBE, CYLINDER, TRIANGULAR PRISM, SQUARE PRISM.
Lines, Angles, Triangle, Square, Circle.

Nature and Order of Lessons.	MONDAY. Geometric.	TUESDAY. Reduction.	WED'SDAY. Memory.	THURSDAY. Dictation.	FRIDAY. Object.	Nature and Order of Lessons.	MONDAY. Geometric.	TUESDAY. Reduction.	WED'SDAY. Memory.	THURSDAY. Dictation.	FRIDAY. Object.
Lines perpendicular to each other.			Lesson of Tuesday		Flag.	Light lines divided into two equal parts.			Lesson of Tuesday		Tatting shuttles.
Angles, right angles.			Lesson of Tuesday	L D H P	Corners of the blackboard, a book, etc.	Square with light lines.			Lesson of Tuesday		Four-pointed star in a square.
Acute angles.		V A M K	Lesson of Tuesday	N W Z X	Picture-cord, two sticks, jointed rule.	Triangles.			Lesson of Tuesday		A top.
Obtuse angles.			Lesson of Tuesday		Fan in another position.	Right-angled triangle.			Lesson of Tuesday	Memory Lesson of Wednesday.	End of a toy house or of a house built with blocks.
Division of lines into three equal parts.			Lesson of Tuesday		Round fan with handle.	Light lines divided into three equal parts.			Lesson of Tuesday		Steps built with blocks.
Review of lines and angles.			Lesson of Tuesday		Spool.	Circle with light lines.			Lesson of Tuesday		Wheel.

ORDER OF WORK

FOR THE FIRST PRIMARY YEAR.

THE scheme on pp. 24, 25, shows the order of work for the first primary year.

Pupils must first be made acquainted with the sphere, cube, cylinder, and hemisphere; and, by means of these solids, primarily with surfaces, plane and curved, with plane faces, with edges and lines. It is expected that at least four weeks of the first year will be given especially to lessons from the solid, outlined in Chap I., pp. 30–38, and in Chap. III., pp. 54, 55.

The lessons on lines and plane figures, indicated in the scheme as following the lessons from the solid, should begin from the solid. The arrangement of these lessons is by subjects, as shown in the scheme; one week's work being there laid out for a subject. It is expected, however, that more than one week will be given to a subject if a class requires more time.

It will be noted that a different manner of presenting a subject is assigned to each day in the week. This is for two reasons, — because of the educational value of each manner, and that there may be sufficient variety in the work to insure interest. The scheme provides for a geometric lesson, a lesson in reduction, a lesson in memory-drawing, a lesson in drawing from dictation, and a lesson in drawing from an object for the week's work.

The lesson on the geometric name or term is to be given directly from the solid. This method of giving the geometric name or term from the solid is of great importance, and must not be neglected. The lesson in reduction, to be given from the blackboard, follows the geometric name or term, so as to fix the name or term in the minds of the pupils by giving to them blackboard representations. The memory-lesson may follow the lesson in reduction as laid down in the scheme, or, if desired by the teacher, may follow the dictation or object lesson.

After vertical, horizontal, and oblique lines have been given, the curved line is taken up. Here the lessons on the solid should be reviewed, and curved edge and curved line be brought out. After this follow combinations of straight and curved lines, the division of lines into two equal parts, parallel lines, a circle. This completes the work for the first half-year.

The work for the second half-year takes up perpendicular lines; angles, right, acute, and obtuse; division of lines into three equal parts; light lines; triangle, square, and circle. It requires the use of the sphere, cube, cylinder, and the triangular and square prisms. The order of lessons during the week remains substantially the same as during the first half-year.

WEEKLY WORK IN DRAWING.

The subjects for weekly work in drawing in the first primary year are, —
Lines: Straight, curved, vertical, horizontal, oblique, parallel, perpendicular, light, — divided into two, three, and four equal parts.
Angles: Right, acute, obtuse.
Circle.
Square.
Triangle.

The scheme gives illustrations of the various lessons for each subject. In the scheme but one week's work is given for a subject, and work for only eight weeks in drawing is there laid out for the first half-year, and for only twelve weeks for the second half-year; so that more than one week may be given to any subject when found desirable, or, if this is not desired, that there may be time for review when the work laid out is completed. It will be noted, that, after four weeks' work on straight lines, the scheme provides that curved lines shall be given first from the solid. Then the use of curved lines with straight lines follows in the work in drawing.

THE TEXT OF THE MANUAL.

The text for each subject is arranged as follows: —
1. The subject, followed by illustrations for one week's work on that subject as shown in the scheme, pp. 24, 25.
2. Leading sentences in full-faced type, which give the substance of the ideas to be brought out in the work on the subject for the week, and which are therefore to be particularly noted.
3. Special directions for the daily work of one week; together with directions and illustrations for *Additional Work*, to be used when the teacher desires to review or to devote more than one week to a subject. The definitions given in these directions are for the teacher, and are not to be given to the children in set form.

CHAPTER I.

FORM LESSONS FROM SOLIDS.

The object of the lessons from the solids is to lead pupils to observe the forms of objects, to help them to acquire definite ideas of form through sight and touch, and to lead them to express these ideas correctly in language, in moulding, and in drawing. The solids must be before the pupils and in their hands as much as possible, in order to cultivate perception by leading pupils to observe the forms of the solids. Pupils must be taught, not only to look, but also to observe. Observation of objects may be cultivated by the touch as well as by the sight. It is not enough that pupils *see* that a sphere is round, and that a cube has corners. Let them hold a sphere, and feel the smooth, round surface in the hand; let them hold a cube, and feel the sharp corners and edges in the hand.

By various exercises calling forth observation, lead pupils to discover for themselves the various properties of the surfaces of solids, and thus develop ideas concerning form. Development of ideas is made possible by means of comparison and contrasts. All knowledge is based upon comparison. Comparison and contrast are only possible where differences exist. One would have no conception of day if there were no night, of heat if there were no cold. It is important that this law should be remembered in the lessons on form. The idea of a curved surface obtained through observation will be rendered much more clear and definite if a plane surface is contrasted with the curved surface.

Cultivate the power of expression, and remember that words are not the only means of expression. Delineation is often more expressive than the best chosen language. Having developed an idea, give pupils the correct term to express it. Fix this term in the minds of the pupils by repeated application, and be careful that pupils use the terms in speaking.

The aim of the first lessons must be simply to familiarize pupils with the appearance and name of the sphere, cube, and cylinder, by entertaining exercises.

The first solid to be presented is the *sphere*, the simplest solid. It has but one surface, — a curved surface. The *cube*, having many surfaces which are plane, is presented as contrasting with the sphere. The cylinder is next presented as a combination of sphere and cube, having a curved surface and plane surfaces. The idea of surfaces must not be presented in the first lessons, however.

After children are acquainted with the names and general appearance of

the sphere, cube, and cylinder, lessons intended to develop the idea of surface, face, edge, line, point, should follow.

These will lead directly to the lessons on lines and plane figures, which should follow, as indicated in the scheme for the first half-year on p. 24.

Do not continue a lesson if the children seem wearied. If the idea of a lesson does not seem well developed in the minds of a class by the exercise of one day, continue the lesson with variation on the next day.

During all the lessons from the solids, children should be led by suitable exercises to know which hand is the right hand and which the left, that they may know them well when the lessons on lines and plane figures begin.

ORDER OF A LESSON FROM THE SOLID.

1. Review.
2. Observation { by the eye. by the hand.
3. Term or name given.
4. Drill.
5. Application.
6. Drawing and moulding, when practicable.

MOULDING.

It will readily be seen that moulding a form is, perhaps, the surest means of impressing its characteristics upon the mind. Lessons in moulding should be a part of primary work, and should be given as complementary to the lessons from the solid. It is not so formidable a matter to conduct a lesson in moulding as it might seem to those who have had no experience in it.

The clay should be kept moist in an earthen jar. A cubic mass of clay of about four inches side is more than sufficient for one lesson for the children in an ordinary-sized schoolroom. The teacher brings the mass on a slate, cuts off little masses of about a cubic inch, and places them on a slate for distribution to the children. The children receive them on their slates, and mould them by imitating the teacher and by following directions.

A sphere, or ball, is moulded by rolling the clay between the palms of the hand, the fingers being turned backward.

A cube is moulded from a sphere by dropping the sphere gently but squarely on the slate for three successive times on one part, then turning the clay, dropping it on the part exactly opposite for three successive times, and so on.

A cylinder is made from a sphere by rolling and dropping on the slate.

A sphere may be cut into two hemispheres by fine wire.

An oblong prism and a triangular prism can be made by dropping.

When the lesson is over, the various masses of clay are gathered on a slate, and returned to the teacher's desk. The children's hands and slates are rapidly sponged with a moist sponge. From the forms which have been

moulded, the teacher selects any which may be worthy of preservation. The remainder of the clay is put together, moistened, and swedged (thrown on a hard surface until it becomes one mass again), which may be used another day.

Exercise I. — A Sphere.

A sphere will roll.
A sphere will stand.

Tr. at head of long table; chn. around it; a number of blocks and objects all along the middle of the table.

Tr. (taking up a sphere). See what I have (*rolls it gently to Annie, who stands next her*). Annie, what did I do?

Observation by sight and by touch.

Annie. You rolled the ball to me.

Tr. You may take it in your hand. You may roll it gently to me. (*Annie rolls it to tr. Tr. rolls it to John, who stands next on the other side of the tr.*) John, take it in your hands. You may roll it gently to Mary, who stands next you. Mary, you may roll it gently to George, who is on the other side of the table, next to Annie. George, what can you do with it?

George. I can roll it.

Tr. You may roll it gently across the table. Who has it?

Edward. I have.

Tr. Can you make it stand still?

Edward. Yes (*does so*).

Tr. So you can: you can make it stand. You may roll it back to me. I will make it stand here. It can roll, and it can stand. We call it a sphere. (*Rolls the sphere to Margaret.*) Margaret, you may take the sphere in your hands. What have you in your hands?

Term.

Margaret. A sphere.

Drill.

Tr. All tell me what Margaret has in her hands.

Chn. A sphere.

Tr. Margaret, hand the sphere to Elsie, who stands next you. Elsie, you may bring the sphere to me. What have you brought to me?

Elsie. I have brought a sphere.

Tr. Carrie, can you find a sphere on the table near you? (*Carrie finds one.*) What have you found?

Carrie. I have found a sphere.

Tr. What can you do with the sphere?

Carrie. I can roll it.

Tr. What can you roll?

Carrie. I can roll the sphere.

Tr. Can you do any thing else with the sphere?

Carrie. I can make the sphere stand.

Tr. You may bring the sphere to me, and make it stand by this sphere. (*Carrie brings it.*) What have you done with the sphere?

FORM LESSONS FROM SOLIDS.

Carrie. I have made the sphere stand.

Tr. gives other chn. similar exercises, that they may use the word "sphere."

Tr. (*rolls the sphere to Jennie*). What does the sphere do, Jennie?

Jennie. The sphere rolls.

Tr. Hand the sphere to James. James, put the sphere on the table. Tell me about the sphere now, James.

James. It stands.

Tr. What stands?

James. The sphere stands.

Tr. Roll it to me, and I will make it stand here. Amos, can you find another sphere? (*Amos finds a ball.*) That is right. Bring it to me, and make it stand by these. *Application.*

Tr. has other chn. find other spheres on the table, or perhaps in their pockets. Tr. must be provided with beads, marbles, oranges, and other spherical bodies, for the application, in case the children should have none.

BUSY WORK. — For "busy work" (that is, work to be done carefully by themselves at their seats) chn. may draw little spheres between and touching the lines ruled upon their slates for writing.

NOTE. — This lesson is not intended as a model to be followed *verbatim*. It is intended to be suggestive in the following particulars: —

That every child should not only see the solid, but should also handle it; should not only receive the idea of the lesson, but should also be led to express it; should not only hear the name or term, but should use it; should not only learn the form of a geometric solid, but should also be led to see that form in objects, both natural and manufactured; and, finally, should express the form by moulding and by drawing when suitable.

EXERCISE II. — A Cube.

A cube will stand.
A cube will slide.

Tr. and chn. at table as before.

Tr. calls on the chn. to find a sphere; leads them to show and tell that a sphere will roll and will stand. *Review.*

Tr. takes up a cube, hands it to one ch. after another, makes it stand, asks a ch. to tell what the block will do. The ch. says the block will stand. Tr. repeats with other chn.; asks a ch. to roll block. Chn. find ou by experiment that the block will not roll. *Observation by sight and by touch.*
Tr. pushes block, and asks a ch. what was done. The ch. states that the tr. pushed the block. Chn. do it, and tell what they do. Tr. pushes the block again, and asks a ch. what the block does when pushed. Ch. states that the block slides. Tr. gives the name, "Cube;" gives *Term.*

Drill. other chn. similar exercises, and leads them to say, "**A cube will stand,**" "**A cube will slide.**" Chn. find other cubes, name them, make them stand, or push them, and tell what the cubes will do.

Application. Tr. has many chn. find cubes or cubical objects, and leads them to tell that they have found cubes, and to show and to tell what the cubes will do.

NOTE. — Cubical objects are not common. Cubes may be moulded from clay, or cut from soap, from bread, or cake, for illustrations.

BUSY WORK. — Show the chn. one face of the cube, and tell them they may make something like it between the lines ruled on the slate and touching the lines. They may make several.

EXERCISE III. — A Cylinder.

A cylinder will roll.
A cylinder will stand.
A cylinder will slide.

Tr. and chn. at table as before.

Review. Tr. calls on the chn. to find a sphere, to show and tell what a sphere will do; to find a cube, to show and tell what a cube will do.

Observation by sight and by touch. *Tr.* Mary, do you see any block that isn't a sphere that will roll? If you do, you may take it, and roll it. (*Mary finds a cylinder, and rolls it.*) Why, yes: that block will roll. Hand it to John, and let him roll it to Frank. (*Tr. gives other chn. an opportunity to roll the block.*)

Tr. James, can you show me any thing else this block will do? (*James makes the block stand.*)

Tr. What will the block do, James?

James. The block will stand.

Tr. Hand the block to Annie. Annie, tell me, and show me at the same time, what the block will do.

Annie (makes the block stand). The block will stand. (*Rolls the block.*) The block will roll.

Tr. Edward, what else will the block do? Can you tell me, and show me?

Edward (pushing the block). The block will slide.

Term. *Tr.* Certainly. This block will roll (*rolling the block*). This block will stand (*making the block stand*). This block will slide (*pushing the block*). This block is a cylinder.

Drill. Tr. gives other chn. similar exercises, leading each ch. to state and to show that —

FORM LESSONS FROM SOLIDS.

A cylinder will roll.
A cylinder will stand.
A cylinder will slide.

Tr. has the chn. find cylinders or cylindrical objects (as pencils, ribbon-blocks, collar-boxes), and leads them to state that they have found cylinders, and to show and state what the cylinders will do. **Application.**

Exercise IV. — A Surface.

Tr. and chn. at table, with many blocks and objects, as before.

Tr. Margaret, find me a sphere. Show me what you can do with it, and tell me about the sphere. **Review.**

Margaret (finds a sphere, and rolls it). The sphere will roll. *(Makes it stand.)* The sphere will stand.

Tr. calls on other chn. to find a cube and a cylinder, show what they can do with them, and tell about them.

Tr. moves fingers around in a small circle on the table; has all the chn. do the same. **Observation**

Tr. See what I do *(moving fingers in the same way on a sphere).* **by sight and**
George, upon what do I move my fingers? **by touch.**

George. Upon a sphere.

Tr. (moving fingers on a cube). Upon what do I move my fingers now, Carrie?

Carrie. Upon a cube.

Tr. (moving fingers on a cylinder). Upon what do I move my fingers now, Jennie?

Jennie. Upon a cylinder.

Tr. And now, James?

James. Upon a book.

Tr. Amos, do you see any thing that you can move your fingers upon as I do upon the book? What do you see?

Amos. I see a cube.

Tr. Very well. You may take it, and move your fingers upon it as I moved mine upon the book.

Amos does so. *Tr.* asks other chn. to move fingers upon other things. Chn. move fingers upon blocks, wall, floor, etc. *Tr.* is careful that the chn. move their fingers around in a circle, so that they will not be moved along or over an edge.

Tr. When we move our fingers as we have done just now, we move them on a surface. Who can find me a surface? *(Chn. raise* **Term.** *hands.)*

Tr. John, you may find me a surface. *(John finds one.)* **Drill.**
What have you found?

John. I have found a surface.

Tr. Why do you think you have found a surface?

John. Because I can move my fingers around on it, so.

Tr. has many chn. find surfaces, telling what they have found, and why they think so.

Tr. Mary, you may find a surface of the book. What have you found?

Application.

Mary. I have found a surface of the book.

Tr. Why do you think so?

Mary. Because I can move my fingers around upon it, so.

Tr. has other chn. find a surface of some special object called for, and tell always what they have found, and why they think so.

EXERCISE V. — One Surface; Many Surfaces.

Tr. and chn. at table, with blocks.

Review.

Tr. Annie, find me a surface. Tell me what you think you have found, and why you think so. John, find me a surface, and tell me about it. Mary, find me a surface, and tell me about it. (*Other chn. find surfaces, and tell about them.*)

Observation by sight and by touch.

Frank, find me a surface of a cube, and tell me all about it. Move your fingers along on it until the surface stops. (*Other chn. do the same.*) George, find me a surface of a sphere. Move your fingers along until the surface stops.

George (*moves fingers around the sphere*). It doesn't stop.

Tr. Jennie, you may try it.

Jennie (*moving fingers around the sphere*). The surface doesn't stop. (*Other chn. try.*)

Tr. Carrie, how many surfaces has a sphere?

Carrie. One.

Tr. Yes: a sphere has one surface. Now, let us look at the cube (*holding up a cube*). Edward, find me a surface of this cube. Hold your fingers on it. Grace, find me another surface. Hold your fingers on it. Frank, find another, and hold your fingers on it. (*Calls other chn. to do the same until all the surfaces are found.*) How many chn. have found a surface! and each one has found a surface on this cube. How many surfaces the cube has! Mary, the sphere has one surface: can you tell me about the surfaces of the cube?

Term.

Mary. The cube has a great many surfaces.

Drill.

Tr. That's right. The cube has many surfaces.

Tr. has other chn. do the same, and tell about it.

Application. Tr. has many chn. find other objects having many surfaces.

Exercise VI. — A Hemisphere.

A hemisphere will stand.
A hemisphere will roll.
A hemisphere will slide.
A hemisphere has two surfaces.
A hemisphere is half a sphere.

Tr. and chn. at table, with blocks.

The chn. find a sphere, and tell and show that the sphere will roll and will stand; find a cube and a cylinder, and tell and show about them; find the surface of a sphere, and tell about it; and find surfaces of other blocks, and tell about them. — *Review.*

Tr. (*has a sphere that can be separated into hemispheres; hands the sphere entire to Harry*). Harry, look at this sphere, and see what you can find out. — *Observation by sight and by touch.*

Harry (*turns it over, and discovers that it comes apart*). Why, it comes in two.

Tr. Yes, there are two parts. Hand one to Mary, and the other to George. Mary and George, put them side by side. (*Mary and George perhaps place them on the curved faces.*) Mary, what can you tell me about your part?

Mary. It will stand.

Tr. George, how is it with your part?

George. It will stand.

Tr. George, of what is your block a part?

George. A part of a sphere.

Tr. Right. Hand your part of a sphere to Helen; and, Mary, hand your part to Bessie Helen and Bessie, see if you can put these parts of a sphere on the table in a different way. (*Helen and Bessie place them on the plane faces.*) Helen, what can you tell me about your part of a sphere?

Helen. My part of a sphere will stand.

Tr. And, Bessie, what can you tell about your part of a sphere?

Bessie. My part of a sphere will stand.

Tr. Bessie, hand your part to Frank. Frank, see if you can find out something else about that part of a sphere.

Frank (*rolls the hemisphere*). This part of a sphere rolls.

Tr. What! does it roll like a sphere?

Frank. No; but it rolls.

Tr. Yes, it rolls around: so we can say that it rolls. Find a sphere, Grace, and roll it, and tell me how a sphere rolls.

Grace. It rolls right along.

Tr. Yes. Carl, can you find another block that rolls along? (*Carl finds a cylinder.*) Frank, give your part of a sphere to Martha; and, Helen,

pass yours to Henrietta. Martha and Henrietta, put them side by side. Martha, how do they look?

Martha. They look just alike.

Tr. leads the chn. to observe that the hemisphere will slide, that the blocks have two surfaces; leads other chn. to observe that the two blocks are exactly alike.

Term. Tr. gives the term, "**Hemisphere.**"

Tr. has other chn. find other hemispheres; gives many chn. similar
Drill. exercises with hemispheres, leading them to use the term "hemisphere," and to state that —

A hemisphere will stand.
A hemisphere will roll.
A hemisphere will slide.
A hemisphere has two surfaces.
A hemisphere is half a sphere.

Application. Tr. has chn. find hemispherical objects, as apples or oranges, balls of soap or of clay, halved.

NOTE. — There is material here for more than one lesson.

EXERCISE VII. — A Curved Surface.

A block which rolls has a curved surface.

The tr. with chn. at table, with blocks.

Review. Tr. reviews surface.

Tr. has the chn. move fingers over curved surfaces, and over plane surfaces; asks the chn. if fingers move the same on the surface of a sphere,
Observation and on the surface of the top of the table. Chn. state that
by sight and fingers move *around* a sphere, *along* a table. Chn. find the blocks
by touch. that roll. Chn. observe again how fingers move over the surface of a sphere; observe the part of the cylinder that rolls; observe how the fingers move over the surface of the part that rolls.

Term. Tr. gives the term, "**Curved surface.**"

Chn. find blocks having curved surfaces, telling and showing
Drill. how they know them. The tr. leads the chn. to state that —

A sphere has a curved surface;
A cylinder has a curved surface; —

showing and telling how they know the curved surfaces.

Application. Chn. find objects with a curved surface, not only on the table, but around the room.

Exercise VIII. — A Plane Surface.

A block which slides has a plane surface.

Tr. and chn. at table.

Tr. reviews surface and curved surface. — Review.

Chn. move their fingers over plane surfaces of the top of table, etc.; state that their fingers move along these surfaces; observe the surfaces of a cube; observe how their fingers move over them; observe that the cube slides; observe the surfaces of a cylinder, that the part which has a curved surface rolls, that the other parts slide. — Observation by sight and by touch.

Tr. gives the term, "Plane surface." — Term.

Chn. find blocks having plane surfaces, telling and showing how they know them. Tr. leads the chn. to state that — Drill.

A sphere has a curved surface.
A cylinder has a curved surface and two plane surfaces.
A cube has six plane surfaces.

Chn. find plane surfaces all about the room, and tell and show about them. — Application.

Exercise IX. — A Face.

When the whole of a surface can be seen, it is called a face.

Tr. reviews thoroughly surface, curved and plane surfaces. — Review.

Tr. leads chn. to observe that they can see all of one surface of a cube; that they cannot see all of the surface of a sphere; that they can see all of either surface of a hemisphere; that they cannot see all of the curved surface of a cylinder, etc. The chn. move their fingers over the surface of a sphere in many directions, and observe that the surface never stops; move their fingers over curved surface of a hemisphere in many directions, and observe that the surface ceases; move their fingers over the plane surface of a hemisphere in every direction, and observe that the surface stops; move their fingers over the surfaces of a cube in every direction, and observe that the surface stops; observe also, that, when a surface stops, they can see all of the surface, as in hemisphere, cube, etc.; that, when a surface does not stop, they cannot see all of the surface, as in sphere, curved surface of cylinder. — Observation by sight and by touch.

Tr. gives the term, "Face." — Term.

The chn. find many faces. The tr. leads the chn. to state that they have found faces, and to show and tell how they know them. — Drill and application.

The chn. draw the faces. — Drawing.

Exercise X. — An Edge; a Line.

The line in which two faces, or a face and a surface, meet, is called an edge.

Review. The tr. reviews faces thoroughly.
 Tr. moves fingers on the adjacent faces of a cube. The chn. observe.
Observation by sight and by touch. The tr. moves fingers on the faces of the cube until they meet; leads the chn. to state that fingers were moved no farther, because they met; that they were moved on the faces of the cube. The chn. are led to see then that the faces meet, and that they meet in a line. The tr. has similar exercises with a cylinder and a hemisphere.
Term. Tr. or ch. gives the term, "**Edge**."
Drill and application. The chn. find many edges, telling and showing how they know they are edges.
Drawing. The chn. draw edges pointed out by the tr.

Exercise XI. — A Straight Edge; a Straight Line.

An edge where two plane faces meet is called a straight edge.

Review. The tr. reviews edge.
Observation by sight and by touch. Chn. observe now what kind of faces meet in solids and objects; find plane faces; find edges where two plane faces meet; state that two plane faces meet.
Term. Tr. gives the term, "**Straight edge**," using also "**Straight line**."
Drill. The tr. drills on straight edge and line.
Drawing. The chn. draw straight edges pointed out by the tr.

Exercise XII. — A Point.

A point is the end of a line.

Review. Tr. reviews edge and line.
Observation by sight and by touch. Chn. observe the sharp points of the corners of solids, the points of pins, etc.; that the end of a straight edge is a point; that the beginning and the end of an edge, or line, may be represented on the board by a dot; that a dot may be placed not only at the beginning and end of a line, but also in any part of it.
Term. Tr. gives the term, "**Point**," instead of "Dot."
Drill. Tr. has the chn. find many points; also has them make points
Application. on the board and slate, showing them that the points thus made
Drawing. should be small; for a point at the end of a line should not be thicker than the line itself.

CHAPTER II.

VERTICAL LINES.—HORIZONTAL LINES.—OBLIQUE LINES.—SQUARE.

The teacher should remember to look over the whole week's work on any subject before giving any lesson on the subject.

SUBJECT.— **Vertical Lines.**

MONDAY.	TUESDAY.	WEDNESDAY.	THURSDAY.	FRIDAY.
Geometric.	Reduction.	Memory.	Dictation.	Object.
│ │ │	││││	Lesson of Tuesday.	▭	Vertical lines in the room.

A vertical line stands up.
A vertical line should be drawn from the upper end downward.

Sentences like the above, which are directly below the scheme for a subject, are not given as a set form to be used by the teacher or children, but are given as "leading sentences," embodying the ideas to be developed or recalled in the minds of the children.

MONDAY.

Vertical Lines. GEOMETRIC NAME OR TERM.—This lesson should be given from the solid and from objects.

The teacher and children at a table, with blocks.

A review of straight edge (straight line) should be given from the cube. Review.

The children move their fingers on two adjacent edges (one horizontal, one vertical) of a cube held upright. The children move their fingers toward each other on these edges till their fingers meet. The children observe that the fingers on one edge do not move in the same direction as the fingers on the other edge. The teacher has the children move their fingers on vertical edges; leads them to say that the edges, or lines, stand up. The children find other lines that stand up. Observation by sight and by touch.

The teacher gives the term, "**Vertical;**" writes it on the board. Term.

Drill and application.
The children find many vertical lines, tell and show how they know the lines are vertical lines.

Drawing.
The teacher asks the children to draw on the board or on the slate something like the vertical edges or lines of the cube.

Additional Work.

The *Additional Work* is to be used when it is necessary to devote more than one week to a subject. Suggestions and illustrations for this work are given under the directions for each day when necessary. As a general thing, however, no suggestions will be made for additional work in the lesson on Monday; for the lesson of Monday of the second week on a subject should always be after the manner of the lesson for Monday of the first week, the teacher presenting as many new objects as possible, and seeking for new ways of interesting the children.

Busy Work for the Week on Vertical Lines.

Busy Work should be done with care. (See p. 16.) Various modes of Busy Work, which relate directly to the form lessons and to the work in drawing, are here suggested: —

First, Children may arrange sticks or pegs on the desk vertically, and then may draw them. Let the children draw them as they see them. Some will represent them simply as lines; some will draw the face of the stick or peg. The sticks and pegs may sometimes be given out by themselves, and sometimes together. If they are given out together, the teacher may sometimes suggest an arrangement, as one stick and one peg. one stick and two pegs, two sticks and one peg, etc.; or the children may sometimes be required to invent their own arrangement. The sticks and pegs may be placed so as to be on a line at the lower end; and then the children will enjoy thinking of them as men and boys in a row, or they may be placed so as to be on a line at the upper end, or with their centres on a line.

Second, The slates may be placed with their short sides parallel to the fronts of the desks, and children may draw vertical lines connecting the lines that are usually ruled for writing upon one side of slates in primary schools. At first the vertical lines may be short, connecting the first two ruled lines. The variety possible in the arrangement of these lines is almost endless; —

1. The lines consecutively as far apart as the length of the lines.

2. Two lines as far apart as the length of the lines, a larger space; two lines, a space; two lines, etc.

3. Two lines, a space; one line, a space; two lines, etc.

These groupings may be varied to the extent of the children's ability in number.

The vertical lines may connect the first and third ruled lines in the various groupings indicated above. Vertical lines connecting the first two ruled lines may alternate in various groupings, with vertical lines connecting the first and third ruled lines.

VERTICAL LINES.

Vertical lines in these various groupings may be extended gradually across several of the ruled lines.

A vertical line connecting the second and third lines may alternate with one connecting the first and fourth ruled lines.

Children may invent groupings of their own to extend across a definite number of ruled lines assigned by the teacher.

Third, The teacher may give children simple objects about the room to draw from by themselves, calling attention to the vertical lines.

All the results of these various kinds of Busy Work should be carefully and encouragingly noted by the teacher during the exercise or at its close.

TUESDAY.

Three Vertical Lines. REDUCTION FROM THE BLACKBOARD. — For this lesson it will be well for the teacher to draw quickly upon the board an oblong representing a slate in the position of the slates on the children's desks. This oblong should be much larger than a slate. The teacher should then place points for, and draw, three vertical lines in the upper left-hand part of the oblong. The lines which the children draw upon their slates should not be longer than their forefingers at first. The lines which the teacher draws within the slate upon the board should be of such proportion to the oblong drawn upon the board as the proportion which the lines to be drawn by the children (about the length of their forefingers) will have to their slates. Explain to the children the direction of vertical lines on their slates as they lie on their desks. Show them how to lay a pencil on a slate vertically; and, before they begin to draw, ask them to lay their pencils vertically on their slates. Let the children, some at their seats and some at the board, imitate the lines drawn by the teacher, making the points small, drawing the lines carefully, using the pencil or crayon lightly, and looking at the lines, when finished, to see if they stand up. In the course of this lesson, care should be taken to give the terms "upper end" and "lower end," and to drill the children in their use. The directions which follow are for the teacher, and not for the children: —

DIRECTIONS FOR THE TEACHER. — Place points for the ends of a vertical line, and draw it. — Bisect it; that is, divide it into two equal parts. — Bisect the upper half. — Place points for a second vertical at the right of the first, of the same length, as far from it as one-fourth its length, and draw it. — Place points for a third vertical at the right of the second, of the same length, as far from it as one-fourth its length, and draw it.

DRILL. — When the three vertical lines are completed, the teacher may give a drill exercise on vertical lines below those just drawn. This exercise is to be a drill, simply in drawing *vertical* lines, without special reference to

length, direction being the main consideration: therefore the lines may be drawn without points. When the length of lines is of importance, points should be made. In drill exercises the lines should be drawn at the word of the teacher. Counting "One, two," for the beginning and ending of a line, produces good results. The counting should be regular, and no opportunity should be given to erase a line. The row of lines should extend across the slate; and, while drawing, children should look to see if all the lines stand up.

Additional Work.

Four Vertical Lines in Groups of Two. REDUCTION FROM THE BLACKBOARD.

DIRECTIONS FOR THE TEACHER. — Place points for a vertical line, and draw it. — Bisect it. — Bisect the upper half. — Place points for a second vertical at the right of the first, of the same length, as far from it as one-fourth its length, and draw it. — Place points for a second group of two verticals as far to the right of the first group as half their length, and draw the lines.

WEDNESDAY.

Three Vertical Lines. FROM MEMORY. — Let the children draw from memory vertical lines of the same length and number, and in the same position, as those drawn the day before. The teacher may recall to their minds what they drew the day before, by some pleasant allusion, and ask them to tell what they drew then. They will remember the three lines and the drill exercise. After obtaining as full a description as possible of the three lines, the teacher may call upon the children to draw these lines from memory, *without* further direction. After the three lines have been completed, the teacher may repeat the drill exercise of the preceding day.

The *Additional Work* of Wednesday is of course fixed by the *Additional Work* of the preceding day.

THURSDAY.

Upper Side, Lower Side, Centre. Vertical Line. FROM DICTATION. — The illustration given in the scheme represents a slate with one vertical line drawn through the centre from side to side. This may seem very simple; but the children have several things to learn in this exercise. They have to discover the difference between the slate and the slate-frame; they have to learn the upper side and the lower side of the slate, and to find the centre of the upper side and the centre of the lower side. When the children have marked these points, the teacher directs them to connect the points by a vertical line. This will be a long line for little fingers; but it is good occasional practice to draw such lines.

The directions for dictation lessons are to be given by the teacher to the children. They are separated, to mark the steps. Before giving the directions for any step, the teacher should learn from the children, by conversation,

whether they are prepared for it; and, if they are not, should, by further conversation, lead them to see what is implied in that step before giving the direction to them.

DIRECTIONS. — Put your fingers on the *upper side* of your slate. — Find the *centre* of the upper side of the slate. — Mark the *centre of the upper side* by a point. — Put your fingers on the *lower side* of your slate. — Find the *centre of the lower side* of the slate. — Mark the centre of the lower side by a point. — Draw a *vertical line* from the centre of the upper side to the centre of the lower side.

Finding the centre of the sides of the slate should be a matter of daily practice. When a child succeeds in finding the centre of a side, the point may be marked permanently for future use by a puncture in the slate-frame.

DRILL. — A drill on placing points may be advantageously introduced here. Let each child place a point in the centre of the slate, a point above the centre, a point below the centre, a point at the left of the centre, a point at the right of the centre, until all place points readily.

Additional Work.

Three Vertical Lines. FROM DICTATION. — Before beginning this exercise, children must be practised on finding the left part and right part.

DIRECTIONS. — (Give the directions for the vertical line of the preceding exercise.) — Find the left part of the upper side of the slate. — Find its centre, and mark it. — Find the left part of the lower side of the slate. — Find its centre, and mark it. — Draw a vertical from the upper point to the lower point. — (Give similar directions for the vertical at the right.)

FRIDAY.

Vertical Lines. DRAWING FROM OBJECTS. — The teacher should select some object in which the most noticeable lines are vertical. Every schoolroom furnishes many such objects; for example, the wainscoting of the room, the sides of the casing of the windows or doors, etc. A plumb line illustrates a vertical line perfectly, and may be used as an object for this lesson. Remember that one important object of these lessons is to cultivate the observation. Therefore, before beginning to draw from any object for this exercise, lead children to discover all the vertical lines in the object, to point them out and tell about them.

As no special practice has been given as yet in drawing horizontal lines, the lines on the slates ruled for writing can sometimes be used to advantage in this exercise. The ruled lines may be traced by the children for the horizontal lines which may be found in the object selected. Sometimes the ruled lines may answer without tracing. A single row or a half-row of a paper of pins may be given as an object. After studying the row, children discover that the pins are vertical. Their fancy is then much pleased by supposing the ruled lines to be the folds in the paper through which the pins pass; and they work with delight at making the vertical pins on the ruled lines.

Subject. — **Horizontal Lines.**

MONDAY.	TUESDAY.	WEDNESDAY.	THURSDAY.	FRIDAY.
Geometric.	Reduction.	Memory.	Dictation.	Object.
—	≡	Lesson of Tuesday.	▭	Lines in blackboard, table, etc.

A horizontal line lies down.
A horizontal line should be drawn from left to right.

MONDAY.

Horizontal Lines. Geometric Name or Term. — This lesson should be given from the solid.

The teacher and children with blocks at a table.

Review. The children find vertical edges, vertical lines, and show and tell how they know they are vertical.

Observation by sight and by touch. The teacher holds a cube upright; the children find the edges of the cube that are not vertical, and pass their fingers over such edges. The teacher leads the children to say that these edges (lines) lie down. The children find many lines that lie down.

Term. The teacher gives the term, "**Horizontal**," writes it on the board, and gives the children practice in speaking it.

Application and drill. The children find many horizontal lines, always showing and telling what they have found, and how they know the lines to be horizontal; they also recall any horizontal lines they may have seen.

Drawing. The children draw on the slate and on the board the horizontal lines and edges which they find.

Busy Work for the Week.

The Busy Work (p. 16) in form for the week can be carried on in the way suggested for the preceding week's Busy Work on vertical lines.

Sticks and pegs may be arranged horizontally, or horizontally and vertically, in various groupings.

The ruled lines on the slate may again be connected; but the slate must be placed with the long sides parallel to the front of the desk. Horizontal lines may be drawn connecting the ruled lines in various groupings.

HORIZONTAL LINES.

The children may draw by themselves objects in which horizontal lines are particularly noticeable.

After Tuesday's *Additional Work* has been given, for Busy Work the cross can be given for repetition and for alternation with vertical or horizontal lines between the ruled lines.

TUESDAY.

Vertical and Horizontal Lines. REDUCTION FROM THE BLACKBOARD. — Horizontal lines should always be drawn from left to right. Give the children practice in finding the left end and the right end of a line. The following directions for this exercise are for the teacher, and not for the children: —

DIRECTIONS FOR THE TEACHER. — Sketch upon the board an oblong for a slate. — Place points for and draw a vertical line of the same length as the vertical lines given the Tuesday previous. — Mark the centre of the vertical. — Place a point opposite the centre of the vertical for the left end of the central horizontal. — Place a point above and a point below this point, opposite the centre of each half of the vertical, for the left ends of the first and third horizontals. — Place points for the right ends of the horizontals, and draw the lines. — Place points for the second vertical line, and draw it.

It will be noted that definite directions are here given for placing the points for the left ends of the first and third horizontals. These directions, however, cannot yet be understood by the children: therefore, let them take the points by imitating the work on the board.

Remember that the length of lines generally required from children at this stage should not be longer than their fore-fingers.

DRILL. — After this exercise is completed, a drill on horizontal lines, drawn at the word of the teacher, should be given.

Additional Work.

Cross. REDUCTION FROM THE BLACKBOARD. — The teacher draws a slate on the board as before, and draws a cross of suitable size in the upper left-hand part of the slate. This should be so placed that the margin at the upper part of the slate and that at the left side will be of the same width. The teacher should always place the blackboard figures carefully, and the children should *imitate* the placing as well as the lines. No detailed directions should be given to the children about placing the figures until they have more knowledge of and familiarity with terms.

DIRECTIONS FOR THE TEACHER. — Place points for a horizontal line, carefully estimating the distance they should be from the left side and from the upper side of the slate, and draw the line. — Mark its centre. — Place points as far above and below the centre as half the line. — Connect these points by drawing a vertical.

The teacher should lead the children to find out that one part of the vertical line on the board is as long as one part of the horizontal.

When the children have drawn the cross in the upper left-hand part of their slates, the teacher may repeat it in the upper right-hand part of the slate drawn on the board, for the children to imitate. After two crosses are drawn, a drill on horizontal lines should follow.

WEDNESDAY.

Lesson of Tuesday. FROM MEMORY. — Try and lead the children to remember not only the arrangement of the lines, but also their position on the slate and their length.

THURSDAY.

Left Side, Right Side. Horizontal Line. FROM DICTATION. — The dictation lesson of this week is similar to that of the week preceding. The children have now to learn the left side, the right side, the centre of the left side, and the centre of the right side. As the illustration shows, the slate should be placed with the short sides parallel to the front of the desk.

DIRECTIONS. — Hold up your left hand. — Put the fingers of your left hand on the *left side* of your slate. — Find the *centre of the left side*, and mark it with a point. — Hold up your right hand. — Put the fingers of your right hand on the right side of your slate. — Find the *centre of the right side*, and mark it with a point. — Draw a horizontal line from the centre of the left side to the centre of the right side.

Additional Work.

Three Horizontal Lines. FROM DICTATION. — In addition to the work of the dictation lesson of the previous week, the centre of the upper half and the centre of the lower half are now to be learned. The manner of giving the lesson should follow that of the dictation lesson of the *Additional Work* on vertical lines, p. —

FRIDAY.

Horizontal Lines. FROM OBJECTS. — Care should be taken not to give too large a group of lines. Do not give more lines of an object than the children can count with ease. If telegraph wires can be seen from the window, they may serve for the lesson.

Additional Work.

If it is desired, the face of an object with horizontal and vertical edges can be given to the children for imitation; but, before the children attempt to draw it, the teacher should lead them to see and to tell about its edges. When objects are given to the children to draw from in Busy Work, the drawing must of course be simple imitation according to the mind of the child; but, when objects are given as a lesson, the teacher must endeavor by conversation to develop the power of observation in the children.

SUBJECT. — **Oblique Lines.**

MONDAY.	TUESDAY.	WEDNESDAY.	THURSDAY.	FRIDAY.	
Geometric.	Reduction.	Memory.	Dictation.	Object.	
/ \	\ /	/ /	Lesson of Tuesday.	▣	Lines in the room, picture-cord, wall paper.

An oblique line leans.

MONDAY.

Oblique Lines. GEOMETRIC NAME. From solids and objects. — The teacher, holding a cube upright, reviews vertical and horizontal edges (lines) with the children. *Review.*

The teacher stands a tall block, a cylinder, or pencil, upright; leads the children to say that the block, cylinder, or pencil stands up. The teacher lays the block or pencil on the table; leads the children to say that it lies down; stands the pencil up, then tips it, and leads the children to tell the difference. The teacher stands up, then leans against the wall, and asks the children to tell about the two positions. The children say that the teacher leans, the pencil leans, etc. The teacher holds a cube inclined; leads the children to see and to say that the edges (the lines) lean. *Observation by sight and by touch.*

The teacher gives the term, "**Oblique line;**" writes the word "Oblique" on the board, and leads children to state that **An oblique line leans.** *Term.*

The children find oblique lines on the wall, in objects, on the board, telling what they have found, and how they know what they have found. *Application and drill.*

The children draw oblique lines in different directions on the slate and the board. *Drawing.*

Busy Work for the Week.

Oblique lines can now be used to vary the Busy Work. At least half of the lines in the Busy Work should now connect the first and third ruled lines, thus increasing the length of the lines.

The sticks and pegs may be laid obliquely, and may also be laid in groups of the three kinds of straight lines. (See p. 231, Figs. A.)

TUESDAY.

A Vertical, a Horizontal, and an Oblique Line. REDUCTION FROM THE BLACKBOARD. — The teacher draws a slate on the board; draws the three straight lines, vertical, horizontal, and oblique, in the upper left-hand corner, being careful to draw them of a length proportional to those to be drawn on the slates by the children.

DIRECTIONS FOR THE TEACHER. — Place points for a vertical line, and draw it. — Opposite the upper end of the vertical, place points for a horizontal as long as the vertical, and draw it. — Below the left end of the horizontal and opposite the lower end of the vertical, place a point. — A short distance below the right end of the horizontal, place a point. — Connect these points by drawing an oblique line.

In drawing an oblique line, which inclines at an angle of 45°, it is immaterial at which end the line is commenced. If the line inclines more to the horizontal than to the vertical, begin at the left end of the line to draw. If it inclines more to the vertical than to the horizontal, begin at the upper end to draw.

This group of lines may be repeated in the upper right-hand part of the slate.

DRILL FOR THE WEEK. — A drill on oblique lines should be given. The teacher should look over the results of the drill exercises, and notice the prevailing fault (it is well to speak of but one fault at a lesson), so as to be able to caution the children against it at the next drill exercise.

Additional Work.

Two Vertical and Two Oblique Lines. REDUCTION FROM THE BLACKBOARD. — It will be noted that the oblique lines incline in the opposite direction from that of the line given on the previous Tuesday.

DIRECTIONS FOR THE TEACHER. — Place points for a vertical line, and draw it. — Quadrisect it; that is, divide it into four equal parts. — Place points for a second vertical as far to the right of the first as one-fourth the length of the vertical, and draw it. — As far to the right of the upper end of the second vertical as one-fourth the line, place a point. — As far to the right of the lower end of the second vertical as the length of the vertical, place a point. — Connect these points by an oblique line. — Place points for a second oblique line as far away as one-fourth the vertical, and draw it.

The children must place these lines by imitation.

WEDNESDAY.

Lesson of Tuesday. FROM MEMORY.

OBLIQUE LINES.

THURSDAY.

Upper Left-hand Corner, Upper Right-hand Corner, Lower Left-hand Corner, Lower Right-hand Corner. Oblique Lines. FROM DICTATION. — This lesson calls for two very long lines. Where such long lines are to be drawn, it is well to move the pencil over the slate without touching it, in the direction of the line to be drawn, two or three times before drawing the line. The lesson also calls for a knowledge of the upper left-hand corner, the lower left-hand corner, the upper right-hand corner, and the lower right-hand corner. The children must be led to observe and name these corners.

DIRECTIONS. — Find the *upper left-hand corner* of the slate. — Find the *lower right-hand corner* of the slate. — Hold up the first finger of the right hand. — Put that finger in the upper left-hand corner of the slate. — Move it as straight as you can to the lower right-hand corner. — Move it again as straight as you can from corner to corner. — Take the pencil, and move it just above the surface of the slate, without touching it, from corner to corner. — Draw an oblique line from the upper left-hand corner to the lower right-hand corner. — (Give similar directions for drawing from the lower left-hand to the upper right-hand corner.)

Additional Work.

Oblique Lines. FROM DICTATION. — The lesson is based on the previous dictation exercise.

DIRECTIONS. — (Give the directions for the oblique lines of the previous dictation exercise.) — Find the centre of the left side of the slate, and mark it. — Find the centre of the upper side, and mark it. — Move the pencil over the slate, without touching it, from the centre of the left side to the centre of the upper side. — Draw an oblique line from the centre of the left side to the centre of the upper side. — (Give similar directions for drawing the remaining oblique lines.)

FRIDAY.

Picture-Cord. FROM THE OBJECT. — Oblique lines are a little more difficult to find in a schoolroom than vertical or horizontal lines. The wall-paper or a picture-cord sometimes furnishes oblique lines. If there is no picture-cord in the room, one may be improvised with twine large enough to be seen across the room. The children may draw both lines of the cord, thus giving two oblique lines meeting in a short curve at the top.

Additional Work.

End of a Book. FROM THE OBJECT. — The end of a book, resting on the long edges of the covers, with the covers slightly spread, will serve for an object. If the leaves can be made to remain together in a single mass, the end of the book will furnish two oblique lines, two verticals, and two horizontal or slightly curved lines.

SUBJECT. — **Square.**

MONDAY	TUESDAY.	WEDNESDAY.	THURSDAY.	FRIDAY.
Geometric.	Reduction.	Memory.	Dictation.	Object.
□	□	Lesson of Tuesday.	⊠	Square of bright paper.

A square has four sides.
A square has four corners.

A square has four equal sides.
A square has four square corners.

MONDAY.

Review. **Square.** GEOMETRIC NAME. From solids and objects. —The teacher reviews faces, plane and curved faces. The children find the faces of a cube.

Observation by sight and by touch. The teacher leads the children to observe the face of a cube, observe its edges as straight, count its edges, say that it has four edges; count its corners, say that it has four corners; measure its edges, say that its edges or sides are equal; observe its corners, say that it has four square corners.

Term. The term "**Square**" for the face of a cube is given by the teacher or the children. The teacher writes the word "**Square**" on the board, leads the children to state that —

A square has four sides.
A square has four corners.

A square has four equal sides.
A square has four square corners.

Application and drill. The children find many squares, tell and show what they have found, and how they know what they have found.

Drawing. The children draw squares on the slate and on the board.

Busy Work for the Week.

Whole rows of squares may be drawn, which may be, in the imagination of the children, boxes set on a shelf. Large and small squares may alternate or not as the teacher may direct. In the Busy Work it must always be

SQUARE. 51

remembered that the work should be assigned definitely by the teacher; being sometimes an arrangement which the teacher suggests, and sometimes an arrangement which the children make themselves.

At this stage something new may be introduced into the Busy Work. Heretofore slender sticks have been simply *laid* for lines. These sticks may now be held together by peas rendered soft by soaking. The sticks having pointed ends may be inserted in the peas, and thus a figure which will hold together may be made. A figure thus made may serve as a subject for an object lesson.

The children may also build up skeleton cubes on their squares with sticks and peas.

TUESDAY.

Square. REDUCTION FROM THE BLACKBOARD. — The placing of the first point just as far from the left side of the slate as it is from the upper side must now be especially explained. Endeavor to have this point placed *an inch* from the upper, and *an inch* from the left, side. A cube an inch square is a convenient standard for the teacher; and it is a good idea to distribute such cubes sometimes, and allow the children to place the cube in the corner of the slate, and mark the point at its inner corner. The children should still draw the lines of the length of their forefingers, and the teacher's work on the board should be proportional to the work expected from the children.

DIRECTIONS FOR THE TEACHER. — Place points for a vertical line, and draw it. — As far to the right of the upper end of the vertical as the length of the vertical, place a point, and draw a horizontal, — the upper side of the square. — Directly opposite the lower end of the vertical, and directly below the right end of the horizontal, place a point, and draw a horizontal, — the lower side of the square. — Draw the right vertical side of the square.

These directions for the teacher always contain suggestions of certain things which the children should be led to see before they begin to draw.

The teacher may now begin to develop ideas of proportion, showing that the sides of a square have the same proportion to each other whether the square is large or small. Having drawn the square in the upper left-hand part of the slate, the children may draw a smaller square in the upper right-hand part. The children must look at each square when completed to see if it has equal sides and square corners.

DRILL FOR THE WEEK. — The drill should be on lines of one kind, and not on the square.

Additional Work.

Horizontal Border formed by the Repetition horizontally of a Square and its Diagonals. REDUCTION FROM THE BLACKBOARD. — The diagonal of a square is a straight line connecting opposite angles of the square. The teacher may or may not use the term " diagonal " in conversation with the children. The vertical lines of the border drawn upon the

slate by the children should be an inch long. The vertical lines drawn upon the board should be properly proportioned to those to be drawn on the slate.

DIRECTIONS FOR THE TEACHER. — Place points for a vertical line, and draw it. — From the upper end of the vertical line draw a horizontal line rather more than three times as long as the vertical. — From the lower end of the vertical draw a similar horizontal. — Place a point on the upper horizontal as far to the right of the vertical as the length of the vertical. — From this point draw a vertical to meet the lower horizontal, thus making a square. — Place points for, and draw, two other vertical lines, thus making three consecutive squares. — Erase what remains of the horizontal lines. — Draw the diagonals of each square.

Obtain the directions from the children before they begin to draw.

WEDNESDAY.

Lesson of Tuesday. FROM MEMORY.

THURSDAY.

Square and its Diagonals. FROM DICTATION. — The children have now to *place* a figure, from dictation, for the first time. In previous dictation exercises they have commenced their lines from the sides or corners of the slates. Great care must therefore be taken to have the dictation clear.

DIRECTIONS. — Place a point, as you did in the lesson of Tuesday, so that it shall be as far from the left side of the slate as it is from the upper side. — Place a point as far below it as the length of your forefinger. — Draw a vertical line connecting the points. — This is one side of a square. — Place a point for the upper right corner of the square. Remember that it must be as far to the right of the upper end of the vertical as the length of the vertical. — From the upper end of the vertical draw a horizontal to the point just made. — Place a point for the lower right corner of the square. Remember that it must be directly below the right end of the horizontal, and directly opposite the lower end of the vertical. — From the lower end of the vertical draw a horizontal to the point just made. — Complete the square by drawing a vertical, — the right side of the square. — Find the upper left corner of the square. — Find the lower right corner of the square. — Draw an oblique line from the upper left corner to the lower right corner. — Find the upper right corner. — Find the lower left corner. — Draw an oblique line from the upper right corner to the lower left corner.

Do not weary of being minute in the directions for dictation exercises. If dictation exercises are given carefully at first, a good foundation will be laid. The children will soon be able to understand directions having less detail.

SQUARE.

Additional Work.

Square, with Diagonals and Diameters. From Dictation. — The diameter of a square is a straight line connecting the centres of opposite sides. The teacher may or may not use the word "diameter" in giving the lesson to the children.

Directions. — (Give the directions for the preceding figure, — a square and its diagonals.) — Find the left side of the square. — Find the centre of the left side, and mark it lightly. — Find the right side of the square. — Find the centre of the right side, and mark it lightly. — Draw a horizontal line from the centre of the left side to the centre of the right side. — (Give similar directions for the vertical diameter.)

FRIDAY.

Square cut from Bright Paper. From the Object. — The square may be fastened against the casing of a door, against the blackboard frame, or against the front of the teacher's desk. The bright color will bring out the form of the square in a new way.

An exercise in judging proportion from the object may be introduced here. A large square sheet of paper may be held before the class. The children may then be called on to compare the sides by looking at them, and to judge whether they are equal or not. It is quite probable that some may think the vertical sides longer than the horizontal. The sides should then be measured before the class to show that they are equal.

Additional Work.

Cover of a Book. From the Object. — Objects having a square face are not common, but there are square books and square boxes. A book or box cover which has a simple ornamentation, like a marginal line, may be used.

CHAPTER III.

CURVED SURFACE. — CURVED LINE. — FROM THE SOLID.

At this time a week at least should be devoted to lessons from solids and objects. A rapid review of the exercises of Chapter I. should first be taken. After this review, the following exercises on curved surfaces and lines should be given.

Exercise I. — A Curved Surface.

A curved surface or face is always rounding in some directions.
A curved surface may be straight in some directions.

Review. The teacher and children, with blocks at the table. The teacher reviews curved and plane surfaces and faces. The children find many curved surfaces. The teacher leads the children to state that —

A curved surface or face is always rounding in some directions.

Observation by sight and by touch. The children pass their fingers *around* the rounding part of cylinders, then pass them *along* the rounding part of cylinders. The teacher leads the children to state that —

A curved surface may be straight in some directions.

Application and drill. The children find curved surfaces rounding in all directions; others rounding in some directions, and straight in some directions.

Exercise II. — A Curved Edge; a Curved Line.

The edge where a plane face and a curved surface or face meet may be a straight edge.
The edge where a plane face and a curved surface or face meet may be a curved edge.

Review. The teacher reviews curved and plane faces; straight edge; straight line.

Observation by sight and by touch. The children observe the edges of cylinders, hemispheres, etc., and the straight and curved edges of semi-cylinders, which may be made from clay if there are none among the blocks. The teacher has the children find the edges made by the meeting of a plane face and a curved surface or face.

It will be noted that the meeting of a curved surface and a plane surface, as in the case of a semi-cylinder, may produce a curved edge, or may

A CURVED EDGE; A CURVED LINE.

produce a straight edge. A semi-cylinder has six edges, — two straight edges produced by the meeting of two plane faces; two straight edges produced by the meeting of a plane face and a curved face; and two curved edges produced by the meeting of a plane face and a curved face. These facts can be made very clear to the children.

The teacher gives the term "**Curved edge,**" and leads the children to state that — *Term.*

A curved edge is made by the meeting of a curved surface or face and a plane face.

The children find many curved edges, and tell what they have found, and how curved edges are formed. *Application and drill.*

The children draw curved lines on the slate and on the board. *Drawing.*

CHAPTER IV.

STRAIGHT AND CURVED LINES. — DIVISION OF LINES. — PARALLEL LINES. — CIRCLE.

The teacher should remember to look over the whole week's work on any subject before giving any lesson on the subject.

SUBJECT. — **Straight and Curved Lines.**

MONDAY.	TUESDAY.	WEDNESDAY.	THURSDAY.	FRIDAY.
Geometric.	Reduction.	Memory.	Dictation.	Object.
		Lesson of Tuesday.		Bow of wood or whalebone.

A curved line bends at every point.

Sentences like the above, placed directly below the scheme for a subject, are not given as a set form to be used by the teacher or children, but are given as "leading sentences," embodying the ideas to be developed or recalled in the minds of the children.

MONDAY.

Straight and Curved Lines. GEOMETRIC NAMES. — From solids, from objects, and from the board.

Review. The teacher reviews curved surface and curved edge, or line.

Observation by sight and by touch. The lesson may be illustrated by a section of a cylinder, cut from clay so that the ends will correspond in shape to the illustration given (that is, so that the altitude of the curve will be one-fourth of its base); by a hoop, by a wire, and by drawing on the board. The children observe straight lines, and examine them to see if they bend at any point; then examine curved lines to see if they are straight in any part.

Drill and application. The children find many curved lines in the solids, on the walls, in objects, and on the board. The teacher leads the children to observe and to state that —

A curved line bends at every point.

Drawing. The children draw curved lines in various positions on their slates and on the board.

STRAIGHT AND CURVED LINES.

Busy Work for the Week.

Curved lines may be introduced with the straight lines. The curved lines may connect the first and fourth or the first and fifth ruled lines on the slate.

TUESDAY.

Two Curves on Vertical Bases, One curved to the Left, the Other to the Right. REDUCTION FROM THE BLACKBOARD. — The base of a curve is a straight line connecting the extremities of the curve. The altitude of a curve is the greatest perpendicular distance from the base.

It will be noticed that the first point for this exercise should be placed farther from the left side of the slate than from the upper side.

DIRECTIONS FOR THE TEACHER. — Place points for a vertical line, and draw it. — Quadrisect the line; that is, divide it into four equal parts. — Place a point as far to the left of the centre as one-fourth the line. — From the upper end of the vertical draw a curve, through the point just made, to the lower end of the vertical. — Place points for a second vertical as far to the right of the first as one-half its length. — Draw the second vertical. — Place a point for the altitude of the curve as far to the right of the centre of the line as one-fourth the line, and draw the curve.

The teacher should lead the children to discover from the figure on the board that the highest point of the curve is opposite the centre of the straight line, and that the curve is like that of a circle, and then leave them to imitate the curve. Let the children turn their slates to draw the curves.

DRILL FOR THE WEEK. — Curved lines curving to the left or right.

Additional Work.

Two Curves on Horizontal Bases, One curving Upward, the Other curving Downward. REDUCTION FROM THE BLACKBOARD. — The first point must now be placed farther from the upper side of the slate than from the left side. The directions given above for the teacher for two curves on vertical bases, serve for this exercise by changing the direction of the lines.

WEDNESDAY.

Lesson of Tuesday. FROM MEMORY.

THURSDAY.

Curves balanced. FROM DICTATION. — Although the subject of design is not definitely presented in the first primary year, yet the figures given illustrate principles of design, such as symmetry and repetition. While imitating such figures, the children are, in a certain way, assimilating the principles which will be definitely stated later in the course. This exercise furnishes a very simple example of symmetry produced by repetition of a curve, thus giving curves which balance each other. The curves are alike, not only in themselves, but as to their position with relation to the central figure.

DIRECTIONS. — Place a point which shall be farther from the left side of the slate than from the upper. — Place a point as far below it as the length of your forefinger. — Connect the points by drawing a vertical line. — From the upper end of the vertical, draw a short horizontal to the right. — From the lower end of the vertical, draw a horizontal to the right as long as the horizontal above. — Draw a vertical to connect the ends of the horizontals. — From the upper end of the left vertical to the lower, draw a curve to the left, like that of Tuesday. — From the upper end of the right vertical to the lower, draw a similar curve to the right.

Additional Work.

Curves in a Square. FROM DICTATION.

DIRECTIONS. — Place a point which shall be as far from the left side of the slate as from the upper side. — Place a point as far below it as the length of your forefinger. — Connect the points by drawing a vertical line. — As far to the right of the upper end of the vertical as the length of the vertical, place a point. — Draw a horizontal from the upper end of the vertical to the point just made. — As far to the right of the lower end of the vertical as the length of the vertical, place a point. — Draw a horizontal from the lower end of the vertical to the point just made. — Draw a vertical from the right end of the upper horizontal to the right end of the lower horizontal. — Find the left end of the upper horizontal. — Find the right end. — From the left end to the right end, draw a curve curving downward. — (Give similar directions for the lower curve.)

FRIDAY.

Bow of Wood or Whalebone. FROM THE OBJECT. — A bit of hoop or of whalebone, notched near the ends, and held curved by a cord, may be given as an object.

Additional Work.

Box. — A round box, cushioned on the top, and having a few pins in the cushion, will delight the children as an object from which to draw, and will illustrate the subject of the week. Before giving the object to the children, draw on the board geometric views of several simple objects with rounding surfaces, like the illustrations given below of a pail, a cup, a goblet, and show that the drawings represent only the height and width of the objects, and do not represent the rounding surfaces.

Place the box as nearly on a level with the eyes of the children as possible, and let them try to draw it.

DIVISION OF LINES INTO TWO EQUAL PARTS.

SUBJECT. — **Division of Lines into Two Equal Parts.**

MONDAY.	TUESDAY.	WEDNESDAY.	THURSDAY.	FRIDAY.
Geometric.	Reduction	Memory.	Dictation.	Object.
		Lesson of Tuesday.		Cover of a long note-book.

One mark on a line divides it into two parts.
One mark at the centre of a line divides it into two equal parts, or halves; that is, bisects it.

MONDAY.

Bisection of Lines. GEOMETRIC TERM. With splints and slender sticks, and from the board. — The teacher has the children break splints or sticks into *two parts*, then into two parts that are just alike in length, — *equal;* the children compare the parts. The teacher has the children mark sticks or splints in the centre; the children compare the parts by measuring them. The children observe that *one* mark at the centre of a line divides it into *two* equal parts, or *halves*. *Observation by sight and by touch.*

The teacher gives the term, "**Bisect ;**" writes the word upon the board, and explains to them, that, when they divide lines into two equal parts, they bisect the lines. The children are led to see and to state that — *Term.*

One mark at the centre of a line divides it into two equal parts or halves; that is, bisects it.

The teacher calls on the children to bisect many splints, sticks, and lines drawn on the board; to tell what they have done; and to show by measurement that they have divided the splints, sticks, or lines into two *equal* parts, or halves. *Drill.*

Busy Work for the Week.

The children may bisect the ruled lines on the slate, and draw lines between them half as long as the ruled lines. They may also lay splints or sticks so as to bisect each other.

TUESDAY.

Application of Vertical Lines divided into Two Equal Parts. REDUCTION FROM THE BLACKBOARD. — There are two different exercises in

this lesson. The first is, having drawn a line, to make a second line, in the *same* direction, half as long as the first line. The second is, having drawn a line, to make a second line, in a *different* direction, half as long as the first line.

DIRECTIONS. — Place points for a vertical line, and draw it. — Quadrisect the line. — One-fourth of its length to the right, place points for another vertical half as long as the first, and draw it.

Place points for a third vertical as long as the first, and as far away as half the length of the first line, and draw it. — Bisect this line. — Place a point as far to the right of the upper end of the vertical as half the line, and draw a horizontal from the upper end of the vertical to the point. — Bisect the horizontal. — From the centre of the vertical, draw a horizontal to the right half as long as the horizontal just drawn.

The children should be led to discover all the divisions from the figures on the board, and to give the substance of the directions except that for the placing of the second vertical.

DRILL FOR THE WEEK. — Curved lines curving upward or downward.

Additional Work.

Application of Horizontal Lines divided into Two Equal Parts. REDUCTION FROM THE BLACKBOARD. — The first two lines are so similar to the first two lines of the exercise given above, that no directions will be needed. Directions for the stool follow.

DIRECTIONS FOR THE TEACHER. — Place points as far below each end of the first horizontal as half its length, for a third horizontal, and draw it. — Bisect it. — Place a point as far below the left end of the horizontal as half the horizontal. — Draw a vertical from the left end of the horizontal to the point just made. — Place a point as far below the right end of the horizontal as half the horizontal. — Draw a vertical from the right end of the horizontal to the point just made. — Bisect the left-hand vertical. — Bisect the right-hand vertical. — Connect the points of bisection by a horizontal.

WEDNESDAY.

Lesson of Tuesday. FROM MEMORY. — Remember the importance of the memory lesson. Endeavor to have the children remember the placing of the figures, as well as the figures themselves.

THURSDAY.

Chair. FROM DICTATION.

DIRECTIONS. — Place points for a vertical line, and draw it. — Bisect the vertical. — As far to the right of the centre as half the line, place a point for a horizontal. — From the centre of the vertical, draw a horizontal to the point

DIVISION OF LINES INTO TWO EQUAL PARTS. 61

just made. — Place a point directly below the right end of the horizontal, and directly to the right of the lower end of the vertical. — From the right end of the horizontal, draw a vertical line to the point just made. — Find the lower half of the first vertical. — Bisect the lower half. — Bisect the second vertical. — Connect the two points of bisection by a horizontal. — What have you? — We will add a little to it. — Find the upper horizontal. — From the left end to the right end of the upper horizontal, draw a curve curving upward.

After the chair has been drawn once from dictation, the teacher may dictate it again, to be drawn larger or smaller than before, taking the opportunity to develop the idea of proportion in the minds of the children.

Additional Work.

High Stool. FROM DICTATION.

DIRECTIONS. — Place points for a vertical line, and draw it. — Bisect the vertical. — Place points for a second vertical as far to the right of the first as half the line. — Draw a second vertical. — Connect the upper ends of the vertical by drawing a horizontal. — Bisect the vertical at the right. — Both verticals are now bisected. — Connect the points of bisection by a horizontal. — From the left end to the right end of the upper horizontal draw a curve curving upward.

The stool may also be dictated to be drawn a second time larger or smaller than the first time, in order to continue the development of the idea of proportion.

FRIDAY.

Cover of a Long Note-Book. FROM THE OBJECT. — Some object should be chosen having the proportion of one to two in its sides, in order that practice in the division of lines and its application may be given. There are note-books which are twice as long as they are wide, and which have two rounded corners. The cover of one of these serves well for this lesson.

Before the object is presented to the class, an exercise in judging proportion from an object having simply surface and no perceptible thickness should be introduced. A large oblong sheet of paper twice as long as wide should be held before the class. The children should then be called on to judge as to the comparative length of the sides by looking at them. When the children have compared the sides, the teacher should then compare them by actual measurement to show the real proportion between them.

Additional Work.

A door twice as high as it is wide, a window-sash having two panes of glass, any object requiring bisection of lines in its construction, may be given. Let the object chosen be as simple as possible.

SUBJECT. — **Parallel Lines.**

MONDAY.	TUESDAY.	WEDNESDAY.	THURSDAY.	FRIDAY.
Geometric.	Reduction.	Memory.	Dictation.	Object.
		Lesson of Tuesday.		Ruler,

Parallel lines run in the same direction.
Parallel lines are everywhere the same distance apart.

MONDAY.

Parallel Lines. GEOMETRIC NAME. From the solids, from objects, by laying or holding sticks, from memory, from the board. — The teacher should now be able to devise the lesson, remembering the several stages, — Review, Observation by Sight and by Touch, Term, Drill, Application, Drawing.

For example, the lesson on parallel lines should give —

REVIEW of the different kinds of straight lines from solids and objects.

OBSERVATION BY SIGHT AND BY TOUCH by looking at parallel lines, by measuring the distance between them at various parts of the lines.

TERM, "Parallel lines."

DRILL in using the term, "Parallel."

APPLICATION by finding parallel lines in the room, by laying and holding sticks parallel to each other, by holding a finger of one hand parallel to a finger of the other, by recalling objects having parallel lines.

DRAWING parallel lines on the board and on the slate.

Additional Work.

In addition to the exercises suggested above, give various short dictation exercises to be drawn on the board by the children, such as the following: —

Draw two long parallel lines.
Draw two short parallel lines.
Draw a long line and a short line parallel to it.
Draw three parallel vertical lines.
Draw two parallel horizontal lines.
Draw two parallel oblique lines.

PARALLEL LINES.

Give also exercises in quadrisecting sticks and lines, and lead children to discover that *three* points divide into *four* parts.

Busy Work for the Week.

The variety possible in Busy Work increases with every new lesson. The teacher will readily devise new arrangements of Busy Work which will introduce the new features. (See also p. 231, Figs. B.)

For variety of work in this feature, each child may have six splints; may lay three of them parallel to each other horizontally; and may then weave in the three remaining splints vertically, endeavoring to have the splints in each direction parallel, and to have the distance between the splints lying in one direction the same as that between those lying in the other direction.

TUESDAY.

Five Parallel Vertical Lines. REDUCTION FROM THE BLACKBOARD. — The space between the lines is equal to one-fourth the length of the lines.

DIRECTIONS FOR THE TEACHER. — Place four points as for a square. — Quadrisect the space between the two upper points. — Quadrisect the space between the two lower points. — Connect the points by vertical lines.

Lead the children to discover from the figure on the board that the points are obtained by bisection and by bisection again, and also that the points divide the space into four parts.

Five parallel horizontal lines may be drawn in the same way.

DRILL FOR THE WEEK. — Vertical, horizontal, and oblique lines.

Additional Work.

Five Parallel Oblique Lines. REDUCTION FROM THE BLACKBOARD. — The drawing of parallel oblique lines is more difficult than parallel vertical or parallel horizontal lines, and great care must be taken in placing the points.

DIRECTIONS FOR THE TEACHER. — Place four points as for a square. — Connect the upper right-hand point with the lower left-hand point by an oblique line. — As far to the right of the second upper point as the distance between the first and second points, place a point. — Quadrisect the space between the last two upper points. — Quadrisect the space between the two lower points. — Draw four oblique lines connecting the points.

Five parallel oblique lines slanting in the opposite direction may be drawn in the same way.

WEDNESDAY.

Lesson of Tuesday. FROM MEMORY.

THURSDAY.

Ladder. FROM DICTATION.

DIRECTIONS. — Place points for a vertical line, and draw it. — Bisect the vertical. — As far to the right as half the vertical, place points for a second vertical as long as the first, and draw it. — Bisect each half of the first vertical, thus dividing the line into four equal parts, or fourths. — Divide the second vertical into four equal parts. — Connect the upper points by a horizontal. — Connect the second points by a horizontal. — Connect the third points by a horizontal.

Drill the children on dividing a line into four equal parts, or fourths.

Additional Work.

Shelves. FROM DICTATION.

DIRECTIONS. — Place points for a vertical line, and draw it. — As far to the right of the vertical as the length of the line, place points for a second vertical, and draw it. — Divide the vertical at the left into four equal parts. — Divide the vertical at the right into four equal parts. Connect the upper points by a horizontal. — Connect the second points by a horizontal. — Connect the third points by a horizontal.

FRIDAY.

Ruler. FROM THE OBJECT. — The teacher may give a ruler for this lesson, placing it first in one position, then in another.

Remember that it is suitable to introduce a drill exercise at the close of every drawing lesson.

Additional Work.

Paper-Cutter. FROM THE OBJECT. — This may be given in different positions.

Subject. — Circle.

MONDAY.	TUESDAY.	WEDNESDAY.	THURSDAY.	FRIDAY.
Geometric.	Reduction.	Memory.	Dictation.	Object.
⊕	⊕	Lesson of Tuesday.	⊕	Plate.

A circle is perfectly round.

MONDAY.

Circle. Geometric Name. — From the cylinder and hemisphere; from a large pasteboard circle, with a string drawn through its centre and knotted on the under side.

The children measure the distance from the centre to the circumference of the circle (the line which bounds a circle is called its circumference) in various directions, and find that it always measures the same. They measure, and find that the distance from any point in the circumference (the outline of the circle) to its opposite point, when measured through the centre, is the same as the distance from any other point in the circumference of the same circle to its opposite point when measured through the centre.

The diameter of a circle is a straight line passing through the centre, and terminating at each end in the circumference. The teacher draws two diameters on the circular face: the children discover that they cross each other in the centre. The teacher draws two diameters, perpendicular to each other, on the circular face of a solid: the children see that they divide the circle into four equal parts, and that the diameters do not incline toward each other.

The teacher leads the children to recall any forms in nature or any objects resembling a circle, and to draw them from memory.

Busy Work for the Week.

If drawing from objects is assigned for Busy Work, a five-cent piece, using the side on which there is a figure 5, will serve well as an object. This may be drawn between the ruled lines, and may be made the actual size. It may then be repeated as many times as the width of the slate will allow

TUESDAY.

Two Concentric Circles, with Diameters, the Inner having a Radius One-half that of the Outer. REDUCTION FROM THE BLACKBOARD. — Concentric circles are circles which have a common centre. The radius of a circle is a straight line drawn from the centre to the circumference; i.e., half a diameter.

It must be remembered that accuracy of work should not be expected from little children. Any thing approaching a circle should be considered good.

In this exercise the children should be led to observe that figures may have the same shape, though they differ in size.

DIRECTIONS FOR THE TEACHER. — Place points at a suitable distance from the upper and left sides of the slate for the horizontal diameter of a circle, and draw it. — Bisect the horizontal. — Place points as far above and below the centre of the horizontal as half the horizontal, for a vertical diameter, and draw it. — Draw a circle through the ends of these lines. — Bisect each half of each diameter. — Through the points of bisection draw a second circle.

DRILL. — Circles of a uniform size may be drawn on their diameters.

Additional Work.

Two Circles, Side by Side, the Second having a Radius Half that of the First. REDUCTION FROM THE BLACKBOARD.

DIRECTIONS FOR THE TEACHER. — Draw a circle on its diameters, according to the directions for the first circle of the preceding Tuesday. — As far to the right of the horizontal diameter as half the radius, place a point for the left end of a horizontal. — As far to the right of this as half the horizontal diameter, place a point for the right end of a horizontal, and draw it for the horizontal diameter of a second circle. — Bisect it, and draw the vertical diameter. — Through the ends of the diameters draw a second circle.

WEDNESDAY.

Lesson of Tuesday. FROM MEMORY.

THURSDAY.

Two Concentric Circles, the Inner having a Radius Three-fourths that of the Outer. FROM DICTATION. — The practice which the children have had in bisection will render it easy for them to get the length of the inner radius.

DIRECTIONS. — Place points for a horizontal line, as on Tuesday, and draw it. — Bisect the horizontal. — Place a point as far above the centre of the horizontal as half the horizontal. — Place a point as far below the centre of the

CIRCLE.

horizontal as half the horizontal. — Draw a vertical connecting these points. — Through the ends of these lines draw a circle. — Find the vertical diameter. Divide the upper half into four equal parts. Divide the lower half into four equal parts. — Find the horizontal diameter. Divide the left half into four equal parts. Divide the right half into four equal parts. — Through the *outer* points of division (the points nearest the outside of the circle), draw a second circle.

This figure may be repeated, changing the manner of the directions; for instance, after quadrisecting one radius (half a diameter), the fourth thus obtained may be set off on the other radii from their outer extremities, thus obtaining the points required without quadrisecting the other radii.

Additional Work.

Two Concentric Circles, the Inner having a Radius One-fourth that of the Outer. FROM DICTATION. — The directions for this exercise are the same as those given above, excepting that for the second circle. The second circle passes through the *inner* points of quadrisection (those nearest the centre of the circle), instead of the outer points, as in the preceding dictation exercise.

FRIDAY.

Plate. FROM THE OBJECT. — The plate must be placed before the children upright, so that it will be seen as a circle. Two or more concentric circles will be required to represent the plate. Lead the children to estimate carefully the distance between the circles of the rim, or any which may be marked on the plate, as compared with the radius.

Additional Work.

Circles on a Clock-Face. FROM THE OBJECT. — The numerals and the hands may be added simply as an exercise in imitation.

Of course, no very accurate results should be expected from this exercise. Its purpose is to give practice in observation.

CHAPTER V.

LINES PERPENDICULAR TO EACH OTHER. — ANGLES: RIGHT ANGLES, ACUTE ANGLES, OBTUSE ANGLES. — DIVISION OF LINES INTO THREE EQUAL PARTS. — REVIEW OF LINES AND ANGLES.

The teacher should remember to look over the whole week's work on any subject before giving any lesson on the subject.

SUBJECT. — **Lines Perpendicular to Each Other.**

MONDAY.	TUESDAY.	WEDNESDAY.	THURSDAY.	FRIDAY.
Geometric.	Reduction.	Memory.	Dictation.	Object.
⌐ ⊥ + ×	✦	Lesson of Tuesday.	✦	A Flag.

Lines perpendicular to each other do not lean toward or from each other.
Lines perpendicular to each other make square corners.
· Two lines perpendicular to each other may make one, two, or three square corners.

Sentences like the above, placed directly below the scheme for a subject, are not given as a set form to be used by the teacher or children, but are given as "leading sentences," embodying the ideas to be developed or recalled in the minds of the children.

MONDAY.

Lines Perpendicular to Each Other. GEOMETRIC TERM. From solids and objects. — The children find square corners; observe the lines that form the corners. The children make one, two, or three square corners with two sticks.

Remember the order of the lessons from the solids, — Review, Observation by Sight and by Touch, Term, Drill, Application, Drawing.

Additional Work.

From solids and objects. Also laying sticks, and drawing lines. Especial attention may be given to oblique lines perpendicular to each other.

Busy Work for the Week.

One kind of Busy Work for this subject may be with splints. Each child having six splints arranges them so that they are perpendicular to each other by twos or otherwise, and then draws on the slate the figure or figures made by the splints. (See also p. 231, Figs. B.)

TUESDAY.

Arrangement of Lines Perpendicular to Each Other. REDUCTION FROM THE BLACKBOARD. — The children should now draw their lines of a definite length in inches. To enable them to do this, they should have constantly before them a horizontal and a vertical scale of inches. These can be very readily drawn in the slate-frame with a sharp-pointed instrument. The centre of each side of the frame has already been punctured. Make the points thus made on the upper and left sides of the frame the centres of scales of three inches in length, divided into half-inches. Make the points on the right and lower sides of the frame the centres of scales of four inches in length, divided into quarter-inches.

From this time the directions given by the teacher to the children for the length of lines should be given in inches. The attention of the children should be constantly drawn to the scales on their slates as the standards of length which they are to imitate. Children can attain great accuracy in estimating distances, if properly trained.

The horizontal and the vertical in this exercise should be two inches long. The first point to be taken is the left end of the horizontal: it may be placed an inch from the left side, and two inches from the upper side, of the slate, or it may be placed an inch to the right of the centre of the left side of the slate.

Hereafter, as a general thing, directions will not be given for placing the figure of Tuesday: this will be left to the discretion of the teacher. This is one of the details of the lesson which must be carefully decided upon by the teacher before giving the lesson.

DIRECTIONS FOR THE TEACHER. — Place points for a horizontal and a vertical line, intersecting at their centres, and draw them. — Bisect each half of each line. — Connect the points of bisection by oblique lines.

The directions for the teacher are condensed. Those which the children give before drawing should be detailed like those for a dictation lesson. The children should be led, not only to give the directions, but also to find all the lines perpendicular to each other.

DRILL FOR THE WEEK. — Lines perpendicular to a vertical line.

Additional Work.

Oblique Lines Perpendicular to Each Other. REDUCTION FROM THE BLACKBOARD.

DIRECTIONS FOR THE TEACHER. — Place points for a square. — Connect the lower left-hand with the upper right-hand point by an oblique line. — Bisect the line. — From the point of bisection to the lower right-hand point, draw an oblique line. — From the upper end of the first oblique line, draw an oblique line downward, perpendicular to, and as long as, the first line.

As this is an exercise in direction, no point is placed for the lower end of the last line. This may be repeated for a drill exercise. Remember that in every reduction and every drill exercise a certain proportion of the children should work at the board. They should also work at the board in Friday's lesson when practicable.

WEDNESDAY.

Lesson of Tuesday. FROM MEMORY.

THURSDAY.

Arrangement of Straight Lines Perpendicular to Each Other, with Curved Lines. FROM DICTATION.

DIRECTIONS. — Place a point an inch from the left side, and two inches from the upper side, of the slate. — Two inches to the right of this, place a second point. — These are points for a horizontal. — Draw the line. — Bisect the horizontal. — As far above the centre of the horizontal as half the horizontal, place a point. — As far below the centre of the horizontal as half the horizontal, place a point. — These are points for a vertical. — Draw the line. — Bisect each half of the horizontal. — Bisect each half of the vertical. — Find the point of bisection on the upper half of the vertical. — Find the point of bisection on the left half of the horizontal. — Connect these two points by drawing a curve curving inward; that is, toward the centre of the figure. — (Give similar directions for the other curves.)

Additional Work.

Arrangement of Straight Lines Perpendicular to Each Other, with Curved Lines. FROM DICTATION.

DIRECTIONS. — (Give directions for placing points for a square (p. 51) having a side of two inches.) — Draw an oblique line from the upper left-hand point to the lower right-hand point. — How can you draw a line perpendicular to the line just drawn, and passing through its centre? — Draw such a line. — Connect the upper ends of the two oblique lines by a curve curving downward. — (Give similar directions for the other curves.)

FRIDAY.

Flag. FROM THE OBJECT. — A toy flag can be used, and may be placed with the staff horizontal. Lead the children to find all the lines in the flag which are perpendicular to each other. More simple flags than the American flag can be made from the full-page illustrations of flags in the dictionaries of Webster and Worcester.

Additional Work.

Flag placed Obliquely. FROM THE OBJECT. — The flag may now be placed so that the staff is oblique.

Subject. — Angles: Right Angles.

MONDAY	TUESDAY.	WEDNESDAY.	THURSDAY.	FRIDAY.
Geometric	Reduction.	Memory.	Dictation.	Object.
		Lesson of Tuesday.	L D	Corners of a blackboard.

When two straight lines meet, they form an angle.

An angle like a knife half open is called a right angle.

When two lines meet so as to make a square corner, they form a right angle.

Two lines perpendicular to each other form one or more right angles.

MONDAY.

Angles: Right Angles. GEOMETRIC NAME. From solids and objects. — The children find two lines that meet in solids and objects. The teacher shows open knife, scissors, folding-rule; also draws angles on the board, some having the sides equal, some having the sides unequal, so that the children see that it is not necessary that the sides of an angle should be equal. The children make angles with sticks, and draw angles.

The teacher develops the idea of a right angle in a similar way, taking especial pains to show that right angles may be in different positions, and that right angles may be formed of oblique lines as well as of vertical and horizontal lines.

Busy Work for the Week.

The Busy Work need not always be confined to the subject of the week. It may sometimes be well to use it as a means of review. The children may make horizontal, vertical, or oblique rows of horse-chestnuts, or kernels of corn. Again, there may be three parallel rows, and three rows perpendicular to them. The horse-chestnuts and the kernels of corn may be arranged to make two concentric circles; the horse-chestnuts forming a large circle without, and the kernels of corn forming a small circle within.

TUESDAY.

Right Angles in Different Positions. REDUCTION FROM THE BLACKBOARD. — The horizontal and vertical lines drawn by pupils in this exercise should be two inches long. Let the teacher draw the exercise on a slate before coming to the class, in order to determine just where the children should place the figures.

DIRECTIONS FOR THE TEACHER. — Place points for a vertical line, and draw it. — As far to the right of the lower end of the vertical as the length of the vertical, place a point, and draw a horizontal from the lower end of the vertical to this point. — Bisect the horizontal. — Directly to the right of the upper end of the vertical, and directly above the centre of the horizontal, place a point. — As far to the right of the right end of the horizontal as half the length of the horizontal, place a point. — Connect the two points just made by drawing an oblique line. — Directly to the right of the upper end of the oblique, and directly above the lower end of the oblique, place a point. — As far to the right again, place a point. — Connect this point with the lower end of the oblique by drawing an oblique line.

DRILL FOR THE WEEK. — Lines perpendicular, or at right angles to horizontal or oblique lines.

Additional Work.

Right Angles in Different Positions. REDUCTION FROM THE BLACKBOARD.

DIRECTIONS FOR THE TEACHER. — Place points for a vertical line, and draw it. — As far to the right of the upper end of the vertical as the length of the vertical, place a point, and draw a horizontal from the upper end of the vertical to this point. — Bisect the horizontal. — Directly to the right of the lower end of the vertical, and directly below the centre of the horizontal, place a point. — As far to the right of the right end of the horizontal as half the length of the horizontal, place a point. — Draw an oblique line from the point at the right of the lower end of the vertical. — As far to the right of the lower end of the oblique as the length of the horizontal, place a point. — As far again to the right, place a point. — Draw an oblique line from the upper end of the oblique to the point just made.

WEDNESDAY.

Lesson of Tuesday. FROM MEMORY.

THURSDAY.

Letters L and D. FROM DICTATION.

DIRECTIONS. *Letter L.* — An inch from the upper, and an inch from the left, side of the slate, place a point. — Two inches below this, place a point. — Connect these points by drawing a vertical. — Bisect the vertical. — As far to the right of the lower end of the vertical as half the vertical, place a point for the right end of a horizontal. — Draw a horizontal from the lower end of the vertical to the point just made.

ANGLES: RIGHT ANGLES.

Letter D. — An inch below the lower end of the vertical in the letter L, place a point. — Two inches below this, place a point. — Draw a vertical connecting the points. — Bisect the line. — As far to the right of the point of bisection as the length of the vertical, place a point. — Beginning at the upper end of the vertical, draw a curve which shall pass through the point just made, and end at the lower end of the vertical.

The letters are admirable figures for continuing the development of the idea of proportion, and for showing that the shape of a figure does not depend at all on its size. The letters may be repeated larger or smaller than when first given.

Additional Work.

Letters H and P. FROM DICTATION.

DIRECTIONS. *Letter H.* — An inch from the upper side and an inch from the left side of the slate, place a point. — Two inches below this, place a point. — Draw a vertical line, connecting the two points. — Bisect the vertical. — As far to the right of the upper end of the vertical as half the vertical, place a point. — Two inches below this, place a point. — Draw a vertical, connecting the points just made. — Bisect this vertical. — Connect the points of bisection on the verticals by drawing a horizontal.

Letter P. — An inch below the first vertical of the letter H, place a point. — Two inches below this, place a point. — Draw a vertical, connecting the two points. — Bisect the vertical. — Bisect the upper half. — As far to the right of the last point of bisection made as half the vertical, place a point. — From the upper end of the vertical, draw a curve, passing through the point just made, to the centre of the vertical.

Question the children as to the right angles in the letter H.

FRIDAY.

Corners of the Blackboard. FROM THE OBJECT.

Additional Work.

Corners of a Book. FROM THE OBJECT. — Place the book so that the lines of the cover will be oblique.

A carpenter's square may also be used as an object.

SUBJECT. — Acute Angles.

MONDAY.	TUESDAY.	WEDNESDAY.	THURSDAY.	FRIDAY.
Geometric.	Reduction.	Memory.	Dictation.	Object.
∠∧	VA	Lesson of Tuesday.	NW	Picture-cord; two sticks.

An angle that looks like a knife not half open is called an acute angle.
An angle that is less than a right angle is called an acute angle.

MONDAY.

Acute Angles. GEOMETRIC NAME. From solids (triangular prisms and objects). Also by laying sticks, and drawing. — The teacher reviews right angle, and then develops the idea of an acute angle after the manner of the development of the idea of a right angle, and leads the children to see that the size of an angle does not depend on the length of its sides, by drawing acute angles having very long sides on the board, and applying on them angles of the same opening made of short sticks; also by opening a large knife and a small knife at the same angle, or by opening a pair of shears and a small pair of scissors at the same angle. The teacher contrasts the acute angle with the right angle.

Busy Work for the Week.

Among other exercises for Busy Work, the teacher may draw upon the board a simple zigzag border made of acute angles, and leave the children to imitate it, first by laying sticks, then by laying kernels of corn, and lastly by drawing the border on the slate. The letters given to illustrate right angles, as well as those which illustrate acute angles, may be used for drawing in Busy Work. They may be given singly or combined in words; as *lap, lad, man, wan,* etc.

TUESDAY.

Letters V and A. REDUCTION FROM THE BLACKBOARD. — The letters chosen for this week form admirable exercises, not only because they illustrate the subject of the week well, but also because the forms are very familiar to the children. They may be drawn large and small to fix the idea of proportion.

ACUTE ANGLES.

DIRECTIONS FOR THE TEACHER. *Letter V.* — Place points for a horizontal. — Bisect the space between the points. — Place a point as far below the point of bisection as twice the distance between the two points first made. — Draw oblique lines from the upper points at the left and right to the lower point.

Letter A. — Place a point as far to the right of the lower point of V as the distance between the upper ends of the two oblique lines. — Place a point as far to the right again. — Bisect the space between the two points. — Directly above the point of bisection, place a point on a line with the upper ends of the lines of the letter V. — From this point draw oblique lines to the two outer points below. — Connect the oblique lines by drawing a horizontal a little lower than half-way down.

DRILL FOR THE WEEK. — Curved lines curving to the left or right. Remember to tell the children that these curved lines must look like parts of circles.

Additional Work.

Letters M and K. REDUCTION FROM THE BLACKBOARD.

DIRECTIONS FOR THE TEACHER. *Letter M.* — Place points for a vertical line, and draw it. — Bisect the vertical. — As far to the right of the vertical as half its length, place points for a second vertical of the same length, and draw it. — Bisect the space between the lower ends of the verticals. — Draw an oblique line from the upper end of each vertical to the point of bisection.

Letter K. — Place points for a vertical as far to the right of the letter M as half the vertical, and draw it. — Bisect the vertical. — Place points as far to the right of the ends of the vertical as half the vertical. — Draw an oblique line from each of these points to the point of bisection.

WEDNESDAY.

Lesson of Tuesday. FROM MEMORY.

THURSDAY.

Letters N and W. FROM DICTATION.

DIRECTIONS. *Letter N.* — An inch to the right of the left side, and an inch below the upper side of the slate, place a point. — Two inches below this, place a point. — Draw a vertical to connect these points. — Bisect the vertical. — Place a point as far to the right of the upper end of the vertical as half the vertical. — Two inches below this, place a point. — Draw a vertical to connect the points. — Draw an oblique from the upper end of the left-hand vertical to the lower end of the right-hand vertical.

Letter W. — An inch to the right of the upper right point of the letter N, place a point. — An inch to the right of that, place a point. — Bisect this inch. — Two inches below the point of bisection, place a point. — Draw an oblique from the upper point at the left to the point just made. — Draw an oblique from the upper point at the right to the same point. — An inch to the right of the upper end of the second oblique, place a point. — Bisect this inch. — Two inches below the point of bisection, place a point. — Draw an oblique from the upper end of the second oblique to the point just made. — Draw an oblique from the upper point at the right to the same point.

Additional Work.

Letters Z and X. FROM DICTATION.

DIRECTIONS. *Letter Z.* — Place a point an inch from the upper and an inch from the left sides of the slate. — An inch to the right of this, place a point. — Draw a horizontal connecting these points. — Two inches below the left end of the horizontal, place a point. — Two inches below the right end, place a point. — Draw a horizontal connecting these points. — Draw an oblique from the right end of the upper horizontal to the left end of the lower horizontal.

Letter X. — An inch to the right of the upper horizontal, place a point. — An inch to the right again, place a point. — Two inches below the point at the left, place a point. — Two inches below the point at the right, place a point. — Draw an oblique line from the upper point at the left to the lower point at the right. — Draw an oblique from the upper point at the right to the lower point at the left.

FRIDAY.

Picture-Cord. FROM THE OBJECT. — If there is no picture-cord in the room making an acute angle, improvise one, or form an acute angle with two long sticks, and give the angle thus formed in various positions.

Additional Work.

Folding-Rule. FROM THE OBJECT. — The rule may be folded to make an acute angle, and placed in different positions.

OBTUSE ANGLES.

SUBJECT. — **Obtuse Angles.**

MONDAY.	TUESDAY.	WEDNESDAY.	THURSDAY.	FRIDAY.
Geometric.	Reduction.	Memory.	Dictation.	Object.
∟	▱	Lesson of Tuesday.	🪭	Fan in another position.

An angle that looks like a knife more than half open is called an obtuse angle.
An angle that is greater than a right angle is called an obtuse angle.

MONDAY.

Obtuse Angles. GEOMETRIC NAME. From solids (triangular and square prisms combined) and from objects. — Laying sticks and drawing by the children.

The teacher reviews right and acute angles, develops the idea of an obtuse angle after the manner of the development of the idea of right and acute angles, and contrasts right and acute angles with the obtuse angle. The teacher gives exercises like the following for drawing: —

Draw a horizontal line. Draw a line that will make an acute angle with the horizontal line.

Draw a vertical line. Draw a line that will make an obtuse angle with the vertical line.

Draw an oblique line. Draw a line that will make a right angle with the oblique line.

Busy Work for the Week.

It is not desirable that children should always be in their seats for busy work: they should frequently be at the table of blocks and frequently at the blackboard for Busy Work. It has been suggested as one kind of Busy Work for acute angles, that the teacher should draw a zigzag border of acute angles on the board, and leave the children to imitate it. In the Busy Work for obtuse angles the children may themselves make borders of obtuse angles with sticks at the table, or may draw such borders on the board. (See p. 281, Figs. C.)

TUESDAY.

Obtuse Angles. REDUCTION FROM THE BLACKBOARD.

DIRECTIONS FOR THE TEACHER. — Place points for a vertical line. — As far to the right of the lower point as the distance between the points, place a third point. — As far to the right again, place a fourth point. — Bisect the space between the second and third points, and that between the third and fourth points. — Draw an oblique line from the first point made to the first point of bisection. — Draw a horizontal from the first to the second point of bisection. — Directly to the right of the first point made, and directly above the ends of the horizontal just drawn, place points for a horizontal, and draw it. — Draw an oblique from the right end of the horizontal to the lower point remaining.

DRILL FOR THE WEEK. — Curved lines curving upward or downward, the curves resembling that of a circle.

Additional Work.

Obtuse Angles. REDUCTION FROM THE BLACKBOARD.

DIRECTIONS FOR THE TEACHER. — Place points for a vertical line. — As far to the right of the upper point as the distance between the points, place a third point. — As far to the right again, place a fourth point. — Bisect the space between the first and third points, and that between the third and fourth points. — Draw an oblique line from the first point of bisection to the second point made. — Draw a horizontal from the first to the second point of bisection. — Directly to the right of the lower end of the oblique, and directly below the ends of the horizontal just drawn, place points for a horizontal, and draw it. — Draw an oblique from the upper point remaining to the right end of the lower horizontal.

WEDNESDAY.

Lesson of Tuesday. FROM MEMORY.

THURSDAY:

Open Fan. FROM DICTATION.

DIRECTIONS. — Draw an obtuse angle opening upward, and having each line two inches long. — Connect the upper ends of the lines by a curved line curving upward. — Bisect each straight line. — Connect the points of bisection by a curved line, curving upward, parallel to the curve just drawn. — Bisect each curve. — Draw a straight line from the point of bisection on the outer curve, through the point of bisection on the inner curve, to the point of the angle. — Bisect each half of each curve. — Draw straight lines from the outer points of bisection, through the inner points of bisection,

OBTUSE ANGLES.

to the point of the angle. — Bisect each fourth of each curve. — Draw straight lines from the outer points of bisection, through the inner points, to the point of the angle. — Bisect each part of each curve. — Draw straight lines from the outer points of bisection, through the inner points, to the point of the angle.

Additional Work.

Border of Obtuse and Acute Angles. FROM DICTATION.

DIRECTIONS. — An inch from the upper and left sides of the slate, place a point. — Three inches to the right of this, place a point. — Draw a horizontal connecting the points. — An inch below the left end of the horizontal, place a point. — Draw a vertical from the left end of the horizontal to this point. — Three inches to the right of the lower end of the vertical, and one inch below the right end of the horizontal, place a point. — Draw a horizontal from the lower end of the vertical to this point. — Draw a vertical connecting the right ends of the horizontals. — Divide the upper horizontal into inches. — Divide the lower horizontal into inches. — Draw an oblique from the left end of the upper horizontal to the first point on the lower horizontal; that is, the point nearest the left end of the horizontal. — Draw an oblique, parallel to the first oblique, from the first point on the upper horizontal (that is, the point nearest the left end of the horizontal) to the second point on the lower. — Draw a third oblique, parallel to the other two, from the second point on the upper horizontal to the right end of the lower horizontal.

FRIDAY.

Open Fan in another Position. FROM THE OBJECT. — This may be drawn larger than the fan drawn on Thursday. The details should of course be taken from the object.

Additional Work.

Pair of Dividers. FROM THE OBJECT. — These should be opened so as to make an obtuse angle.

SUBJECT. — **Division of Lines into Three Equal Parts.**

MONDAY.	TUESDAY.	WEDNESDAY.	THURSDAY.	FRIDAY.
Geometric.	Reduction.	Memory.	Dictation.	Object.
⫴⫴	⟊⟊ +	Lesson of Tuesday.	◇	Round fan with handle.

Two marks on a line divide the line into three parts.
Two marks on a line which are at equal distances from each other and from the ends of the line divide the line into three equal parts, or thirds; that is, trisect it.

MONDAY.

Trisecting Lines. GEOMETRIC TERM. With splints and slender sticks. — The teacher develops first the idea of division into three parts; then that of division into three *equal* parts, or thirds, — that is, trisection. See lesson on the division of lines into two equal parts, p. 59.

Busy Work for the Week.

For one exercise, the children may lay two splints perpendicular to a third splint, and at such distances from each other and from the ends of the third splint as to trisect it. The two splints may be laid so that they will be bisected by the third splint, so that their upper ends will touch the third splint, or so that their lower ends will touch the third splint. The children, having laid the splints, can draw on their slates or on the board the figures thus made.

TUESDAY.

Vertical Line divided into Three Equal Parts, and Application. REDUCTION FROM THE BLACKBOARD. — This lesson, like the Tuesday lessons on the bisection of lines, contains two different exercises. The first is, having drawn a line, to make a second line, in the *same* direction, two-thirds as long as the first. The second is, having drawn a line, to make a second line, in a *different* direction, two-thirds as long as the first line. Review the children on thirds, making them familiar with one, two, and three thirds.

From this time forward, through the term, the children should make the principal lines of the exercises three inches long.

DIVISION OF LINES INTO THREE EQUAL PARTS. 81

DIRECTIONS FOR THE TEACHER. — Place points for a vertical line, draw it, and trisect it. — As far to the right of the upper end of the line as one-third the line, place a point. — As far to the right of the second point of trisection as one-third the line, place a point. — Connect these points, thus making a vertical two-thirds as long as the first vertical.

As far to the right of the first vertical as its length, place points for a line as long as the first vertical, and draw it. — Trisect it. — As far to the left and right of the first point of trisection as one-third the line, place points for a horizontal, and draw it.

DRILL FOR THE WEEK. — The teacher should give for the drill exercise the kind of lines on which the children most need drill. The drill on lines must be systematically pursued through the whole primary course.

Additional Work.

Division of Horizontal Lines into Three Equal Parts, and Application. REDUCTON FROM THE BLACKBOARD.

DIRECTIONS FOR THE TEACHER. — Place points for a horizontal line, draw it, and trisect it. — As far below the left end of the horizontal as one-third the line, place a point. — As far below the second point of trisection as one-third the line, place a point. — Connect these points, thus making a horizontal two-thirds as long as the first.

Place points for a horizontal as far below the first as its length. — Draw the horizontal, and trisect it. — As far above and below each point of trisection as one-third the line, place points. — Connect these points by verticals. — Connect the ends of the first vertical with the left end of the horizontal by curves curving inward. — Connect the upper ends of the verticals by a horizontal. — Connect the lower ends of the verticals by a horizontal. — Connect the ends of the second vertical with the right end of the central horizontal by curved lines curving inward.

WEDNESDAY.

Lesson of Tuesday. FROM MEMORY.

THURSDAY.

Kite. FROM DICTATION.

DIRECTIONS. — An inch below the upper side of the slate, and two inches from the left side, place a point. — Three inches below it, place a point. — Connect the points by drawing a vertical. — Trisect the line. — As far to the left of the upper point of trisection as one-third the line, place a point. — As far to the right of the upper point of trisection as one-third the line, place a point. — Draw a horizontal to connect the points. — Connect the upper end of the vertical and the left end of the horizontal by drawing an oblique. — Connect the left end of the horizontal and the lower end

of the vertical by an oblique. — Connect the upper end of the vertical and the right end of the horizontal by an oblique. — Connect the right end of the horizontal and the lower end of the vertical by an oblique.

When the figure is completed, question the children on the lines and angles to be found in it.

Every opportunity should be taken to develop in the minds of the children the idea that the lines of a figure always bear the same proportion to each other whether the figure is large or small. The idea will be readily grasped by the children if the figure represents a familiar object. Therefore this exercise may be used profitably to develop the idea of proportion. A kite having the shape of the figure given for dictation, whether it is large or small, always has the cross-piece two-thirds as long as the upright piece. Therefore, in the picture of a kite of this shape, whether it is large or small, the horizontal must always be two-thirds the vertical.

Additional Work.

Kite-shaped Figure. FROM DICTATION.

DIRECTIONS. — An inch below the upper side of the slate, and two inches from the left side, place a point. — Three inches below it, place a point. — Connect the points by drawing a vertical. — Trisect the line. — As far to the left of the upper point of trisection as one-third the line, place a point. — As far to the right of the upper point of trisection as one-third the line, place a point. — Draw a horizontal to connect the points. — Connect the upper end of the vertical and the left end of the horizontal by drawing a curve curving inward. — Connect the left end of the horizontal and the lower end of the vertical by a curve curving inward. — Connect the upper end of the vertical and the right end of the horizontal by a curve curving inward like the curve on the left of the vertical. — Connect the right end of the horizontal and the lower end of the vertical by a curve curving inward like the curve on the left of the vertical.

FRIDAY.

Round Fan with a Handle. FROM THE OBJECT. — Suppose a vertical line through the centre of the fan, and note what part of this line is occupied by the handle, and also what part is occupied by the vertical diameter of the circular part of the fan. (See p. 233, Fig. 3.)

An exercise in judging proportion from a large oblong sheet of paper three times as long as it is wide should be given here. (See p. 61.)

Additional Work.

Side of a Box. FROM THE OBJECT. — The side should be oblong, and should have the proportion of one to three or two to three; that is, the box must be one or two thirds as high as it is long, or *vice versa*.

REVIEW OF LINES AND ANGLES.

SUBJECT. — **Review of Lines and Angles.**

MONDAY	TUESDAY.	WEDNESDAY.	THURSDAY.	FRIDAY.
Geometric.	Reduction.	Memory.	Dictation.	Object.
⊠	⊠	Lesson of Tuesday.	⊞ (with X's)	A Spool.

A vertical line stands up.
A horizontal line lies down.
An oblique line leans.

Parallel lines run in the same direction.
Parallel lines are everywhere the same distance apart.

Lines perpendicular to each other do not lean toward or from each other.
Lines perpendicular to each other make square corners.
Two lines perpendicular to each other may make one, two, or three square corners.

When two straight lines meet, they form an angle.
An angle like a knife half open is called a right angle.
When two lines meet so as to make a square corner, they form a right angle.
Two lines perpendicular to each other form one or more right angles.

An angle that looks like a knife not half open is called an acute angle.
An angle that is less than a right angle is called an acute angle.

An angle that looks like a knife more than half open is called an obtuse angle.
An angle that is greater than a right angle is called an obtuse angle.

MONDAY.

Straight Lines and Angles. GEOMETRIC NAMES AND TERMS. From solids and objects. — Also laying sticks, and drawing by the children. Also a rapid review of lines and angles from the square and its diagonals drawn upon the board by the teacher.

84 TEACHERS' PRIMARY MANUAL.

Busy Work for the Week.

The Busy Work should, like other lessons of the week, embrace a review of lines and angles.

TUESDAY.

Design in a Square. REDUCTION FROM THE BLACKBOARD. Concentric squares with diagonals. — Concentric squares are squares which have a common centre. Let the children find how many lines and angles there are of each kind.

DIRECTIONS FOR THE TEACHER. — Place points for a square, and draw it. — Draw its diagonals. — Bisect each semi-diagonal; that is, each half-diagonal. — Connect the points of bisection by verticals and horizontals, making a second square.

Additional Work.

Design in a Square. REDUCTION FROM THE BLACKBOARD. — Two concentric squares, the sides of one horizontal and vertical, with its diameters; the sides of the other, oblique.

DIRECTIONS FOR THE TEACHER. — Place points for a square, and draw it. — Bisect its sides, and draw its diameters. — Connect the ends of its diameters by oblique lines, forming a second square.

WEDNESDAY.

Lesson of Tuesday. FROM MEMORY.

THURSDAY.

Repetition of Design of Tuesday, to cover a Surface. FROM DICTATION AND MEMORY. — An exercise in horizontal repetition will be found in the *Additional Work* on obtuse angles, p. 79, and another in the *Additional Work* on p. 51. Repetition to cover a surface is now given. This kind of repetition is admirable for Busy Work.

DIRECTIONS. — An inch from the upper and the left sides of the slate, place a point. — Three inches below this, place a point. — Draw a vertical line connecting the points. — Three inches to the right of the upper end of the vertical, place a point. — Draw a horizontal from the upper end of the vertical to meet the point. — Three inches below the right end of the horizontal, place a point. — You have two sides of a square. Which sides have you? — Draw the right vertical side. — Draw the lower horizontal. — Bisect the upper horizontal. — Bisect the lower horizontal. — Draw a vertical connecting the points of bisection. — Bisect the left vertical side. — Bisect the right vertical side. — Draw a horizontal connecting the points of bisection. — How many small squares have you? — Draw the design of Tuesday and Wednesday in each small square.

REVIEW OF LINES AND ANGLES. 85

Additional Work.

Vertical Border. Repetition of the Concentric Squares of Tuesday.
FROM DICTATION AND MEMORY.

DIRECTIONS. — Place a point an inch from the upper and the left sides of the slate. — Three inches below this, place a point. — Draw a vertical line connecting the points. — An inch to the right of the upper end of the vertical, place a point. — Draw a horizontal from the upper end of the vertical to this point. — Place a point three inches below the right end of the horizontal. — Draw a vertical from the right end of the horizontal to this point.— Draw a horizontal connecting the lower ends of the verticals. — Trisect the left vertical. Trisect the right vertical. — Draw a horizontal connecting the upper points of trisection. Draw a horizontal connecting the lower points of trisection. — How many squares have you ? — Draw in each square the design given Tuesday and repeated Wednesday.

FRIDAY.

Spool. FROM THE OBJECT. — Choose a large spool, and study its proportions. The illustration shows that the drawing will contain all the lines and angles.

Lead the children to imagine a vertical line through the centre. They should begin their work from the object by drawing this imaginary line, which should be light.

Additional Work.

Tin Basin. FROM THE OBJECT. — This object should be given after the manner of the preceding lesson.

CHAPTER VI.

LIGHT LINES. — SQUARE WITH LIGHT LINES. — TRIANGLE. — RIGHT-ANGLED TRIANGLE. — LIGHT LINES TRISECTED. — CIRCLE WITH LIGHT LINES.

The teacher should remember to look over the whole week's work on any subject before giving any lesson on the subject.

SUBJECT. — **Light Lines.**

MONDAY.	TUESDAY.	WEDNESDAY.	THURSDAY.	FRIDAY.
Geometric.	Reduction.	Memory.	Dictation.	Object.
		Lesson of Tuesday.		A Tatting shuttle.

Learn to make light lines; that is, to sketch lines.
Light lines are made by holding the pencil easily, and using it lightly.

Sentences like the above, which are directly below the scheme for a subject, are not given as a set form to be used by the teacher or children, but are given as "leading sentences," embodying the ideas to be developed or recalled in the minds of the children.

MONDAY.

Light Lines. GEOMETRIC NAME. From the board, the children drawing on slates. — After the idea of drawing light lines (sketching) has been developed, the remainder of the time should be given to a drill exercise on sketching lines and bisecting them.

Remember the order of the lesson on Monday, — Review, Observation, Term, Drill, Application, Drawing.

Busy Work for the Week.

The lines ruled on the slate are generally so light that they serve as good models for light lines. The Busy Work in drawing should be given for at least one day in this week to drawing lines between the ruled lines, as light as the ruled lines.

TUESDAY.

Use of Light Lines in Construction. REDUCTION FROM THE BLACKBOARD. — There are certain lines necessary for the proper construction of figures, but which do not make part of the figure proper when completed. These lines are called construction-lines, and in advanced drawing are always erased before the figure is lined in. In order that they may be readily erased, they should be drawn lightly. It is not recommended that primary pupils should erase their construction-lines; but they should draw them lightly. By this practice the habit of drawing light construction-lines is formed, and the figure is seen more plainly than when the construction-lines are strong.

In this lesson the construction-lines are given first, and afterward the completed figure is drawn on the construction-lines.

By imitating the construction-lines in the figures drawn on the board, and by following the directions given in dictation lessons, the children will acquire insensibly the habit of drawing figures on construction-lines.

DIRECTIONS FOR THE TEACHER. — Place points for a vertical, and **sketch** the line; that is, draw it lightly. — Quadrisect it. — As far to the left and right of the centre as one-fourth the line, place points, and **sketch** a horizontal connecting them.

As far to the right of the vertical as half its length, place points for a second vertical of the same length, and **sketch** it. — Quadrisect it. — Place points as far to the left and right of the centre as one-fourth its length, and **sketch** a horizontal connecting them. — Draw oblique lines connecting the ends of the light lines.

It will be noted that when the term "**Sketch**" is used, the line should be drawn lightly; and, when the term "**Draw**" is used, the line should be medium in strength.

Remember, that, in the exercises in reduction from the blackboard, the children should be led to give the directions for drawing the figure.

The directions given are for the use of the teacher in drawing the figure on the board.

DRILL FOR THE WEEK. — The drill for the week should be entirely on light lines.

Additional Work.

Use of Light Lines in Construction. REDUCTION FROM THE BLACKBOARD. — The figures given above are now given in a horizontal position, — first the construction-lines, then the completed figures drawn on the construction-lines. The directions for the figures placed vertically can be readily adapted for the figures placed horizontally.

WEDNESDAY.

Lesson of Tuesday. FROM MEMORY.

THURSDAY.

Drill on Long Light Lines. FROM DICTATION.

DIRECTIONS. — Bisect each half of the upper side of the slate. — Bisect each half of the lower side of the slate. — Sketch a vertical from the left point on the upper side to the left point on the lower side. — Sketch a vertical from the centre of the upper side to the centre of the lower side. — Sketch a vertical from the right point on the upper side to the right point on the lower side. — (Give similar directions for the horizontals.) — Sketch an oblique from the upper end of the first vertical to the left end of the first horizontal. — (Give similar directions for the other obliques.)

Additional Work.

Drill on Light Lines. FROM DICTATION.

DIRECTIONS. — Sketch a vertical from the centre of the upper side of the slate to the centre of the lower side. — Sketch a horizontal from the centre of the left side of the slate to the centre of the right side. — Bisect each half of the vertical. — Bisect each half of the horizontal. — Sketch an oblique from the upper end of the vertical to the left *point* on the horizontal. — Sketch an oblique from the upper end of the vertical to the right *point* on the horizontal. — Sketch an oblique from the upper *point* on the vertical to the left *end* of the horizontal. — Sketch an oblique from the left *end* of the horizontal to the lower *point* on the vertical. — Sketch an oblique from the left *point* on the horizontal to the lower *end* of the vertical. — Sketch an oblique from the right *point* on the horizontal to the lower *end* of the vertical. — Sketch an oblique from the upper *point* on the vertical to the left *end* of the horizontal. — Sketch an oblique from the right *end* of the horizontal to the lower point on the vertical.

FRIDAY.

Tatting-Shuttle. FROM THE OBJECT. — This should be constructed according to its proportions, after the manner of constructing the figure of Tuesday.

Additional Work.

Bottle. FROM THE OBJECT. — Select one of very simple proportion and curvature. A central vertical line will be necessary as a construction-line. This, of course, should be light. Follow the suggestions on pp. 58 and 85.

SQUARE WITH LIGHT LINES.

SUBJECT. — **Square with Light Lines.**

MONDAY.	TUESDAY.	WEDNESDAY.	THURSDAY.	FRIDAY.
Geometric.	Reduction.	Memory.	Dictation.	Object.
□	◇	Lesson of Tuesday.	◎	✦

Opposite sides face each other.
The light lines given in the square connect the centres of opposite sides of the square.

MONDAY.

Square with Light Lines. GEOMETRIC NAME. Solids, objects, and the blackboard. — The teacher first develops the idea of *opposite;* two children face each other; two lines face each other. The teacher draws light diameters on the face of a cube, draws a square and light diameters on the board, and then leads the children to see that the light lines connect the *centres* of *opposite* sides. The teacher may give the term "Diameter," or not.

Busy Work for the Week.

Exercises in Busy Work can be based on the square with light diameters which has been drawn on the board.

Four white and two red splints may be given to each child. The children may then make the square which is on the board, using the white splints for the square, and the red splints for the light lines. They may then draw upon their slates or upon the board a square with light lines.

Eight red splints for construction-lines, and eight uniform sets of white splints, each set containing eight splints, which gradually decrease in length by inches, furnish material for many designs based on a square. A design may be drawn on the board by the teacher, and the children may be left to imitate it with the splints. After the children have become accustomed by imitation to make the four sides alike, they may try to make arrangements of their own.

TUESDAY.

Design in a Square. REDUCTION FROM THE BLACKBOARD. — The light diameters of the square given in Monday's exercise are now used as

construction-lines. The diameter of a square connects the centres of its opposite sides. A square has two diameters.

DIRECTIONS FOR THE TEACHER. — Place points for a square, and **draw** it. — Bisect its sides, and **sketch** its diameters. — Connect the ends of the diameters by drawing oblique lines. — Bisect each half of each side. — Connect the two points nearest each corner by a short oblique line parallel to a side of the inner square.

DRILL FOR THE WEEK. — Light lines.

Additional Work.

Design in a Square. REDUCTION FROM THE BLACKBOARD.

DIRECTIONS FOR THE TEACHER. — Place points for a square, and **draw** it. — Bisect its sides, and **sketch** its diameters. — Connect the ends of the diameters by **drawing** oblique lines. — Bisect each semi-diameter (half a diameter). — Connect the points of bisection by **drawing** oblique lines, thus making three concentric squares.

WEDNESDAY.

Lesson of Tuesday. FROM MEMORY.

THURSDAY.

Design in a Square. FROM DICTATION.

DIRECTIONS.—(Give first the dictation for a square, as on p. 84.) — Bisect the left vertical side of the square. Bisect the right vertical side. **Sketch** a horizontal connecting the points of bisection. — Bisect the upper side. Bisect the lower side. — **Sketch** a vertical connecting the points of bisection. — **Draw** an oblique from the upper end of the light vertical to the right end of the light horizontal. — (Give similar directions for the other sides of the inner square.) — Find the light vertical. — Bisect its upper half. — Bisect its lower half. — Find the light horizontal. — Bisect its left half. — Bisect its right half. — **Draw** a circle through the points of bisection.

Additional Work.

Design in a Square. FROM DICTATION.

DIRECTIONS. — (Dictate a square and its diameters.) — Connect the upper end of the light vertical in the square and the left end of the light horizontal by **drawing** a curved line curving inward. — (Give similar directions for the other curves.) — Bisect the upper half of the light vertical. — Bisect the left half of the light horizontal. — Connect the points by **drawing** an oblique. — (Give similar directions for the other side of the central square.)

FRIDAY.

Four-pointed Star of Bright Paper in a Square. FROM THE OBJECT. — The star may be readily cut from a square. Having a square of bright-colored paper, fold it first through the centre horizontally, and then vertically. This gives a square of four thicknesses. Bisect each of the two folded sides of the square by doubling. Rule a line from the corner of the square which is not folded to each point of bisection. Cut along those lines. Unfold the square, and a four-pointed star appears. Attach this to a square of paper of some contrasting color, and give it as an object to be drawn from by the children. The light construction-lines can be folded in the paper.

Additional Work.

Four-pointed Star of Bright Paper in a Square. FROM THE OBJECT. — The construction of this star differs from that of the preceding figure. In that the semi-diameters were bisected; in this the semi-diagonals are trisected. This star may also be cut quickly.

Having a square of paper, fold it vertically and horizontally as in the directions given above. Now fold it diagonally from the corner not folded to the opposite corner. Trisect the diagonal fold. Rule a line from the inner point of trisection to the corner opposite it. Cut the eight thicknesses along this line, unfold the paper, and a four-pointed star will appear. Attach it to a square of paper of contrasting color, and use the design as an object from which the children may draw.

SUBJECT. — Triangle.

MONDAY.	TUESDAY.	WEDNESDAY.	THURSDAY.	FRIDAY.
Geometric.	Reduction.	Memory.	Dictation.	Object.
(triangle figures)	(triangle figures)	Lesson of Tuesday.	(triangle figure)	A top.

When two lines meet, they form an angle.
A triangle has three angles.
A triangle has three sides.

MONDAY.

Triangle. GEOMETRIC NAME. From a triangular prism and a cube having a face divided diagonally. — The teacher reviews angle. The children lay sticks so as to make a figure having three sides and three angles, also form such figures from sticks and peas, and by drawing, before the teacher shows a triangle.

Large squares, circles, and triangles are drawn on the floor with blackboard crayon before school-hours. The children, marching to music, take their places on the lines, and thus form the various figures.

Busy Work for the Week.

Among other exercises the children may make a border of triangles with shoe-pegs around their slate or along the desk. The border may be made of triangles which touch each other, which are separated by a space, or which are in groups.

TUESDAY.

Right and Acute Angled Triangles. REDUCTION FROM THE BLACKBOARD. — Two different kinds of triangles are given in this exercise, — the right-angled triangle, a triangle which has one right angle; the acute-angled triangle, a triangle which has all its angles acute. The children should study these triangles, observe what kinds of angles are found in each, and draw the triangles. The names of the triangles may be mentioned to the children, if the teacher finds it desirable; but it is not expected that any drill on the names will be given. Simply the triangle is the subject of this exercise.

TRIANGLE.

DIRECTIONS FOR THE TEACHER. *Right-Angled Triangle.* — Place points for the left vertical and lower horizontal sides of a square, and draw them. — Connect the ends of these lines by **drawing** an oblique.

Acute-Angled Triangle. — As far to the right of the horizontal as one-fourth its length, place points for a horizontal, and **draw** it. — Place a point on the horizontal a little to the left of its centre. — As far above this point as the length of the horizontal, place a point. — **Draw** oblique lines connecting this point with the ends of the horizontal.

DRILL FOR THE WEEK. — The drill should be on curved lines.

Additional Work.

Obtuse-Angled Triangle and Isosceles Triangle. REDUCTION FROM THE BLACKBOARD.

Two different kinds of triangles are given in this exercise, — the obtuse-angled triangle, a triangle which has one obtuse angle; the isosceles triangle, a triangle which has two equal sides.

DIRECTIONS FOR THE TEACHER. *Obtuse-Angled Triangle.* — Place points for a horizontal, and draw it. — A little to the left of the centre, place a point. — As far above this point as one-third the horizontal, place a point. — Connect this point with the ends of the horizontal by **drawing** oblique lines.

Isosceles Triangle. — Place points for a horizontal, and **draw** it. — Bisect it. — As far above the centre as the length of the horizontal, place a point. — **Sketch** a vertical from this point to the centre of the horizontal. — Connect the upper end of the vertical with the ends of the horizontal by drawing oblique lines.

WEDNESDAY.

Lesson of Tuesday. FROM MEMORY.

THURSDAY.

Figure containing Triangles. FROM DICTATION. — This exercise furnishes a very simple example of an axis of symmetry, the vertical line being the axis of symmetry. An axis of symmetry is a line which divides a figure into two equal parts, which correspond to each other in form and position with regard to the axis.

DIRECTIONS. — Place a point an inch from the upper, and two inches from the left, side of the slate. — Three inches below it, place another point. — **Sketch** a vertical connecting these points. — Trisect the vertical. — Place a point as far to the left of the upper point of trisection as one-third the line. — Place a point as far to the right of the upper point of trisection as one-third the line. — **Sketch** a horizontal connecting these points. — Draw

a curve like half a circle from the left end of the horizontal, through the upper end of the vertical, to the right end of the horizontal. — Draw an oblique from the left end of the horizontal to the lower end of the vertical. — Draw an oblique from the right end of the horizontal to the lower end of the vertical.

Additional Work.

Variation of the Preceding Figure. FROM DICTATION. — The figure is so similar to the figure given above that directions for dictating it may be given from the directions just given by substituting *a curve like half a circle* for "an oblique" in the last two sentences.

FRIDAY.

Top. FROM THE OBJECT. — See the suggestions on p. 58 for drawing objects with rounding surfaces. A top may be given, or a flat basket with curved handles and slanting sides. (See p. 233, Fig. 4.)

Additional Work.

Paper Cap. FROM THE OBJECT. — If nothing better can be obtained, a trainer cap folded from paper may be made.

Fold a square of paper diagonally, bringing two corners of the square together. Fold it again, bringing the other two corners together. A four-fold right-angled triangle results, the four sides of the square making the long side of the triangle.

Make a fold parallel to the long side, having the part turned up one-fourth the height of the original triangle. Now turn back one thickness, and fold it up on the other side of the triangle. This cap then appears.

SUBJECT. — **Right-Angled Triangle.**

MONDAY.	TUESDAY.	WEDNESDAY.	THURSDAY.	FRIDAY.
Geometric.	Dictation.	Reduction.	Memory.	Object.
			Lesson of Wednesday.	End of a toy house.

An angle like a knife half open is called a right angle.
When two lines meet so as to make a square corner, they form a right angle.
A triangle which has a right angle is called a right-angled triangle.

MONDAY.

Right-Angled Triangle. GEOMETRIC NAME. — The teacher reviews right angle and triangle, and gives right-angled triangle from solids, from a variety of pasteboard triangles, from objects, and from the board. The children select from the pasteboard triangles all the triangles having a right angle, and place them together. The children form right-angled triangles with sticks and peas, by laying splints, and by drawing.

To construct a right-angled triangle, draw a line in any direction; draw a line to meet it perpendicular to it; draw a line to connect the ends of the lines.

Busy Work for the Week.

The children may build block houses, using some blocks which have right-angled triangles as faces.

TUESDAY.

Construction-Lines for the End of a House. FROM DICTATION.—The order of the lessons is changed for this week. The dictation lesson is given on Tuesday, the lesson from the blackboard on Wednesday, and the drawing from memory on Thursday.

It is occasionally allowable, as in this exercise, to draw a vertical line upward.

DIRECTIONS. — (Give the dictation for a square and light vertical diameter, placing it three inches from the upper side of the slate.) — **Sketch** the

vertical diameter of the square upward indefinitely. — Place a point on it as far from the upper side of the square as half the side. — Draw an oblique from this point to the upper left corner of the square. — Draw an oblique from the same point to the upper right corner of the square.

DRILL FOR THE WEEK. — Right-angled triangles in various positions.

Additional Work.

Four-pointed Star in a Square. FROM DICTATION.

DIRECTIONS. — (Dictate a square.) — Draw an oblique from the upper left corner of the square to the lower right corner. — Draw an oblique from the upper right corner to the lower left corner. — (Give directions for sketching the diameters.) — Find the light vertical. — Bisect its upper half. — Draw an oblique from the upper left corner of the square to the point of bisection. — Find the light horizontal. — Bisect its left half. — Draw an oblique from the upper left corner of the square to the point of bisection. — (Give similar directions for the other points of the star.)

WEDNESDAY.

End of a House. REDUCTION FROM THE BLACKBOARD.

DIRECTIONS FOR THE TEACHER. — Follow the directions for Tuesday's figure. — Continue the oblique lines a little beyond the sides of the square. — Draw oblique lines above and parallel to the lines just extended, meeting on the extended vertical diameter. — Connect the parallel oblique lines at the lower ends by short lines perpendicular to them. — Quadrisect the vertical diameter of the square, and draw the horizontal lines of the window through the upper and lower points of quadrisection. — Draw the verticals connecting them.

Additional Work.

Design in a Square. REDUCTION FROM THE BLACKBOARD.

DIRECTIONS FOR THE TEACHER. — Place points for a square, and draw it. — Draw its diagonals. — Sketch its diameters. — Bisect each half of each diameter. — Draw a curve from the upper left corner, through the first point of bisection on the horizontal diameter, to the lower right corner. — Draw similar curves on the other sides of the square.

THURSDAY.

Lesson of Wednesday. FROM MEMORY.

FRIDAY.

End of a Toy House. FROM THE OBJECT. — The children must first find the construction-lines. This they can do if the teacher leads them right.

Additional Work.

End of a House built with Blocks. FROM THE OBJECT.

Subject. — Light Lines Trisected.

MONDAY.	TUESDAY.	WEDNESDAY.	THURSDAY.	FRIDAY.
Geometric.	Reduction.	Memory.	Dictation.	Object.
		Lesson of Tuesday.		Steps built with blocks.

Learn to draw light lines; that is, to sketch them.
Two marks on a line, which are at equal distances from each other and from the ends of the line, divide the line into three equal parts, or thirds; that is, trisect the line.

MONDAY.

Light Lines Trisected. GEOMETRIC TERM. — By marking and breaking splints or sticks; by sketching and trisecting lines on the board and slates.

Busy Work for the Week.

After various exercises in dividing lines, the children may trisect splints by kernels of corn; may trisect the sides of their slates by pegs. They may also draw as large squares as their slates will allow, and divide them into nine smaller squares. They may then repeat in each square one of the designs given on pp. 84, 89, 90, 96, which should be drawn on the board by the teacher.

TUESDAY.

A Square divided into Nine Small Squares. REDUCTION FROM THE BLACKBOARD. — It will be noted that the whole figure is composed of light lines.

DIRECTIONS FOR THE TEACHER. — Place points for a square, and sketch it. — Trisect its sides. — Sketch vertical and horizontal lines connecting the points of trisection.

DRILL FOR THE WEEK. — Light lines.

Additional Work.

Greek Cross. REDUCTION FROM THE BLACKBOARD. — It will be seen that this figure is constructed on the previous figure, certain parts being strengthened.

The directions for the previous figure must be followed, giving a square of nine small squares. Then the inner sides f the corner squares, and the central third of each side of the rge square, must be strengthened.

WEDNESDAY.

Lesson of Tuesday. FROM MEMORY.

THURSDAY.

End of a Flight of Steps. FROM DICTATION.

DIRECTIONS. — (Give directions for sketching a square.) — Trisect the left side of the square. — Trisect the right side. — Sketch a horizontal connecting the upper points of trisection. — Sketch a horizontal connecting the lower points of trisection. — Trisect the upper side. — Trisect the lower side. — Sketch a vertical connecting the left points of trisection. — Sketch a vertical connecting the right points of trisection. — Make the left side of the square a stronger line. — How many small squares have you? — Find the upper left small square. — Make its upper side stronger. — Make its right side stronger. — Find the central square. — Make its upper side stronger. — Make its right side stronger. — Find the lower right square. — Make its upper side stronger. — Make its right side stronger. — Make the lower side of the large square stronger.

Additional Work.

Design in a Square. FROM DICTATION.

DIRECTIONS. — (Give the directions for the light lines of the preceding figure.) — Find the upper horizontal. — Make its central third stronger. — (Give similar directions for the other sides.) — Find the upper left small square. — Draw a curve curving inward from the upper right corner of this small square to its lower left corner. — (Give similar directions for the other curves.)

FRIDAY.

End of a Flight of Steps built with Blocks. FROM THE OBJECT.

Additional Work.

Cover of a Book, its Sides having the Proportion of Two to Three. FROM THE OBJECT. — One of the longer sides should be drawn first, and trisected. The shorter sides should then be made equal to two-thirds the longer.

An exercise in judging proportion from an oblong sheet of paper two-thirds as wide as it is long should be given here. (See p. 61.)

CIRCLE WITH LIGHT LINES WITHIN. 99

SUBJECT. — **Circle with Light Lines within.**

MONDAY.	TUESDAY.	WEDNESDAY.	THURSDAY.	FRIDAY.
Geometric.	Reduction.	Memory.	Dictation.	Object.
		Lesson of Tuesday.		A Wheel.

A circle is perfectly round.
Learn to make light lines.

MONDAY.

Circle with Light Lines within. GEOMETRIC TERM. From the sphere, hemisphere, and cylinder, from pasteboard circles, and from the board. (See p. 65.) — The teacher illustrates on the board the manner of drawing a circle on its diameters by sketching the diameters, and then drawing the circle.

Busy Work for the Week.

One exercise may be to draw a border like that given for *additional work* on Tuesday, and that given on Thursday. This border may be drawn so as to make a marginal border around the slate. Some children who draw well may draw a marginal border on the board. They may also cover their slates with the surface covering shown in the *additional work* for Thursday.

TUESDAY.

Design in a Circle. REDUCTION FROM THE BLACKBOARD.

DIRECTIONS FOR THE TEACHER. — Place points for a horizontal, and sketch it. — Bisect it. — Place points as far above and below the centre as half the horizontal. — **Sketch** a vertical connecting the points. — **Draw** a circle through the ends of the lines. — Bisect each semi-diameter. — Connect the points of bisection by curves curving inward.

DRILL FOR THE WEEK. — Circles.

Additional Work.

Vertical Border. REDUCTION FROM THE BLACKBOARD. — The preceding figure may be repeated in a vertical border of three squares.
Directions for laying out a vertical border will be found on p. 85, where a vertical border made by the repetition of concentric squares is given as additional work in dictation and memory drawing.

WEDNESDAY.

Lesson of Tuesday. FROM MEMORY.

THURSDAY.

Horizontal Border. FROM DICTATION AND MEMORY.

DIRECTIONS. — Place a point an inch from the upper and left sides of the slate. — An inch below it, place a point. — Draw a vertical connecting the points. — Three inches to the right of the upper end of the line, place a point. — Draw a horizontal from the upper end of the vertical to this point. — Three inches to the right of the lower end of the vertical, and an inch below the right end of the horizontal, place a point. — Draw a vertical from the right end of the horizontal to this point. — Draw a horizontal connecting the lower ends of the verticals. — Trisect the upper horizontal. — Trisect the lower horizontal. — Draw a vertical to connect the left points of trisection. — Draw a vertical to connect the right points of trisection. — There are now three squares. — Draw in each square the figure of Tuesday and Wednesday.

Additional Work.

Design to cover a Surface. FROM DICTATION AND MEMORY.

The figure of Tuesday is now to be repeated to cover a surface. Directions for laying out a space in squares for a design to cover a surface will be found on p. 84, where a design for this purpose is given for dictation and memory drawing.

FRIDAY.

Toy Wheel. FROM THE OBJECT.

Additional Work.

Circles of a Clock-Face. FROM THE OBJECT.

PART II.

SECOND PRIMARY YEAR.

SECOND YEAR.—FIRST HALF.

SPHERE, CUBE, CYLINDER, TRIANGULAR PRISM, SQUARE PRISM.
Lines, Angles, Triangles, Square, Oblong.

	MONDAY.	TUESDAY.	WED'SDAY.	THURSDAY.	FRIDAY.
Nature and Order of Lessons.	Geometric.	Enlargement.	Memory.	Dictation.	Object.
Square and its diagonals.			Lesson of Tuesday to cover four squares.		Silk winder of paper or of ivory.
Square and its diameters.			Lesson of Tuesday.		Horizontal border from some object.
Lines divided into three equal parts.			Lesson of Tuesday, oblique lines curved in.		Greek cross of paper or other material.
Square on its diameters.			Lesson of Tuesday in vertical border.		Maltese cross.
Square on its diagonals.			Lesson of Tuesday to cover four squares.		Vertical border from some object.
Oblong.			Lesson of Tuesday.		A slate.

	TUESDAY	WED'SDAY	THURSDAY	FRIDAY
	Enlargement.	Memory.	Dictation.	Object.
Nature and Order of Lessons. / MONDAY Geometric / Lines, horizontal, vertical, oblique, parallel, etc. / Angles, right, acute. / Triangles, right-angled triangles.				
Isosceles triangles.		Lesson of Tuesday in horizontal border.		Envelope.
		Lesson of Tuesday in vertical border.		Folding-rule open at various angles.
		Lesson of Tuesday.		End of toy house.
		Lesson of Tuesday to cover surface.		Isosceles triangles of paper in different positions.
Right-angled isosceles triangles.		Lesson of Tuesday.		Bright colored stars.
Equilateral triangle.		Lesson of Tuesday.		Triangles of paper with open triangular centre.

SECOND YEAR. — SECOND HALF.
CIRCLE, ELLIPSE, OVAL, REVERSED CURVES.
Design, Union of Lines, Axes of Symmetry, Repetition, Conventionalization.

Nature and Order of Lessons.	MONDAY. Geometric.	TUESDAY. Enlargement.	WED'SDAY. Memory.	THURSDAY. Dictation.	FRIDAY. Object.	Nature and Order of Lessons.	MONDAY. Geometric.	TUESDAY. Enlargement.	WED'SDAY. Memory.	THURSDAY. Dictation.	FRIDAY. Object.
Circle and its diameters.			Lesson of Tuesday.		Plate.	Axis of symmetry.			Lessons of Monday and Tuesday.		Pen.
Circle inscribed in a square.			Lesson of Tuesday, horizontal border.		Clock face.	Axes of symmetry.			Lessons of Monday and Tuesday.		Toy wheel.
Union of lines.			Lessons of Monday and Tuesday.		Leaves.	Reversed curves.			Lessons of Monday and Tuesday.		Vase.
Ellipse.			Lesson of Tuesday.		Frame.	Unit of design.			Lesson of Tuesday.		Units from good designs.
Ellipse and circle.			Lessons of Monday and Tuesday.		Lemon.	Conventionalization of leaves.			Lessons of Monday and Tuesday.		Leaves.
Oval.			Lessons of Monday and Tuesday.		Pear.	Conventionalized forms in design.			Lessons of Monday and Tuesday.		Design.

ORDER OF WORK.

THE subjects taken up in the second primary year are, —
Lines, — Vertical, horizontal, oblique, parallel, perpendicular, — divided into two and three equal parts (being a review of work of the first year).
Angles, — Right, acute, obtuse (being a review of work of the first year).
Triangles, — Right-angled, isosceles, equilateral.
Square, — Its diagonal, its diameters; on its diameters, on its diagonals.
Oblong, — Vertical, horizontal, oblique.
Circle, — Diameter, radius; semicircle; quadrant; circle inscribed in a square.
Ellipse, — Vertical, horizontal; ellipse and circle.
Oval, — Upright and reversed.
Reversed curves, — On construction-lines divided into two and three equal parts.
Design, — Union of lines, axes of symmetry, units of design, conventionalization.

The scheme on pp. 102, 103, shows the arrangement of these subjects. It also shows that the nature of the Tuesday lesson is changed in one particular from that for the first year.

In the first year one of the means of developing the idea of proportion was by exercises in REDUCTION FROM THE BLACKBOARD on Tuesday. To develop this idea of proportion still further, and in another manner, ENLARGEMENT FROM CARDS is now given.

The geometric figures which are presented in this year should be given *first* from solids and objects, and then from the blackboard, as the geometric figures of the first year were given. The blackboard should be used more or less in giving all the lessons.

The figures on the cards, as well as the dictation lessons, are based on the geometric figures with which the children have become familiar in the first year; namely, the triangle, the square, and the circle; and also on the geometric figures given in this year. In drawing a figure from the card,

children should be led first to observe the general form, and thus determine upon what geometric figure the card figure is based; then to look for the construction-lines. Construction-lines are lines upon which a figure is built, which, when drawn, reveal its structure. They do not, however, necessarily appear in the figure when completed. The children are led, in the latter part of the first year, by the imitation of the figures on the blackboard, and by the directions given to them in the dictation exercises, to form the habit of drawing figures by the use of construction-lines. The card and dictation exercises of this year should fully establish the habit of using construction-lines. The memory drawing, dictation exercises, and drawing from objects, should be pursued systematically. If the lesson is conducted properly, "object day" will be as great a delight to the children as "clay day" is to kindergarten pupils. The teacher should always study the object with great care before giving the lesson, so as to be ready to lead the children to see every essential of its form. Time lessons and drill exercises should be frequent.

The Busy Work (see p. 16) should change in its character, according to the more advanced character of the lessons.

Twelve weeks' work is given for each half-year, and *Additional Work* is provided to be given as the teacher desires.

THE CARDS.

The cards are for regular use in the Tuesday's lesson, and may also be used for Busy Work at the discretion of the teacher. The scheme shows which figure on the card is to be used in the work for each Tuesday.

The cards contain, —
First, An illustration of Monday's lesson.
Second, The figure to be given on Tuesday, and its construction.
Third, A variation of that figure, to be used at the discretion of the teacher.
Fourth, In some cases, additional figures, illustrating the subject of the week.

For example, Card No. 1, First Series, relates to straight lines. The subject for the first week is straight lines. This subject is to be treated as an orderly review of what the children have had in practice during the first year. The first line of illustrations on Card No. 1 shows to the teacher one way in which this review may be arranged for the lesson of Monday, and also recalls that lesson to the children while using the card on Tuesday. The illustration in the Scheme for the Monday lesson of the first week (p. 107) is necessarily much less extended, on account of the limited space. In Fig. 1, on Card No. 1, all the lines given in the first line of illustrations (excepting light oblique lines, and oblique lines divided into two equal parts) are combined; and Fig. 1 is therefore called the application of these

lines. The construction for Figs. 1 and 2 is given in the illustration at the left of the lower part of the card.

Fig. 2 has the same construction as Fig. 1, but varies from it by reason of the curved lines substituted for the straight oblique lines of Fig. 1. Fig. 2 may be used in various ways, — as a card exercise for *Additional Work*, should the subject be continued for two weeks; as a time exercise after Fig. 1; as a dictation exercise; or for Busy Work.

This explanation of Card No. 1 will serve substantially for Cards Nos. 1 to 6 and No. 12 of the First Series, and Cards Nos. 1, 3, 6 to 11, of the Second Series. The remaining cards differ from these only by having in the first line some illustrations of borders, made by the repetition of simple units of design. These borders are to be used in the various ways just mentioned for the use of Fig. 2, Card No. 1 of the First Series.

The First Series of Cards is to be used during the first half of the second year, the Second Series during the last half.

With each series of cards, there will be found a rule and measure giving the measure of six inches. On one edge of one face of the measure, will be found simple inches; on the opposite edge of the same face, will be found inches divided into half-inches. On one edge of the reverse face, will be found inches divided into quarter-inches; on the opposite edge of the same face fifteen centimetres (a hundred of which make a metre) are laid off, thus giving an illustration of the metric system.

These rules and measures are for the use of the children, and are to be placed in their hands as occasion may require. They may frequently be allowed the use of the measure in testing the length of lines which they have drawn. They may rule the enclosing form and the construction-lines of the work in original arrangement.

Drill exercises in the use of the rule and measure should be given. The children may be called on to rule a certain number of parallel lines at a definite distance from each other. They may be called on to measure their slate-frames, the edges of the cover of a book, etc. They may be called on to divide lines into inches, half-inches, and quarter-inches, and into centimetres.

CHAPTER I.

STRAIGHT LINES. — ANGLES. — TRIANGLES, RIGHT-ANGLED, ISOS-
CELES, RIGHT-ANGLED ISOSCELES, AND EQUILATERAL.

Remember that the whole week's work on a subject should be studied before any lesson is given on the subject.

SUBJECT. — **Straight Lines.**

MONDAY.	TUESDAY.	WEDNESDAY.	THURSDAY.	FRIDAY.
Geometric.	Enlargement.	Memory.	Dictation.	Object.
			Lesson of Tuesday in horizontal border.	Square Envelope.

A REVIEW.

Card No. 1, First Series.

A vertical line stands up; is upright.

A vertical line should be drawn from the upper end downward.

A horizontal line lies down; is level.

A horizontal line should be drawn from left to right.

An oblique line leans; inclines.

Lines are parallel to each other when they run in the same direction, and are everywhere the same distance apart.

Lines are perpendicular to each other when they do not lean toward or from each other; when they meet so as to form a right angle or square corner.

One mark at the centre of a line bisects the line; that is, divides the line into two equal parts, or halves.

Learn to sketch lines when required; that is, to draw light lines.

When light lines are not required, draw a medium line.

Never draw a line with such force as to scratch the slate.

NOTE. — Sentences like the preceding, which are directly below the scheme for a subject, are not given as a set form to be used by the teacher or children, but are given as "leading sentences," embodying the ideas to be developed or recalled in the minds of the children.

MONDAY.

Straight Lines. GEOMETRIC NAMES AND TERMS. — The order to be observed in the lessons from the solids is, Review, Observation, Term, Drill, Application, Drawing. (See pp. 29–38.) The teacher leads the children to show the lines in their different directions and relative positions from the solids, and to tell their names. (See pp. 39, 44, 47, 62, 68.) The children indicate the division of lines by marking and breaking sticks, and by dividing lines drawn on the board. (See pp. 59, 80.) They illustrate the light and the medium line by drawing on the board.

NOTE. — The first line of illustrations on Card No. 1, First Series, shows straight lines in the various directions, positions, divisions, and modifications indicated in the leading sentences above.

Busy Work for the Week.

"Busy Work" (a name given to that kind of work which children do without the assistance of the teacher) should not be dropped at the end of the first year. Many kinds of Busy Work in which the form lessons will be brought into practice will readily suggest themselves to every teacher. In the Busy Work the children may still make use of the lines ruled for writing.

As Busy Work for this week, they may fill the space between any two ruled lines suggested by the teacher with vertical lines, another space with oblique lines, and, turning the slate, may fill another space with horizontal lines; they may draw lines perpendicular to any given ruled line; they may divide any given lines. They may lay sticks in the different directions and relations given for the lines. (See p. 231, Figs. A and B.) They may draw from any object assigned by the teacher. For further explanation of Busy Work, see p. 16.

TUESDAY.

Design in a Square. ENLARGEMENT FROM CARD No. 1, Fig. 1. — Each child should have a card. Lead children to talk of the construction of the figure as shown on the card, and of the figure as completed. Give them opportunities to discover that this figure contains many of the lines given in the upper line of illustrations on the card, and to tell what they have found.

At the beginning of the second primary year children should be able to place a point an inch from the upper and from the left sides of the slate (the long sides of the slate being parallel to the front of the desk), and a point an inch from the left and lower sides, with tolerable accuracy. The distance between these points will be the measure of the side of the square to be drawn for this exercise. The square should then be drawn, the left and upper sides being drawn before the lower and right sides. Directions for the figure are added here for the guidance of the teacher. The teacher,

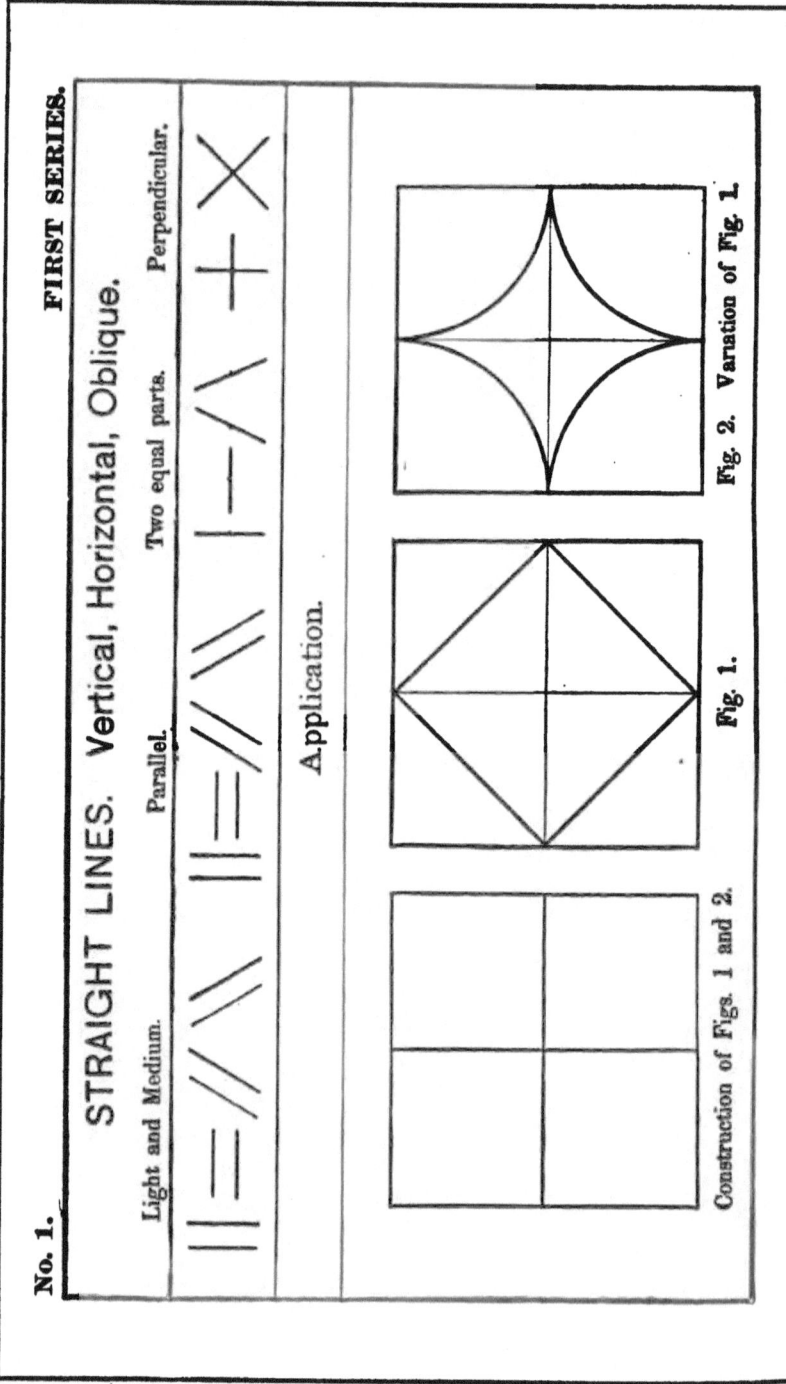

however, should *not* give them to the children, but should lead the children to give the directions themselves from the figure.

It will be noted, that, when the word "**draw**" is used in the directions, the line made should be medium; that, when the word "**sketch**" is used, the line made is to be light.

DIRECTIONS. — Place points for a square. — **Draw** the left, upper, right, and lower sides of the square. — Bisect (that is, divide into two equal parts) each side of the square. — Sketch (that is, draw in light line) a vertical line connecting the points on the upper and lower sides of the square. — Sketch (that is, draw in light line) a horizontal line connecting the points on the left and right sides of the square. — Connect the ends of these light lines by **drawing** straight oblique lines.

DRILL FOR THE WEEK. — The drill on one kind of lines should not be abandoned; but as much time as is necessary should be given to drawing the various straight lines, and dividing them at command, after the manner suggested below.

DIRECTIONS. — **Draw** a vertical. — **Draw** a horizontal. — **Draw** an oblique. — **Draw** a line parallel to the vertical. — **Draw** a line perpendicular to the horizontal. — Bisect the oblique. — **Draw** a horizontal. — Trisect it. — Sketch a vertical. — Divide it into four equal parts. — Sketch an oblique. — Sketch a line perpendicular to it.

Additional Work.

Design in a Square. ENLARGEMENT FROM CARD NO. 1, FIG. 2. — The directions for Fig. 1 serve for Fig. 2 by substituting "curves curving inward" for "straight oblique lines" in the last direction.

WEDNESDAY.

Horizontal Border. FROM MEMORY. — In addition to the memory exercise, this may be made a lesson in arrangement. By repeating the lesson of Tuesday in three squares joining each other horizontally, a border will be produced by horizontal repetition, — a very simple principle in design. Directions for the border may be given, and the manner of its construction may be illustrated on the board. All illustrative work upon the board should be upon a large scale, generally on the scale of about a foot on the board to an inch of slate-work.

DIRECTIONS. — **Draw** a vertical line an inch long. — From the upper end of the vertical line, draw a horizontal line rather more than three inches long. — From the lower end of the vertical, **draw** a similar horizontal. — Place a point on the upper horizontal an inch to the right of the vertical. — From this point, **draw** a vertical to meet the lower horizontal, thus making a square. — Make two other squares in the same way. — Erase what remains of the horizontal lines. — In each of the three squares, **draw** the figure of Tuesday from memory.

THURSDAY.

Design in a Square. FROM DICTATION. — The children should draw the figure, not from any illustration, but from the spoken words of the teacher. A dictation lesson should always be given very clearly, in such terms that the meaning cannot be misconstrued, and with a fulness of detail adapted to those who receive it. If terms are used with which the children are not familiar, if the directions are given too rapidly or not sufficiently in detail, the lesson will be worse than fruitless, leaving the minds of the children in a very confused state. Care should be taken to give sufficient time between the directions for drawing, but not to allow time for erasing. If the class to which this lesson is given is new to the teacher, it will be well to give the lesson very much in detail. The children may even need the directions for placing the square, as in the exercise of Tuesday. It will be better to give detailed directions for this than to give the general direction, "Draw a square as on Tuesday;" for the children may not have had enough previous practice on this to be able to do it without further direction. After the square is drawn, directions for the remaining part of the figure (for which those here given may serve as suggestions) should be given.

These directions are separated, to mark each new step. Before giving the directions for any step, the teacher should learn from the children, by conversation, whether they are prepared for it; and, if they are not, should, by further conversation, lead them to see what is implied in that step before giving the direction to them.

DIRECTIONS. — (Give directions for drawing a square.) — Divide the upper side of the square into two equal parts; that is, bisect it. *Bisect* the lower side of the square. Connect the *points of bisection* by **sketching** (that is, drawing lightly) a vertical line. — *Bisect* the left side of the square. Bisect the right side of the square. Connect the points of bisection by **sketching** a horizontal line. — How many small squares have you? — Mark the *centre* of each small square by a point. — Connect the two upper points by a horizontal. Connect the two points at the left by a vertical. Connect the two lower points by a horizontal. Connect the two points at the right by a vertical. — You have a square in the centre; that is, a *central square*. — Parts of each light line are *outside* of the central square. — *Strengthen* those parts, making them medium lines.

Additional Work.

Design in a Square. FROM DICTATION.

(Give the directions in detail for a square and light diameters, as in the pre-

ceding exercise.) — Find the upper half of the light vertical. Bisect it. Bisect the lower half. — Find the left half of the light horizontal. Bisect it. Bisect the right half. — There are now four points of bisection. — Find the upper point. Find the left point. Connect the *upper* point and the *left*

STRAIGHT LINES.

point by **drawing** an oblique. — Find the lower point. Connect the *left* point and the *lower* point by **drawing** an oblique. — Find the right point. Connect the *upper* point and the *right* point by **drawing** an oblique. — Connect the *right* point and the *lower* point by **drawing** an oblique. — There is now a central square. — Parts of each light line are outside of the central square. — Strengthen those parts, making them medium lines.

FRIDAY.

Square Envelope. FROM THE OBJECT. — If possible, an envelope should be in the hands of each child. The children should be led to observe the form of the envelope and the various lines — as parallel, vertical, oblique — which compose it. The teacher should also question the class as to the manner of beginning the drawing, what line should be drawn first, etc. The children should then place their envelopes on their desks, and draw from them, the teacher giving necessary directions as to the place on the slate and the size of the drawings.

If it is not possible to place an envelope in the hands of each child, the teacher may hold a large envelope before the class, and lead the children to discover its form. After sufficient time has been spent in this way, the envelope may be pinned up where it can be seen, so that the class can draw from the object.

Additional Work.

Oblong Envelope. FROM THE OBJECT. (See p. 233, Fig. 1.)

114 TEACHERS' PRIMARY MANUAL.

SUBJECT.—Angles, Right, Acute, Obtuse.

Card No. 2, First Series.

MONDAY.	TUESDAY.	WEDNESDAY.	THURSDAY.	FRIDAY.
Geometric.	Enlargement.	Memory.	Dictation.	Object.
└ ∠ ┘ ┘ > ┘ ┌ ∧ ┌	◻ (square with X)	Lesson of Tuesday in vertical border.	◇ in ◻ (square with inscribed diamond)	Folding-rule open at various angles.

When two straight lines meet, they form an angle.
When two straight lines run in different directions, they form an angle.

An angle that looks like a knife half open is called a right angle.
When two straight lines meet so as to make a square corner, they form a right angle.

An angle that looks like a knife not half open is called an acute angle.
An angle that is less than a right angle is called an acute angle.

An angle that looks like a knife more than half open is called an obtuse angle.
An angle that is greater than a right angle is called an obtuse angle.

The lines which make an angle are called the *sides* of an angle.
The point where the sides meet is called the *vertex* of an angle.

MONDAY.

Angles, Right, Acute, Obtuse. GEOMETRIC NAMES. From solids and objects, by laying sticks, and from the board. (See pp. 71, 74, 77.) — The children find the lines that form an angle: the teacher gives the term, Sides. The children find the point where the sides meet: the teacher gives the term, Vertex.

Busy Work for the Week.

The cards may be made use of in the Busy Work. The teacher may place upon the board a group of angles from the upper line of illustrations on Card No. 2, and ask the children to imitate them by laying sticks, or by drawing. The children may also make borders of different angles. (See p. 231, Figs. C.)

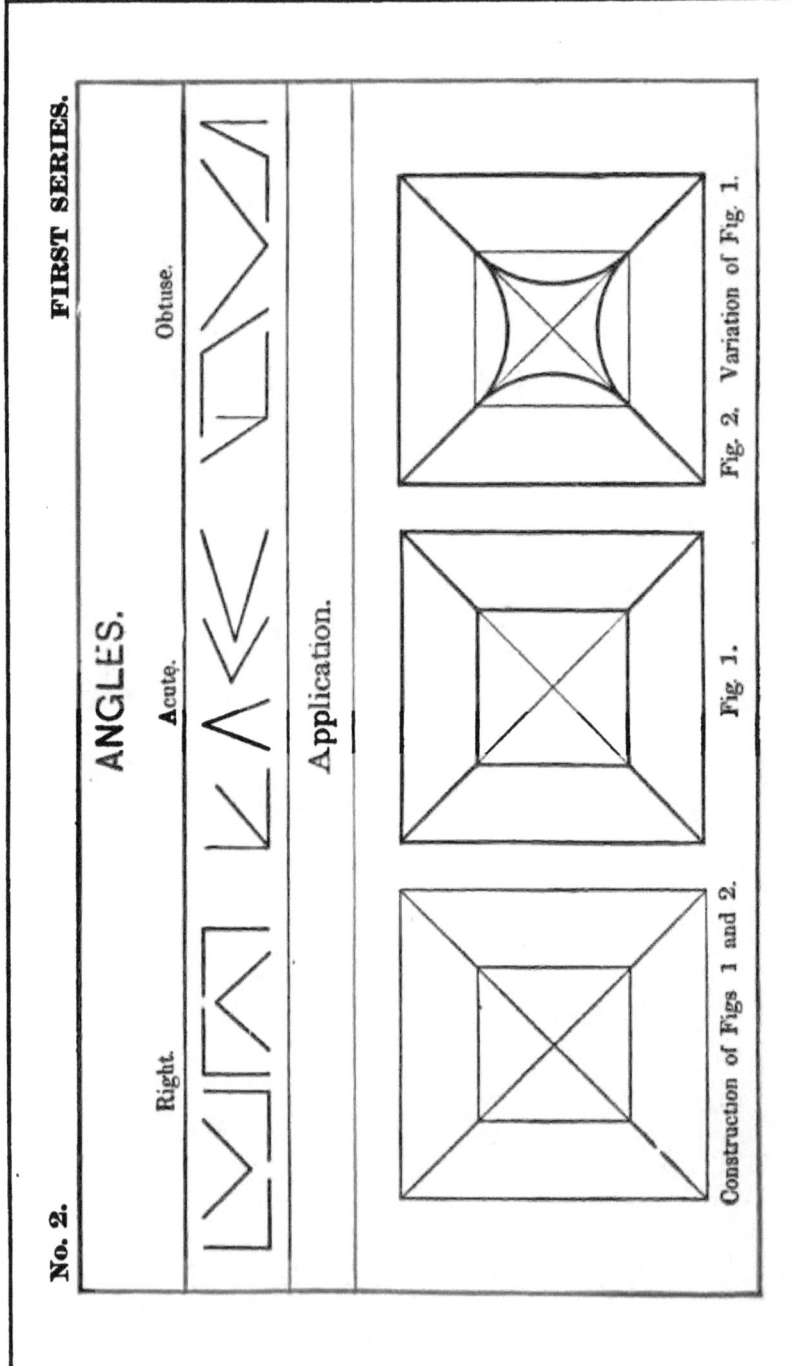

ANGLES, RIGHT, ACUTE, OBTUSE.

TUESDAY.

Design in a Square. ENLARGEMENT FROM CARD No. 2, FIG. 1. — The children should observe the figure carefully, telling how many angles of each kind there are. They should then discover the steps in the construction, and describe them.

DIRECTIONS FOR THE TEACHER. — Place points for a square, and draw it. — Sketch its diagonals. — Bisect each semi-diagonal. — Connect the points of bisection by **drawing** horizontals and verticals. — Strengthen the outer half of each semi-diagonal.

DRILL FOR THE WEEK. — In addition to the regular drill on lines, give directions like the following: —

DIRECTIONS. — **Draw** a vertical. **Draw** a line to meet it, making a right angle. — **Draw** a horizontal. **Draw** a line to meet it, making an acute angle. — **Draw** an oblique. **Draw** a line to meet it, making an obtuse angle. — **Draw** a right angle in five different positions. — **Draw** three different acute angles. — **Draw** three different obtuse angles.

Additional Work.

Design in a Square. ENLARGEMENT FROM CARD No. 2, FIG. 2.

DIRECTIONS FOR THE TEACHER. — (Follow the directions for Fig. 1, except that for the inner square, which should be simply **sketched** in this figure.) — **Draw** curves curving inward on each side of the inner square. — Strengthen the outer half of each semi-diagonal.

WEDNESDAY.

Vertical Border. FROM DICTATION AND MEMORY. — The outline for a vertical border of three squares may be dictated. (See p. 85.) The squares should then be filled from memory with the framework given on Tuesday.

THURSDAY.

Design in a Square. FROM DICTATION. — It will be noted that the figure given here for dictation is the same as that on pp. 89, 90. But the figure was given there for reduction, and here it is to be dictated.

Every figure must be so given as to recall the subject of the week: therefore, after this figure has been dictated and drawn, children should discover the different kinds of angles in the figure.

DIRECTIONS. — (Give directions in detail for a square and light diameters.) — **Draw** an oblique to connect the upper end of the light vertical with the left end of the light horizontal. — **Draw** an oblique to connect the left end of the light horizontal with the lower end of the light vertical. — **Draw** an oblique to connect the upper end of the light vertical with the right end of the light horizontal. — **Draw** an oblique to connect the right end of the light horizon-

tal with the lower end of the light vertical. — Find the upper half of the left side of the square. Bisect it. — Find the left half of the upper side of the square. Bisect it. — **Draw** an oblique line to connect the points of bisection. — (Give similar directions for the remaining short oblique lines.)

Additional Work.

Three Concentric Squares. FROM DICTATION. — This figure was given on p. 90 for reduction from the blackboard.

DIRECTIONS. — (Give directions in detail for a square and light diameters; also for connecting the ends of the diameters by **drawing oblique lines** as in the preceding figure.) — Find the upper half of the light vertical. Bisect it. — Find the left half of the light horizontal. Bisect it. — Connect the points of bisection by drawing an oblique line. — (Give similar directions for the other sides of the central square.)

FRIDAY.

Folding-Rule Open at Various Angles. FROM THE OBJECT. — Before the children draw from the rule, open it at various angles, and call on the children to name the angles as the rule is presented. The children should then draw from the rule fixed at various angles.

Additional Work.

The children may suggest objects in the room having a right angle, an acute angle, an obtuse angle. The teacher should then decide from which objects the children are to draw.

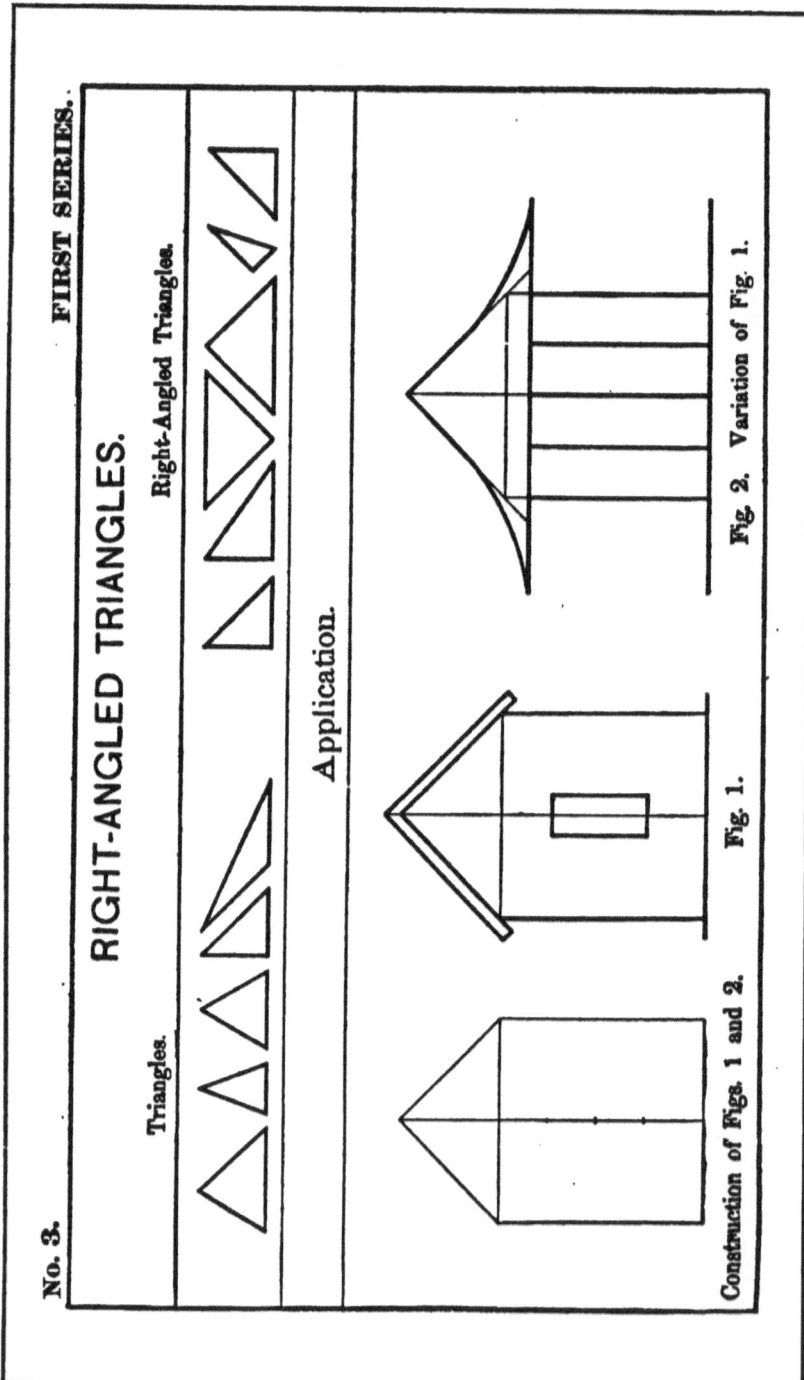

TRIANGLES; RIGHT-ANGLED TRIANGLE.

SUBJECT. — **Triangles; Right-Angled Triangle.**

Card No. 3, First Series.

MONDAY.	TUESDAY.	WEDNESDAY.	THURSDAY.	FRIDAY.	
Geometric.	Enlargement.	Memory.	Dictation.	Object.	
			Lesson of Tuesday.		End of a toy house.

A trianglde has three angles.
A trianglde has three sides.
The side on which a triangle seems to rest is called the base.
The anglde opposite the base of a triangle is called the apex of the triangle.
A trianglde which has a right angle is called a right-angled triangle.

MONDAY.

Triangles, Right-Angled Triangle. GEOMETRIC NAMES. — From solids, froom objects, from pasteboard triangles of various shapes (see first line of illlustrations, Card No. 3), from the board, by laying sticks, by drawing. (Seee pp. 92, 95.)

Busy Work for the Week.

As onae exercise, put the cards in the hands of the children, and let them work fronm the upper line of illustrations. They may also build houses with blocks at ; the table.

TUESDAY.

End cof a House. ENLARGEMENT FROM CARD No. 3, FIG. 1. — This figure is aalso given in the first primary year. The directions for the teacher will be foound on p. 96.

DRILL FOR THE WEEK. — Right-angled triangles of various sizes, and in variouss positions.

Additional Work.

Frontt of a House. ENLARGEMENT FROM CARD No. 3, FIG. 2.

DIRECTIOONS FOR THE TEACHER. — (Follow the directions for construction given on p. 95.) — Continue the oblique lines a little beyond the vertical lines cof the square. — Draw through the lower ends of the oblique lines a

horizontal extending to the left and right of the square as far as half the side of the square. — Bisect each oblique. — Connect each point of bisection with the nearest end of the long horizontal by **drawing** a curve curving inward. — Bisect each half of that part of the long horizontal lying within the square. — Bisect each half of the lower side of the square. — Connect the points of bisection by **drawing** verticals. — Extend the lowest horizontal each way as far as half its length.

WEDNESDAY.

Lesson of Tuesday. Card No. 8, Fig. 1. End of a House. From Memory.

THURSDAY.

Vertical Border. From Dictation.

Directions. — Place a point an inch from the upper and left sides of the slate. Three inches below this point, place another point. **Draw** a vertical connecting the points. — An inch to the right of the upper end of the vertical, place a point. **Draw** a horizontal from the upper end of the vertical to this point. — Place a point an inch to the right of the lower end of the vertical. **Draw** a vertical from the right end of the horizontal to this point. — **Draw** a horizontal connecting the lower ends of the verticals. — Trisect each vertical. — Connect the upper points of trisection by **drawing** a horizontal. — Connect the lower points of trisection by **drawing** a horizontal. — There are now three squares. — (Give directions in detail for placing in the upper square the three concentric squares given on p. 118.) — Repeat in the two remaining squares.

Additional Work.

 Horizontal Border. From Dictation. — Give similar directions to those given for the vertical border. Give directions for placing in each square the figure given for dictation on p. 114.

FRIDAY.

End of a Toy House. From the Object. — The house should be large enough for the children to judge of its general form when it is held before the class by the teacher. If a toy house suitable for the purpose cannot be obtained, the end of one of the houses built by the children may be used as an object.

Additional Work.

End of a House built with Blocks.

ISOSCELES TRIANGLES.

SUBJECT. — **Isosceles** Triangles.

Card No. 4, First Series.

MONDAY.	TUESDAY.	WEDNESDAY.	THURSDAY.	FRIDAY.
Geometric.	Enlargement.	Memory.	Dictation.	Object.
		Lesson of Tuesday to cover surface.		Isosceles triangles of paper in different positions.

A triangle which has two equal sides and two equal angles is called an isosceles triangle.
The side between the equal sides of an isosceles triangle is called its base.

MONDAY.

Isosceles Triangles. GEOMETRIC NAME. From solids, from objects, from the board, by laying sticks, by forming isosceles triangles by sticks and peas, by drawing. — The children select from a variety of pasteboard triangles those triangles which have two equal sides and two equal angles. The term and the drill should follow. To construct an isosceles triangle, **draw** the base, and bisect it; **sketch** a line perpendicular to the centre of the base; **fix** a point on this line; **draw** two lines connecting the point with the ends of the base.

Busy Work for the Week.

Make the Busy Work of this week a preparation for the original arrangements suggested for the *Additional Work* of Thursday. Distribute the sets of splints graduated in length, which are used for designing. (See p. 89.) Let the children make figures with the splints; then let them draw those figures on their slates or on the board.

TUESDAY.

Isosceles Triangles in a Square. ENLARGEMENT FROM CARD No. 4, FIG. 1. — It will be noted that there are two kinds of isosceles triangles in the figure, — one having the two equal sides longer than the third side, the other having the two equal sides shorter than the third side. Do not fail to lead the children to observe this, and also to find how many isosceles triangles there are in the figure.

DIRECTIONS FOR THE TEACHER. — Place points for a square, and draw it. — Sketch its diameters. — Bisect each semi-diameter. — Draw obliques connecting the points of bisection, making a central square. — Connect each corner of the outer square with the two nearest corners of the central square by **drawing** oblique lines, thus making isosceles triangles.

DRILL FOR THE WEEK. — The careful use of the rule and measure.

Additional Work.

Design in a Square. ENLARGEMENT FROM CARD NO. 4, FIG. 2. — Lead the children to observe that the curves are parts of circles.

DIRECTIONS FOR THE TEACHER. — (Follow the directions for Fig. 1, except that for the inner square, which should be simply **sketched** for this figure.) — **Draw** curves curving inward on each side of the inner square.

WEDNESDAY.

Surface Covering. FROM DICTATION AND MEMORY. — A surface of four squares should be dictated. (See p. 84.) Each square should be filled from memory with the figure of Tuesday.

THURSDAY.

Concentric Rhombuses. FROM DICTATION. — A rhombus is a figure having four equal sides, but its angles are not right angles.

DIRECTIONS. — An inch from the centre of the left side of the slate, place a point. Four inches to the right of this, place another point. Sketch a horizontal to connect the points. — Bisect the horizontal. — An inch above the centre of the horizontal, and an inch below it, place a point. Sketch a vertical to connect the points. — From the upper end of the vertical to the left end of the horizontal, **draw** an oblique. — (Give similar directions for the other sides of the outer rhombus.) — Bisect the upper half of the vertical. Bisect the left half of the horizontal. **Draw** an oblique connecting the points of bisection. — (Give similar directions for the other sides of the inner rhombus.)

Additional Work.

In the Busy Work the children have had many opportunities to attempt arrangements of their own. In the memory and dictation lessons they have learned to make horizontal and vertical borders, and to cover a surface by the repetition of figures. In this exercise it is proposed that the children should attempt in a simple way an arrangement of their own around a centre. With this end in view, distribute Cards Nos. 1 and 2 to the children, and let them observe, under the guidance of the teacher, whether, in Figs. 1 and 2 on each of those cards, all sides of the figure are alike, or not. Then, having gathered the cards, draw on the board the construction-figure given

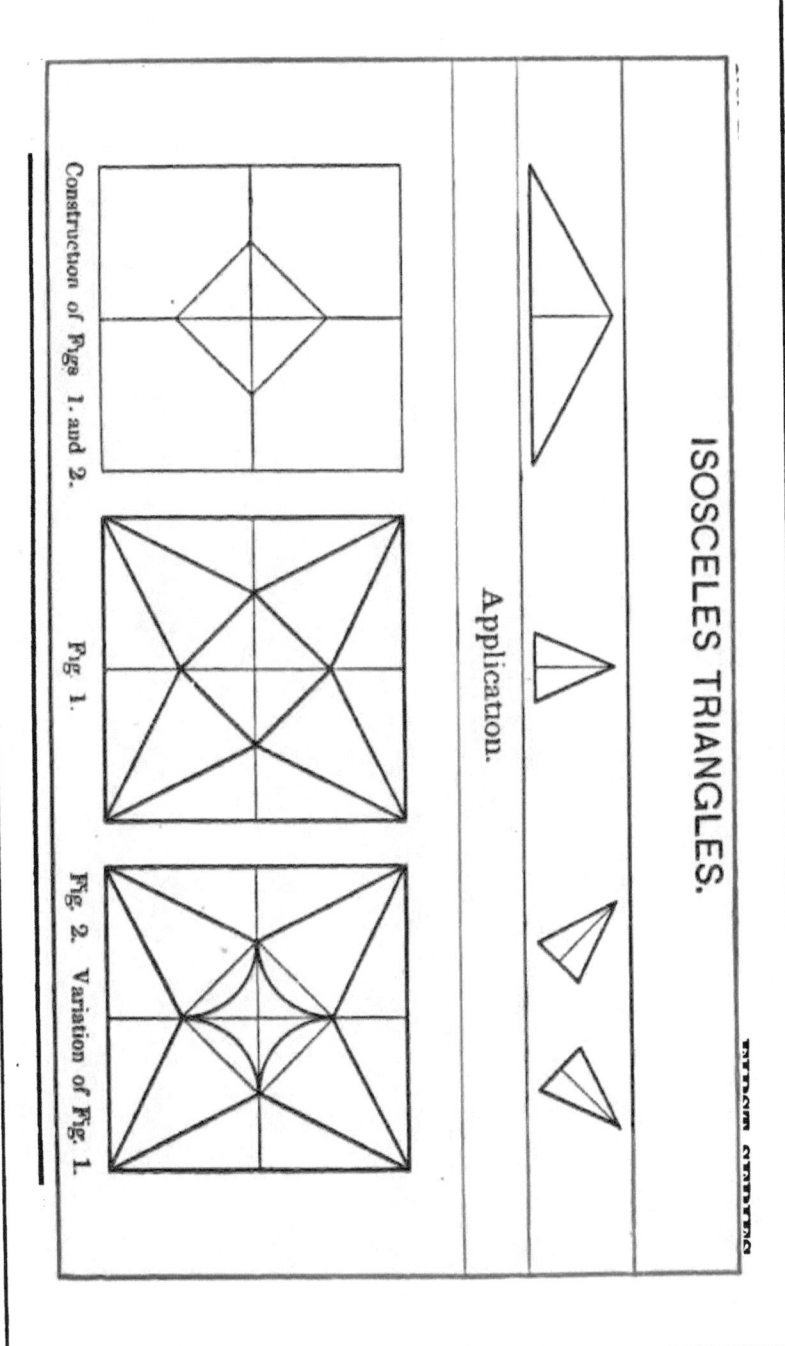

on Card No. 4; call on some child who will work intelligently to draw on the board on that construction, and, by adding lines to it, to make a figure unlike any on the cards, but having its four corners all alike.

FRIDAY.

Isosceles Triangles. FROM OBJECTS. — These triangles should be of different shapes, cut from bright paper, and fastened to the wall in different positions.

Additional Work.

If the schoolroom does not furnish objects illustrating the subject of the week, the teacher should prepare for the lesson by procuring such objects, and placing them in different parts of the room, some time before the lesson is given.

The children then discover objects in the room illustrating the subject of the week, and the teacher selects one suitable for the class.

SUBJECT. — **Right-Angled Isosceles Triangles.**

Card No. 5, First Series.

.MONDAY.	TUESDAY.	WEDNESDAY.	THURSDAY.	FRIDAY.
Geometric.	Enlargement.	Memory.	Dictation.	Object.
		Lesson of Tuesday.		Bright colored stars.

When lines meet so as to make a square corner, they form a right angle.
A triangle has three sides and three angles.
A triangle which has a right angle is called a right-angled triangle.
A triangle which has two equal sides and two equal angles is called an isosceles triangle.
A right-angled triangle which has two equal sides and two equal angles is called a right-angled isosceles triangle.

MONDAY.

Right-Angled Isosceles Triangles. GEOMETRIC NAME. — The children select from a variety of triangles all the right-angled triangles which have two equal sides and two equal angles. A diagonal drawn on the face of a cube will give two right-angled isosceles triangles. The first line of illustrations on Card No. 5 will suggest illustrations for the board.

Busy Work for the Week.

As one exercise, give to each child four isosceles triangles of pasteboard, to be used in connection with splints to make a border or an arrangement about a centre. Remember to give the red splints for construction-lines whenever an arrangement about a centre is to be made.

TUESDAY.

Right-Angled Isosceles Triangles in a Square. ENLARGEMENT FROM CARD No. 5, FIG. 1. — Lead the children to discover the use of all the construction-lines, and to realize that the figure is built on the construction-lines.

DIRECTIONS FOR THE TEACHER. — Place points for a square, and draw it. — Sketch its diagonals. — Bisect its sides, and sketch its diameters. — Connect the ends of its diameters by drawing oblique lines, making a second square.

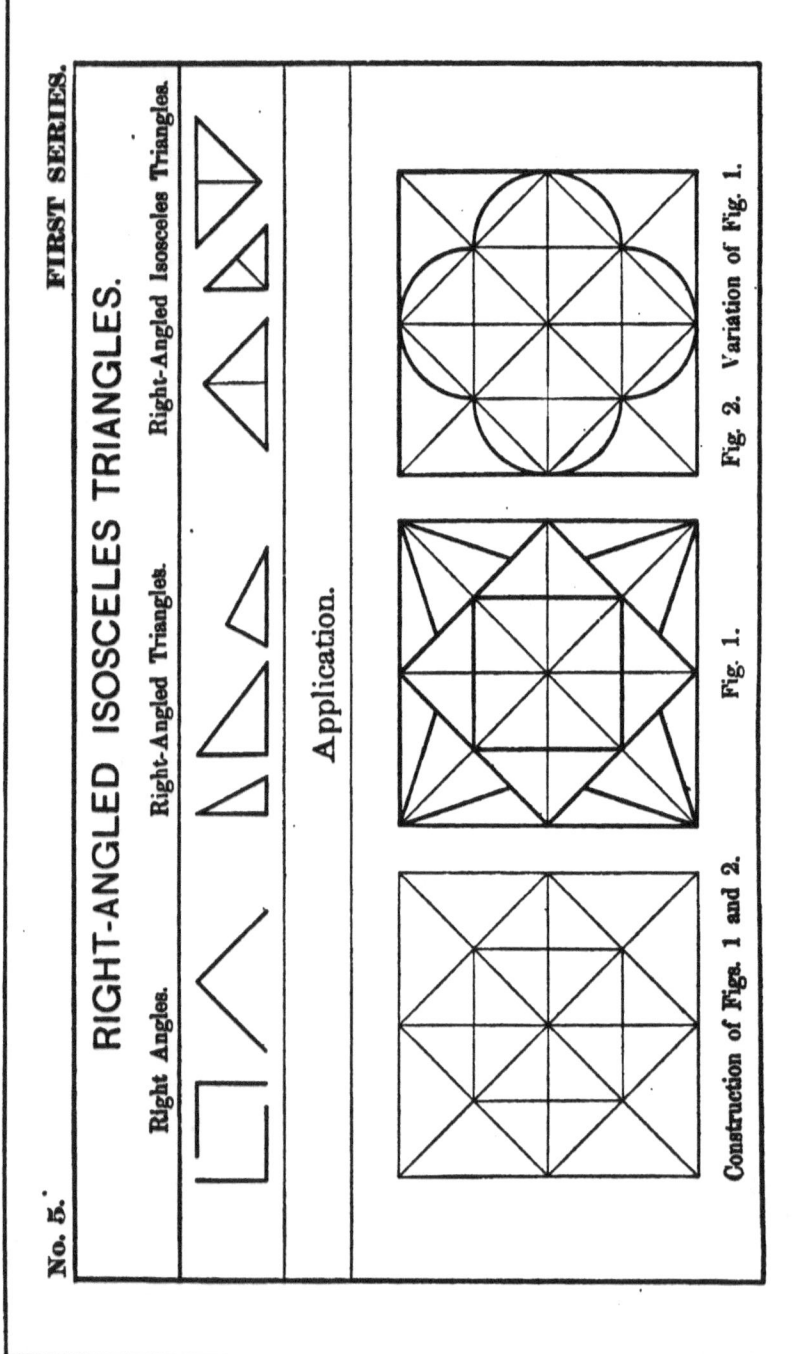

RIGHT-ANGLED ISOSCELES TRIANGLES.

— The sides of the second square are bisected by the diagonals of the first square. — Connect the points of bisection by **drawing** horizontal and vertical lines, making a third square. — Bisect each half of each side of the second square. — Connect each corner of the first square with the two points of bisection nearest it by **drawing** oblique lines.

DRILL FOR THE WEEK. — Isosceles triangles of various kinds and sizes.

Additional Work.

Quatrefoil in a Square. ENLARGEMENT FROM CARD NO. 5, FIG. 2. — A quatrefoil is an ornamental design made of four parts of circles, supposed to be a conventional representation of a four-petalled flower.

DIRECTIONS FOR THE TEACHER. — Place points for a square, and **draw it.** — **Sketch** its diameters and diagonals. — **Sketch** oblique lines connecting the ends of the diameters, making a second square. — The diagonals of the first square bisect the sides of the second square. — Connect the points of bisection by **sketching** horizontal and vertical lines, making a third square. — **Draw** a semi-circle curving outward on each side of the third square.

WEDNESDAY.

Lesson of Tuesday. Card No. 5, Fig. 1. Isosceles triangles in a square. FROM MEMORY.

THURSDAY.

Four-pointed Star. FROM DICTATION.

DIRECTIONS. — (Give directions in detail for **drawing** a square and **sketching** its diameters.) — Bisect the upper half of the light vertical. Bisect the left half of the light horizontal. **Draw** an oblique from the upper left corner of the square to each of the points of bisection. — (Give similar directions for the other points of the star.) — Strengthen that part of the light vertical within the star. — Strengthen that part of the light horizontal within the star.

Additional Work.

Original arrangements by the children based on the construction given on Card No. 5, the construction to be dictated to the children.

FRIDAY.

Bright-colored Stars. FROM THE OBJECT. — Directions for folding and cutting such stars will be found on pp. 90, 91.

Additional Work.

The children discover objects in the room illustrating the subject of the week, and the teacher selects one suitable for the class. The object must not only illustrate the subject of the week, but must also be very simple. The objects from which children are asked to draw should be chosen with as much care and discretion as the words which are given to them in their reading.

SUBJECT. — **Equilateral Triangle.**

Card No. 6, First Series.

MONDAY.	TUESDAY.	WEDNESDAY.	THURSDAY.	FRIDAY.
Geometric.	Enlargement.	Memory.	Dictation.	Object.
		Lesson of Tuesday.		Triangles of paper with open triangular centre.

A triangle which has three equal sides and three equal angles is called an equilateral triangle.

MONDAY.

Equilateral Triangle. GEOMETRIC NAME. From the triangular prism, from objects, from pasteboard triangles, from the board. — The children select from a variety of pasteboard triangles those which have three equal sides and angles. The teacher draws equilateral triangles on the board.

To construct an equilateral triangle, **draw** a line for the base, and bisect it; **sketch** a line perpendicular to the base at its centre. On this line fix a point which shall be as far from each end of the base as the length of the base; **draw** lines connecting this point with the ends of the base.

The teacher draws on the board the equilateral and isosceles triangles in a circle and in a square from the first line of illustrations on Card No. 6.

The children form equilateral triangles with sticks and peas, by laying sticks, and by drawing.

To give additional variety in forming figures, a cord with its two ends tied together is used. Three children take hold of the cord, each with one hand, and then, as requested by the teacher or any one of the class, hold it so as to form a right-angled triangle, an isosceles triangle, or an equilateral triangle.

Three points for the three angles of an equilateral triangle are fixed on the floor, and the children arrange themselves to form the sides of the triangle.

Children also form an equilateral triangle by folding according to the directions for Friday's work (p. 186).

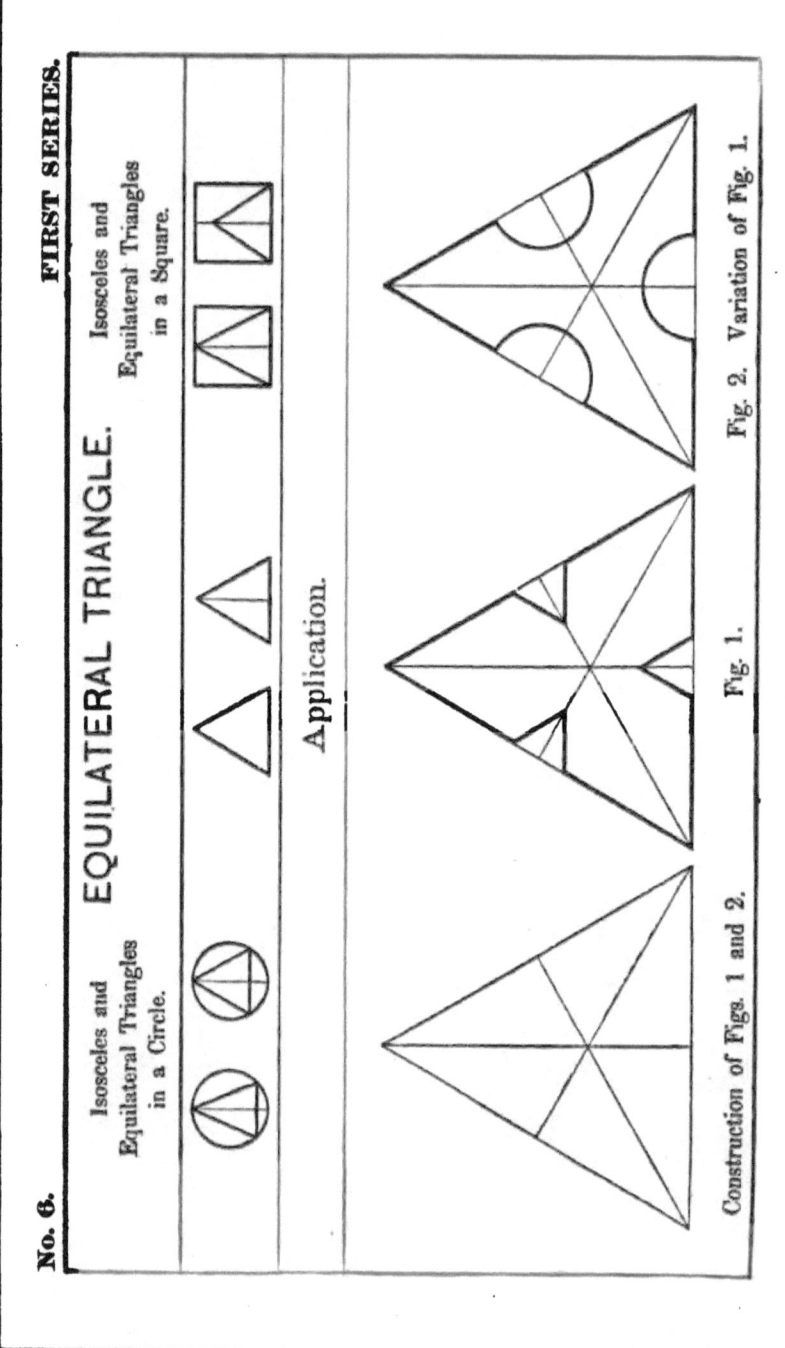

EQUILATERAL TRIANGLE.

Busy Work for the Week.

For some of the exercises, give out splints for an arrangement in an equilateral triangle, remembering that *three* red splints will be needed for construction-lines. Borders may be made of triangles. (See p. 231, Figs. D.)

TUESDAY.

Design based on an Equilateral Triangle. ENLARGEMENT FROM CARD NO. 6, FIG. 1. — It must not be expected that the children will make triangles which are really equilateral. If their work shows that they have endeavored to make the sides equal, it should be considered satisfactory.

DIRECTIONS FOR THE TEACHER. — Sketch a horizontal, and bisect it. — Sketch an indefinite line perpendicular to the horizontal at its centre. — On this line, place a point as far from each end of the horizontal as the length of the horizontal. — Sketch lines connecting this point with the ends of the horizontal. — Bisect each oblique side of the triangle. — Sketch lines to connect each point of bisection with the vertex of the angle opposite. — The three light lines within the triangle, the axes of symmetry, cross each other at the centre of the triangle; and each light line is thus divided into a long part and a short part. — Bisect each short part. — From each point of bisection, draw to the nearest side of the triangle two lines, each parallel to a side of the triangle. — Strengthen the outer parts of the sides of the triangle to meet the lines just drawn.

DRILL FOR THE WEEK. — In addition to the drill on lines, give exercises like the following: —

Draw a vertical three inches long. Using this line as one side, draw a right-angled triangle.

Draw a horizontal two inches long. On this line as a base, construct an isosceles triangle one inch high.

Draw a right-angled isosceles triangle.

Draw a horizontal four inches long. On this line as a base, construct an equilateral triangle.

Additional Work.

Design based on an Equilateral Triangle. ENLARGEMENT FROM CARD NO. 6, FIG. 2.

DIRECTIONS FOR THE TEACHER. — Sketch the construction-lines according to the directions for Fig. 1, bisecting the short part of each axis. — With half each short part as radius, and the centre of each side of the triangle as a centre, draw a semicircle curving inward. — Strengthen the outer parts of the sides of the triangle to meet the semicircles.

WEDNESDAY.

Lesson of Tuesday. Card No. 6, Fig. 1. Design based on an equilateral triangle. FROM MEMORY.

THURSDAY.

Trefoil Form. FROM DICTATION. — A trefoil is a figure having three leaves, and resembling a three-leaved clover. The figure given for dictation is one modification of the trefoil.

DIRECTIONS. — Place a point an inch from the left and lower sides of the slate. Four inches to the right, place another point. Sketch a horizontal connecting the points. — Bisect it. — Sketch an indefinite line perpendicular to the horizontal at its centre. — Place a point on the perpendicular as far from each end of the horizontal as the length of the horizontal; that is, four inches. — Sketch a line connecting the point with the left end of the horizontal. — Sketch a line connecting the point with the right end of the horizontal, thus making an equilateral triangle. — Bisect the left side of the triangle. Sketch a line from the point of bisection to the vertex of the opposite angle. (Give similar directions for the other axis.) — Bisect each half of the left side of the triangle. — Find the light oblique which touches the centre of the left side. — Extend it as far beyond the left side as one-fourth the side. — How many inches will you extend it? — Beginning at the lower point of division on the left side, draw a semicircle curving outward, passing through the end of the extended line, and ending at the upper point of division on the left side of the triangle. Pass your pencil over the points in the direction the semicircle should take before drawing the semicircle. — Strengthen that part of the side of the triangle above the semicircle. — Strengthen that part below the semicircle. — (Give similar directions for the other sides.)

Additional Work.

Original arrangements by the children based on the construction given on Card No. 6, the construction to be dictated to the children.

FRIDAY.

Triangles of Paper. FROM OBJECTS. — An equilateral triangle may be folded for cutting. Having a square of paper, fold it vertically through the centre. Open it, and fold it again so that one end of a horizontal side of the square will exactly touch the line made by the vertical fold. Mark the point where it touches, unfold, and, in order to be sure that the work is exact, fold again so that the other end of the same horizontal side of the square will exactly touch the line made by the vertical fold. See if it coincides with the point marked. This point is the vertex of the triangle, and the horizontal side is its base. Unfold and fold in the original vertical fold. Rule a line from the vertex to one end of the base, and cut along the ruled line. Opening it, an equilateral triangle appears, with the lines made by folding, crossing at the centre of the triangle. Fold in the original vertical fold, and make a horizontal cut (parallel to the base), beginning at the vertical fold, and ending at the oblique made by folding. Make a cut parallel to

EQUILATERAL TRIANGLE.

the oblique sides (which are folded together), to meet the cut just made. Unfold, and a triangle with an open triangular centre appears, which may be used as an object to be drawn. The construction must be carefully studied by the children.

Additional Work.

The children discover objects in the room illustrating the subject of the week; and the teacher decides on one suitable for the class, and gives it as a lesson.

It must be remembered, that, in the regular lessons in drawing from objects, it is expected that only two dimensions — the height and the width — will be represented; thus giving what is called a geometric view. If a teacher wishes to give children an opportunity to draw from objects, in such a way as to give a perspective effect and show the appearance of three dimensions, this opportunity may be given in "Busy Work."

CHAPTER II.

SQUARE AND ITS DIAGONALS.—SQUARE AND ITS DIAMETERS.—LINES TRISECTED.—SQUARE ON ITS DIAMETERS.—SQUARE ON ITS DIAGONALS.—OBLONG.

Remember that the whole week's work on a subject should be studied before any lesson is given on the subject.

SUBJECT.— **Square and its Diagonals.**

Card No. 7, First Series.

MONDAY.	TUESDAY.	WEDNESDAY.	THURSDAY.	FRIDAY.
Geometric.	Enlargement.	Memory.	Dictation.	Object.
		Lesson of Tuesday to cover surface.		Silk winder of paper or of ivory.

A square has four equal sides.
A square has four right angles.
Straight lines that connect the opposite angles of a square are called its diagonals.
A square has two diagonals.
The diagonals of a square are equal.
Half a diagonal is called a semi-diagonal.

NOTE.— Sentences like the above, which are directly below the scheme for a subject, are not given as a set form to be used by the teacher or children, but are given as "leading sentences," embodying the ideas to be developed or recalled in the minds of the children.

MONDAY.

Square and its Diagonals. GEOMETRIC NAMES. From a cube, from the base of a square prism, from objects, from the board. With sticks and peas, by laying sticks, by folding squares, by drawing.

Remember the order of the lesson,— Review, Observation, Term, Drill, Application, Drawing.

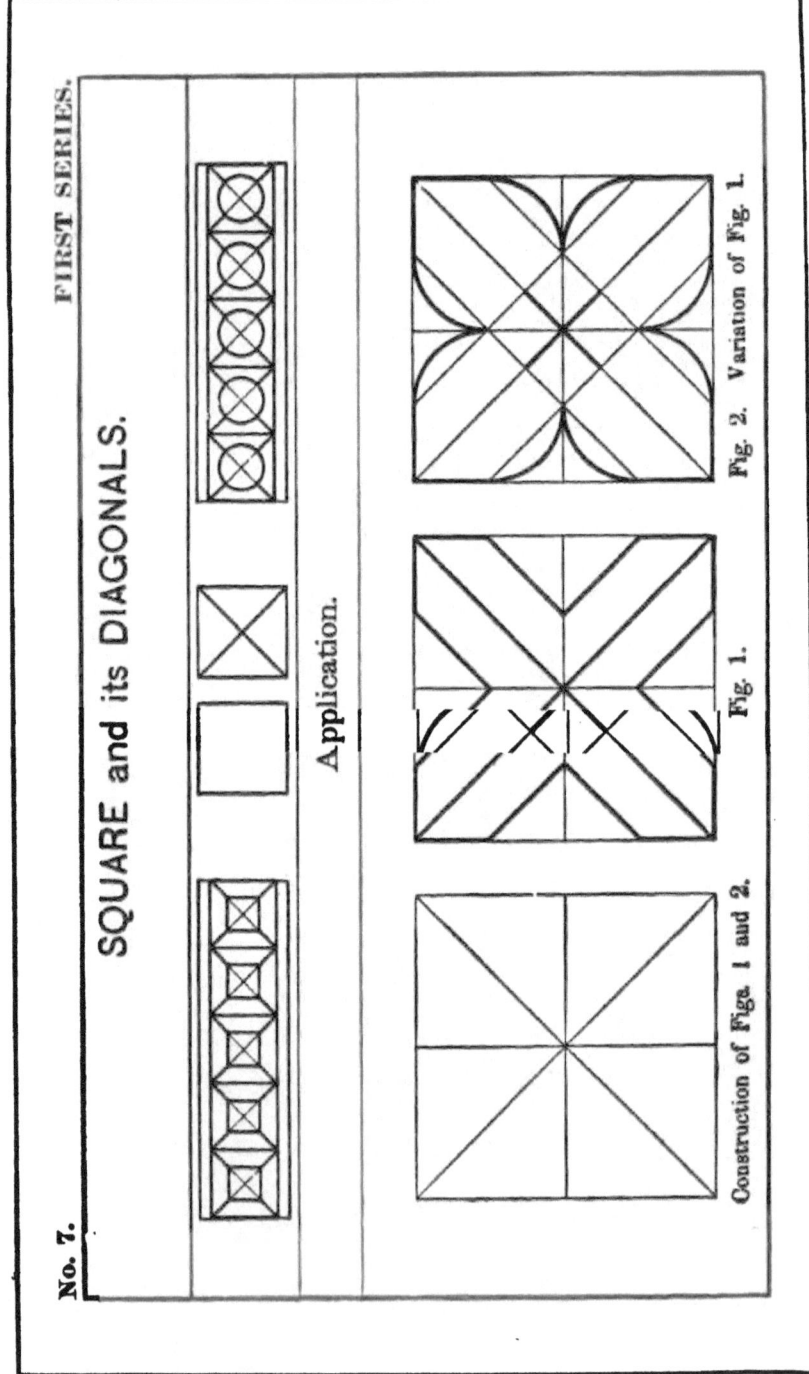

SQUARE AND ITS DIAGONALS. 141

Busy Work for the Week.

The cards may be given to the children to use in Busy Work. The children can copy the straight-line designs by laying splints, or they may lay splints to make designs of their own, based on the construction given on the card. They may also draw any figures on those cards which have been used in the previous lessons.

TUESDAY.

Oblique Cross. ENLARGEMENT FROM CARD No. 7, FIG. 1.

DIRECTIONS FOR THE TEACHER. — Place points for a square, and sketch it. — Draw its diagonals. — Bisect its sides, and sketch its diameters. — Bisect each semi-diameter and each half of each side. — Draw oblique lines connecting each point of bisection on the sides with the nearest point of bisection on a semi-diameter. — Strengthen the corners of the square between the obliques.

DRILL FOR THE WEEK. — The drill for the week should embrace exercises on the diagonals and semi-diagonals of a square, so that the children will draw readily at dictation the diagonal from the upper left corner to the lower right corner, and the diagonal from the upper right corner to the lower left corner; and will find without hesitation the upper left semi-diagonal, the lower left semi-diagonal, etc.

Additional Work.

Design in a Square. ENLARGEMENT FROM CARD No. 7, FIG. 2.

DIRECTIONS FOR THE TEACHER. — Follow the directions for the *construction* of Fig. 1. — Bisect each semi-diameter of the square, and each half of each side. — Sketch an oblique from each point of bisection on a side, through the points of bisection on two semi-diameters, to a point of bisection on an adjacent side. — A central square is formed by the crossing of these obliques. — From each point of bisection on a half-side, draw a quadrant (a quarter of a circle) curving outward to meet the nearest point of bisection on a semi-diameter. — Strengthen the corners of the square between the quadrants.

Horizontal Borders. ENLARGEMENT FROM CARD No. 7. — On Card No. 7 two horizontal borders will be found. The first border is made by a repetition of Fig. 1, Card No. 2. The unit of repetition, or unit of design (that is, the figure repeated), in the second border is a simple modification of the unit in the first border. The construction in both is the same. In the first border the points of bisection on the semi-diagonals of each square are connected by straight lines, thus forming a square; in the second border a circle passes through the points of bisection. It will be noted that marginal lines are added now to all the borders, thus producing greater completeness.

WEDNESDAY.

Surface Covering. From Dictation and Memory. — The children should draw a large square, divide it into four small squares, and draw in each small square the design of Fig. 1 from memory.

THURSDAY.

Design in a Square. From Dictation. — The dictation exercises may now be given a little less in detail.

Directions. — (Give directions for a square.) — Bisect each side of the square. Sketch a vertical connecting the points on the upper and lower sides. Sketch a horizontal connecting the points on the left and right sides. — Bisect each half of the left side of the square. — Bisect the left half of the light horizontal. — Draw a semicircle curving inward from the upper point on the left side, through the point on the light horizontal, to the lower point on the left side. — (Give similar directions for the other semicircles.) — Strengthen the corners of the square between the semicircles.

Additional Work.

Original arrangements by the children, based on the construction given on Card No. 7; the construction to be dictated to the children. Encourage simple arrangements made by few lines.

FRIDAY.

Silk-Winder of Paper or Ivory. From the Object. — This will probably be of similar form to that given in the dictation lesson of Thursday for a design in a square. It may be so placed that the diagonals of the square on which it is based will be horizontal and vertical. Lead the children to study out the necessary construction-lines.

Additional Work.

The children discover objects illustrating the subject of the week, and the teacher selects an object suitable for the class, from which the class draw.

SQUARE AND ITS DIAMETERS. 143

SUBJECT. — **Square and its Diameters.**

Card No. 8, First Series.

MONDAY.	TUESDAY.	WEDNESDAY.	THURSDAY.	FRIDAY
Geometric.	Enlargement.	Memory.	Dictation.	Object.
		Lesson of Tuesday.		Horizontal border from some object.

Straight lines that connect the centres of the opposite sides of a square are called its diameters.

A square has two diameters.

The diameters of a square are equal.
The diameters of a square are as long as its sides.
The diameters of a square are parallel to its sides.

Half a diameter is called a semi-diameter.

MONDAY.

Square and its Diameters. GEOMETRIC NAMES. — From a cube, from the base of a square prism, from objects, from the board. With sticks and peas, by laying sticks, by folding squares, by drawing.

Busy Work for the Week.

Among other exercises, the children should make with splints, designs based on the construction given on Card No. 8. When they have made a straight-line design with splints, they may draw it, substituting curved lines for one set of straight lines in the design which they have made.

TUESDAY.

Four-pointed Star and Concentric Squares. ENLARGEMENT FROM CARD NO. 8, FIG. 1.

DIRECTIONS FOR THE TEACHER. — Place points for a square, and draw it. — Bisect its sides, and sketch its diameters. — Sketch oblique lines to connect the ends of the diameters. — Draw oblique lines connecting each corner of the outer square with the two nearest points of bisection on the semi-diameters. — Strengthen the corners of the inner square that are outside the star. — Strengthen the two inner fourths of each diameter.

144 TEACHERS' PRIMARY MANUAL.

DRILL FOR THE WEEK. — The drill for the week should embrace exercises on the horizontal and vertical diameters of a square, and on the upper vertical semi-diameter, the lower vertical semi-diameter, the left horizontal semi-diameter, and the right horizontal semi-diameter.

Additional Work.

Concentric Circles. ENLARGEMENT FROM CARD No. 8, FIG. 2.

DIRECTIONS FOR THE TEACHER. — Place points for a square, and sketch it. — Bisect its sides, and sketch its diameters. — Draw a circle through the ends of the diameters. — Bisect the diameters. — Draw a circle through the points of bisection.

Horizontal Borders. ENLARGEMENT FROM CARD No. 8. — The first border is formed by the repetition of the figure given for dictation on p. 112. The unit of repetition in the second border is made by drawing a square, sketching its diameters, bisecting the diameters, and connecting the points of bisection by curves curving inward.

WEDNESDAY.

Lesson of Tuesday. Card No. 8, Fig. 1. Four-pointed Star and Concentric Squares. FROM MEMORY. — It is well to use the blackboard occasionally in the memory lesson. The figure to be drawn by the children from memory may be drawn upon the board by the teacher. After the children have had an opportunity to look at it a few minutes, the figure may be covered in some way, perhaps by dropping over it a map or chart which is rolled up above the figure. The children may then draw the figure from memory. After they have completed their work, the figure on the board may be uncovered. The children will then have an opportunity to see if they have reproduced the figure correctly.

THURSDAY.

Oblique Cross formed of Five Squares. FROM DICTATION.

DIRECTIONS. — (Give directions for sketching a square.) — Bisect its sides. — Sketch its vertical diameter. — Sketch its horizontal diameter. — Bisect each half of the upper side. — Bisect each half of the left side. — Bisect each half of the lower side. — Bisect each half of the right side. — Bisect each semi-diameter. — Draw an oblique connecting the two points nearest the upper left-hand corner. — Draw an oblique connecting the two points nearest the lower right-hand corner. — Draw an oblique connecting the upper ends of the short obliques just drawn. This oblique should pass through a point of bisection on each diameter. — Draw an oblique connecting the lower ends of the short obliques. This oblique should pass through a point of bisection on each diameter. — (Give similar directions for the other obliques.)

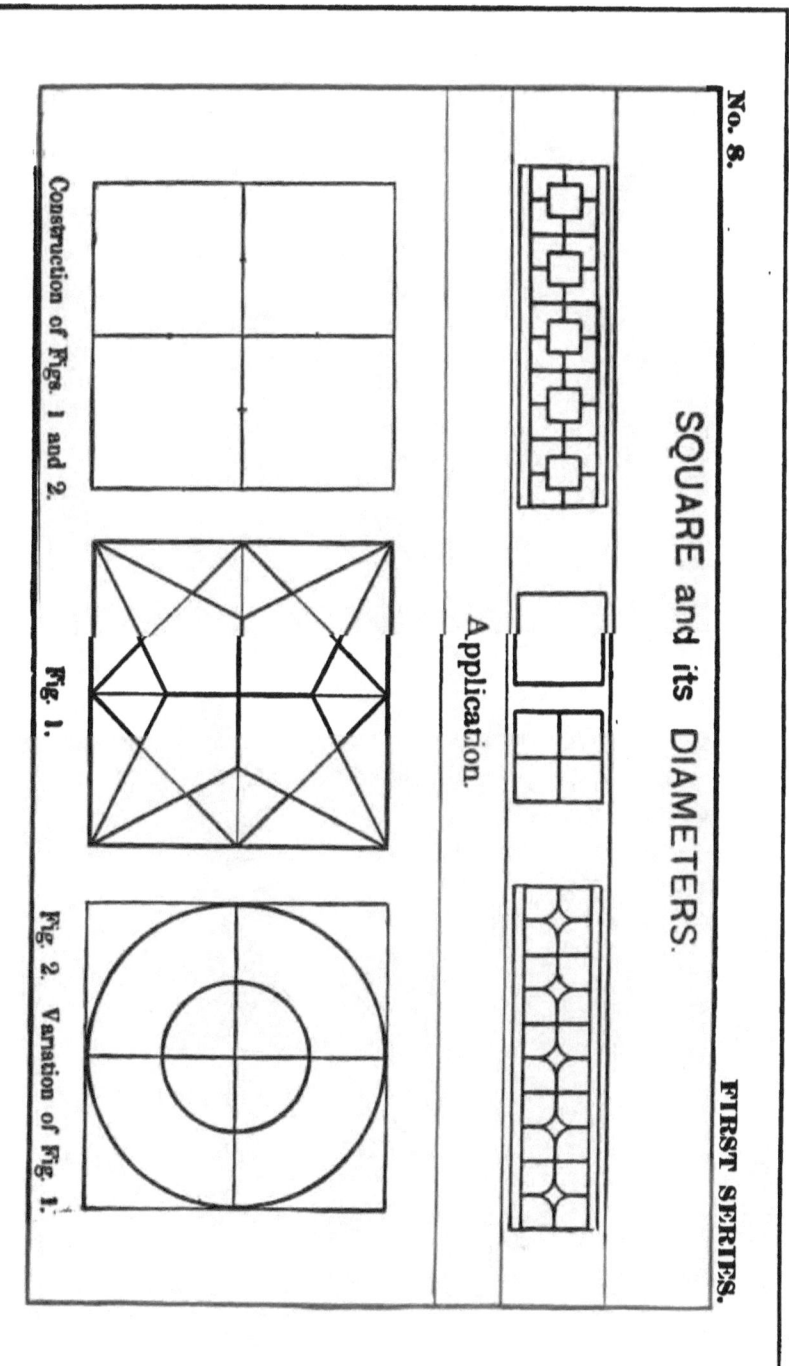

SQUARE AND ITS DIAMETERS. 147

Additional Work.

Original arrangements by the children, based on the construction given on Card No. 8; the construction to be dictated to the children.

FRIDAY.

Horizontal Border. FROM THE OBJECT. — A simple horizontal border may perhaps be found in the wall-paper, on a book-cover, on a dress or apron. If such a border can be found on the wall of the schoolroom, on the cover of a reading-book which is frequently used in the class, on the dress or apron of one of the children, the discovery of the border will make the lesson very interesting. But, if a border cannot be found on an object familiar to them, some examples must be brought into the class. Great care must be taken to have the border sufficiently simple, or the lesson will be a failure.

Additional Work.

The children discover objects illustrating the subject of the week, and the teacher selects from them an object suitable for the class, from which the class draw.

Subject. — Lines Trisected.

Card No. 9, First Series.

MONDAY.	TUESDAY.	WEDNESDAY.	THURSDAY.	FRIDAY.	
Geometric.	Enlargement.	Memory.	Dictation.	Object.	
			Lesson of Tuesday, oblique lines curved in.		Greek cross of paper or other material.

A vertical line is upright.
A horizontal line is level.
An oblique line inclines.
Lines are parallel to each other when they have the same direction, and are equally distant from each other at every point.
Learn to sketch lines when required; that is, to draw light lines.
When light lines are not required, draw a medium line.
Never draw a line with such force as to scratch the slate.
Two marks on a line divide the line into three parts.
Two marks on a line which are at equal distances from each other and from the ends of the line divide the line into three equal parts, or thirds; that is, trisect it.

MONDAY.

Lines Trisected. GEOMETRIC TERM. — Splints and slender sticks, marked and broken into three equal parts. Straight lines drawn and trisected.

Busy Work for the Week.

The children should lay splints, making figures based on the construction given on Card No. 9. It will be necessary, however, for the teacher to notice the character and number of the construction-lines before giving out the splints.

TUESDAY.

Cross, with Right, Acute, and Obtuse Angles. ENLARGEMENT FROM CARD NO. 9, FIG. 1.

DIRECTIONS FOR THE TEACHER. — Place points for a square, and sketch it. — Trisect each of its sides. — Sketch horizontal and vertical lines connecting the points of trisection. — Bisect each side of the central square. — From the two points of trisection on each side of the outer square, draw straight

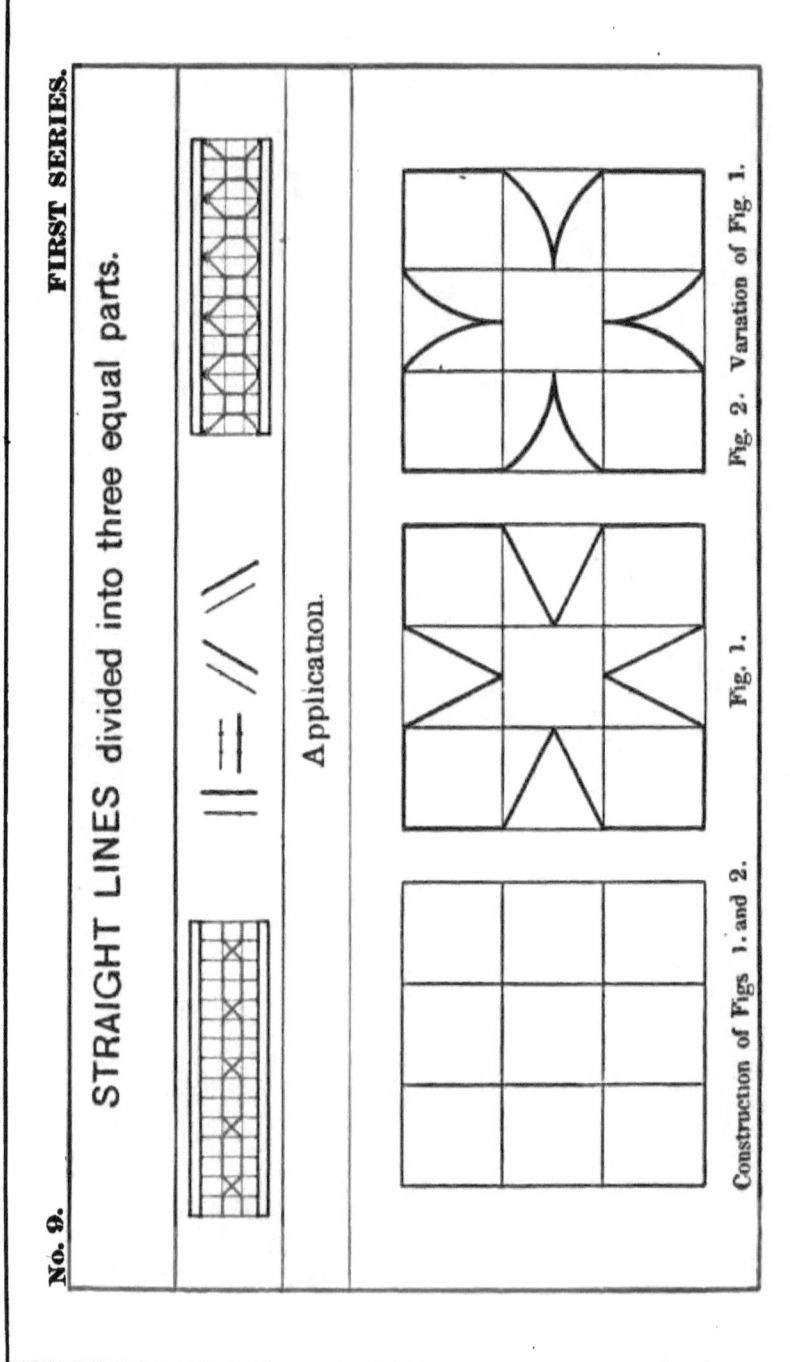

LINES TRISECTED.

oblique lines to the point of bisection on the nearest side of the inner square. — Strengthen the corners of the outer square between the obliques.

DRILL FOR THE WEEK. — The drill should be given in the work in which the children need practice.

Additional Work.

Design in a Square. ENLARGEMENT FROM CARD NO. 9, FIG. 2. — Curved lines curving outward are substituted for the straight oblique lines of Fig. 1.

Horizontal Borders. ENLARGEMENT FROM CARD NO. 9. — Both borders are based on squares divided into nine small squares. In the first border the diagonals of the central square are drawn, and the upper and lower sides of the square on each side of the central square are strengthened. In the second border the sides of the central square are strengthened, and one diagonal of each corner square is drawn to meet a corner of the central square.

WEDNESDAY.

Design in a Square. FROM DICTATION AND MEMORY. — Draw from memory the cross given on Tuesday, with this change: make the straight oblique lines curved lines curving inward.

THURSDAY.

Greek Cross. FROM DICTATION.

DIRECTIONS. — (Give directions for sketching a square.) — Trisect the upper and lower sides. Connect the points of trisection by sketching verticals. — Trisect the right and left sides. Connect the points of trisection by sketching horizontals. — Find the central square of the three upper small squares. — Strengthen its upper side; its left side; its right side. — (Give similar directions for the other arms of the cross.)

Additional Work.

Original arrangements by the children, based on the construction given on Card No. 9, which should be dictated to the children.

FRIDAY.

Greek Cross. FROM THE OBJECT. — If a Greek cross cannot be procured, one may be cut from paper.

Additional Work.

The children discover objects illustrating the subject of the week, and the teacher selects one suitable for the class.

SUBJECT. — **Square on Its Diameters.**

Card No. 10, First Series.

MONDAY.	TUESDAY.	WEDNESDAY.	THURSDAY.	FRIDAY.
Geometric.	Enlargement.	Memory.	Dictation.	Object.
		Lesson of Tuesday in vertical border.		Maltese cross.

A square has four equal sides.
A square has four equal angles.
Straight lines that connect the centres of the opposite sides of a square are called its diameters.
A square has two diameters.
When the diameters of a square are vertical and horizontal, the square is called a square on its diameters.
The diameters of a square are as long as its sides.
The diameters of a square are parallel to its sides.
The diameters of a square may be drawn first, and the sides of the square may then be drawn through the ends of the diameters.
When the diameters of a square are drawn first, and the sides afterward, the square is said to be drawn on its diameters.
Each corner of a square is directly opposite the nearest ends of the two diameters.

MONDAY.

Square on its Diameters. GEOMETRIC TERM. — From the cube and square prism. By laying sticks and splints, and by drawing.

Busy Work for the Week.

As one exercise the children should make squares from splints, laying the diameters first, and then the sides of the square.

TUESDAY.

Design in a Square. ENLARGEMENT FROM CARD No. 10, FIG. 1.

DIRECTIONS FOR THE TEACHER. — Place points for a horizontal, and sketch it. — Bisect the horizontal. — Above and below the horizontal, place points for

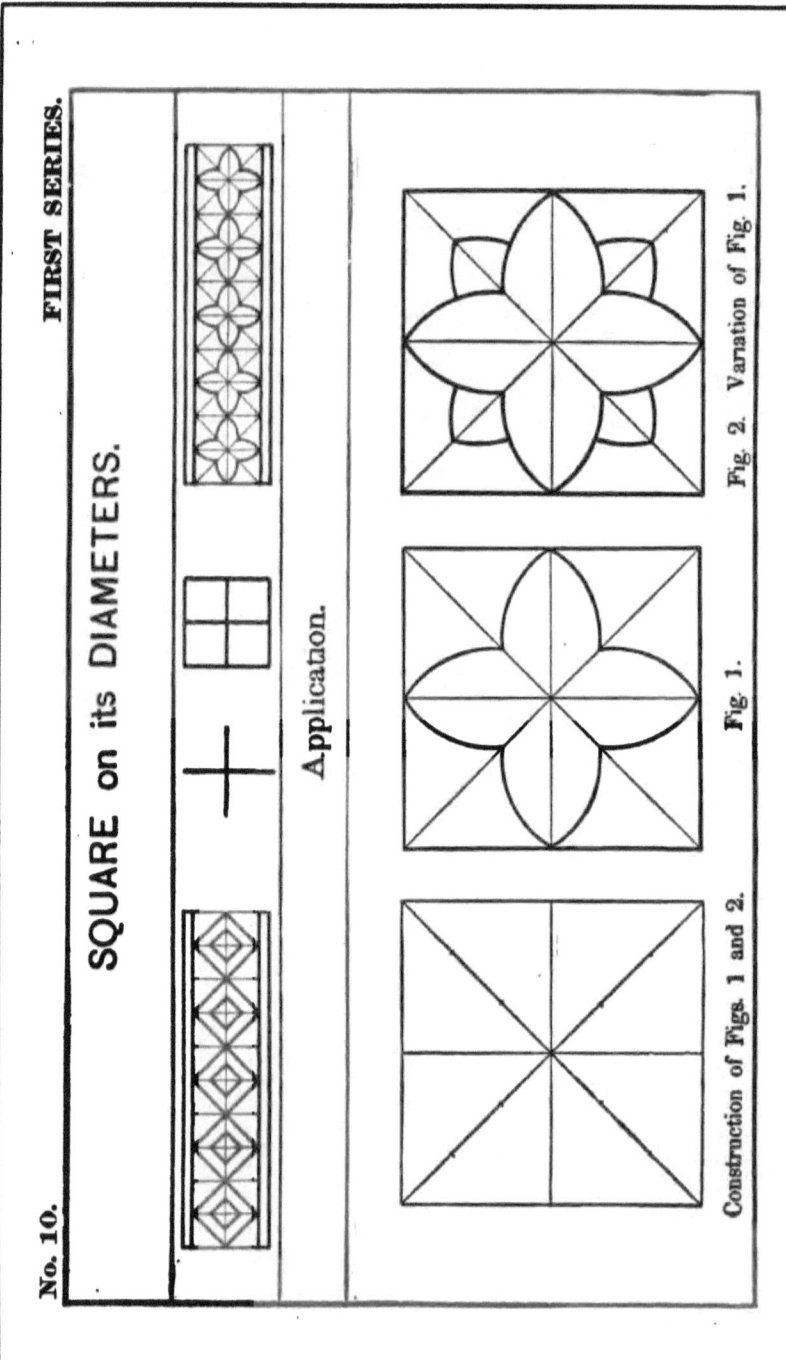

SQUARE ON ITS DIAMETERS. 155

a vertical equal in length to the horizontal, and sketch it. — These lines are for the diameters of a square. — Place points for the corners of the square opposite the ends of the diameters, and **draw** the square. — **Sketch** the diagonals. — Trisect each semi-diagonal. — From each end of each diameter, draw curves curving outward to the two nearest inner points of trisection. — The inner points of trisection are the points nearest the centre of the square.

DRILL FOR THE WEEK. — Exercises should be given in drawing a square and its diameters, and a square on its diameters. These should be alternated and repeated until the children recognize at once the method of drawing the square from the words.

Additional Work.

Design in a Square. ENLARGEMENT FROM CARD No. 10, FIG. 2.

DIRECTIONS FOR THE TEACHER. — Follow the directions for Fig. 1. — From each outer point of trisection on the semi-diagonals, **draw** curves curving outward to meet the two nearest curves at points a little nearer the inner than the outer end.

Horizontal Borders. ENLARGEMENT FROM CARD No. 10. — The borders given are horizontal, but they may be drawn vertically if the teacher desires variety. In the first border the design in a square given on p. 118 is used as a unit; in the second border the design of Fig. 1, Card No. 10, is used.

WEDNESDAY.

Vertical Border. FROM MEMORY. — The children should draw a vertical border, using as a unit the design of Fig. 1, Card No. 10, drawing from memory.

THURSDAY.

Design in a Square. FROM DICTATION.

DIRECTIONS. — Place a point an inch to the right of the centre of the left side of the slate. Four inches to the right of this, place a point. **Sketch** a horizontal to connect the points. — Bisect the horizontal. As far above the centre as half the horizontal, place a point. As far below the centre as half the horizontal, place a point. — **Sketch** a vertical to connect the points. — Place a point so that it shall be directly above the left end of the horizontal and directly to the left of the upper end of the vertical. — Place a point so that it shall be directly below the left end of the horizontal and directly to the left of the lower end of the vertical. — Place a point so that it shall be directly above the right end of the vertical and directly to the right of the upper end of the vertical. — Place a point so that it shall be directly below the right end of the horizontal and directly to the right of the lower end of the vertical. — These are points for the four corners of a square. — **Sketch** the upper side of the square. — **Sketch** the left side. —

Sketch the right side. — **Sketch** the lower side. — **Sketch** the diagonal from the upper left to the lower right corner. — **Sketch** the diagonal from the upper right to the lower left corner. — **Draw** a curve curving inward from the upper end of the vertical diameter to the left end of the horizontal diameter. — (Give similar directions for the other curves.)

Additional Work.

Original arrangements by the children, based on the construction given on Card No. 10; the construction to be dictated to the children by the teacher.

FRIDAY.

Maltese Cross. FROM THE OBJECT. — If it is not possible to obtain a Maltese cross, one may be cut from paper. To cut a Maltese cross having the proportions of the one illustrated, fold a square of paper along its diameters, so as to make a fourfold square. Fold the fourfold square along the diagonal that would run from the corner between the folded sides to the corner between the unfolded sides. Trisect the diagonal, and bisect the unfolded edges. Cut from the bisection to the inner point of trisection; that is, the point of trisection nearest the centre of the original square. Unfold, and a Maltese cross will appear. Lead the children to seek for its construction. Make the cross large, so that it can be seen by all pupils.

Additional Work.

The children discover objects illustrating the subject of the week, and the teacher selects one suitable for the class.

Subject. — **Square on its Diagonals.**

Card No. 11, First Series.

MONDAY.	TUESDAY.	WEDNESDAY.	THURSDAY.	FRIDAY.
Geometric.	Enlargement.	Memory.	Dictation.	Object.
		Lesson of Tuesday to cover four squares.		Vertical border from some object.

Lines that connect the opposite angles of a square are called its diagonals.
A square has two diagonals.
The diagonals of a square are equal.
When a square is so placed that its diagonals are horizontal and vertical, it is called a square on its diagonals.
The diagonals of a square so placed should be drawn first, and then its sides, connecting the ends of the diagonals.
When the diagonals of a square are drawn first, and the sides afterwards, the square is said to be drawn on its diagonals.

MONDAY.

Square on its Diagonals. GEOMETRIC TERM. — From the cube and square prism. By laying sticks and splints, and by drawing.

Busy Work for the Week.

The squares made with splints in the Busy Work this week should be made by laying the diagonals first.

TUESDAY.

Cross with Pointed Ends. ENLARGEMENT FROM CARD No. 11, FIG. 1.

DIRECTIONS FOR THE TEACHER. — Place points for a horizontal and a vertical of equal length and intersecting at their centres, and sketch the lines. — Connect their ends by sketching obliques, thus making a square on its diagonals. — Quadrisect its sides. — Sketch its diameters. — Bisect each semi-diameter. — From each point of quadrisection, draw a straight line to the nearest point of bisection. — Strengthen the corners of the square between the lines just drawn.

DRILL FOR THE WEEK. — The children should be drilled in drawing a square and its diagonals, and a square on its diagonals, until the distinction between the two is perfectly clear to them, and is recognized at once by them.

Additional Work.

Square within a Quatrefoil. ENLARGEMENT FROM CARD NO. 11, FIG. 2.

DIRECTIONS FOR THE TEACHER. — Sketch a square on its diagonals. — Sketch its diameters. — Sketch straight lines connecting the ends of its diameters. — Connect the centres of these lines by **drawing** obliques, making a square on its diagonals. — Connect the centres of the adjacent sides of the outer square by **drawing** semicircles curving outward, and touching the corners of the outer square.

Horizontal Borders. ENLARGEMENT FROM CARD NO. 11. — The first is formed by the repetition of a unit composed of four concentric squares. The second border is based on the dictation lesson on p. 155.

DIRECTIONS FOR THE TEACHER FOR THE UNIT OF THE FIRST BORDER. — Sketch a square. — Sketch its diagonals and diameters. — **Draw** obliques connecting the ends of the diameters, making a square on its diagonals. — Bisect the outer half of each semi-diagonal. — Sketch horizontals and verticals connecting the points of bisection. — Strengthen those parts of these lines which are outside the square on its diagonals. — Trisect the diameters of the outer square. — Connect the inner points of bisection by **drawing** obliques.

DIRECTIONS FOR THE TEACHER FOR THE UNIT OF THE SECOND BORDER. — Sketch a square, its diagonals and diameters. — Connect the ends of its diameters by **drawing** curves curving inward. — Bisect each semi-diameter. — Connect the points of bisection by **drawing** curves curving inward. — Strengthen those parts of the diagonals outside the curves.

WEDNESDAY.

Surface Covering. FROM MEMORY. — The children should draw a large square, and divide it into four small squares, drawing in each small square the design of Fig. 1 from memory.

THURSDAY.

Design based on a Square on its Diagonals. FROM DICTATION.

DIRECTIONS. — Place a point an inch to the right of the centre of the left side of the slate. Four inches to the right of this, place a point. Sketch a horizontal to connect the points. — Bisect the horizontal. — As far above the centre as half the horizontal, place a point. As far below the centre as half the horizontal, place a point. Sketch a vertical connecting the

No. 11.

SQUARE on its DIAGONALS.

FIRST SERIES.

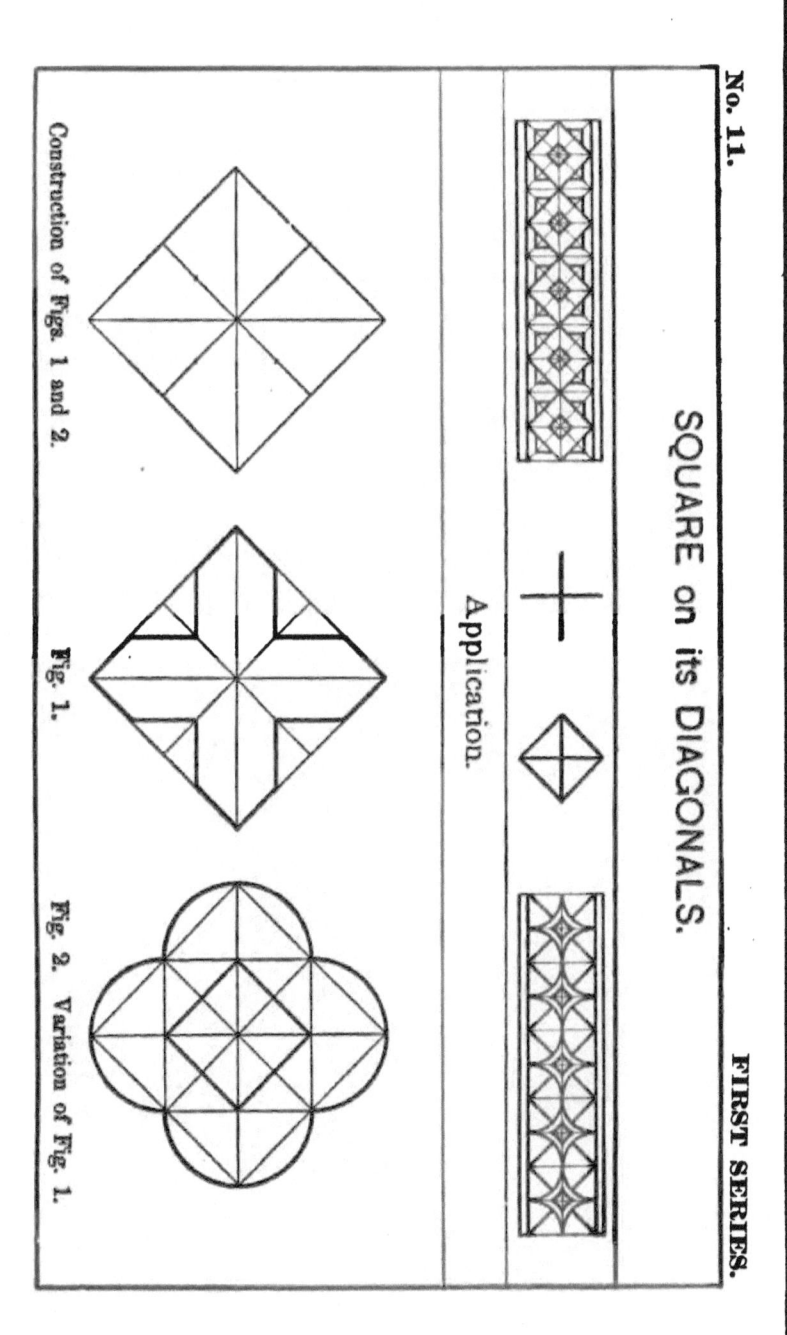

Construction of Figs. 1 and 2. Fig. 1. Fig. 2. Variation of Fig. 1.

Application.

SQUARE ON ITS DIAGONALS.

points. — These lines are the diagonals of a square. **Sketch** lines connecting the ends of these lines, making a square on its diagonals. — Bisect the upper left side of the square. Bisect the lower right side. **Sketch** an oblique connecting the points of bisection. — What is the name of this line? — Bisect the other two sides of the square. **Sketch** an oblique connecting the points of bisection. — What is the name of this line? — How many semi-diameters has the square? — Bisect each semi-diameter. — How many half-sides has the square? — Bisect each half-side. — On the upper left side of the square, from the upper to the lower points of bisection, draw a semicircle curving inward. The semicircle should pass through the point of bisection on the nearest semi-diameter. — (Give similar directions for the other semicircles.) — Strengthen the corners of the square between the semicircles.

Additional Work.

Original arrangements by the children, based on the construction given on Card No. 11; the construction to be dictated to the children.

FRIDAY.

Vertical Border. FROM THE OBJECT. — Find, if possible, in the room a simple vertical border, the unit of which is easily constructed.

Additional Work.

The children discover objects illustrating the subject of the week, and the teacher selects one suitable for the class.

162 TEACHERS' PRIMARY MANUAL.

SUBJECT. — **The Oblong.**

Card No. 12, First Series.

MONDAY.	TUESDAY.	WEDNESDAY.	THURSDAY.	FRIDAY.
Geometric.	Enlargement.	Memory.	Dictation.	Object.
		Lesson of Tuesday.		A slate.

A square has four right angles.
An oblong has four right angles.

A square has four sides.
An oblong has four sides.

A square has four equal sides.
An oblong has two long sides and two short sides.
An oblong has only its opposite sides equal.

An oblong may be vertical, horizontal, or oblique.

MONDAY.

Oblong. GEOMETRIC TERM. — From the triangular and square prism, and from objects. By laying sticks and splints, by the use of sticks and peas, by drawing.

Busy Work for the Week.

In the Busy Work the children must be reminded to make the angles of oblongs right angles. Borders may be made of squares and oblongs. (See p. 231, Figs. E.)

TUESDAY.

Oblong Frame. ENLARGEMENT FROM CARD NO. 12, FIG. 1.

DIRECTIONS FOR THE TEACHER. — Place points for a vertical, and draw it. — Trisect the vertical. — As far to the right of the upper end of the vertical as two-thirds its length, place a point. — Directly below this point, and directly to the right of the lower end of the vertical, place a point. — These points are for the upper and lower right corners of an oblong. Complete the oblong. — Bisect its sides, and sketch its diameters. — Trisect each half of the upper and lower sides. — From the outer points of trisection, draw

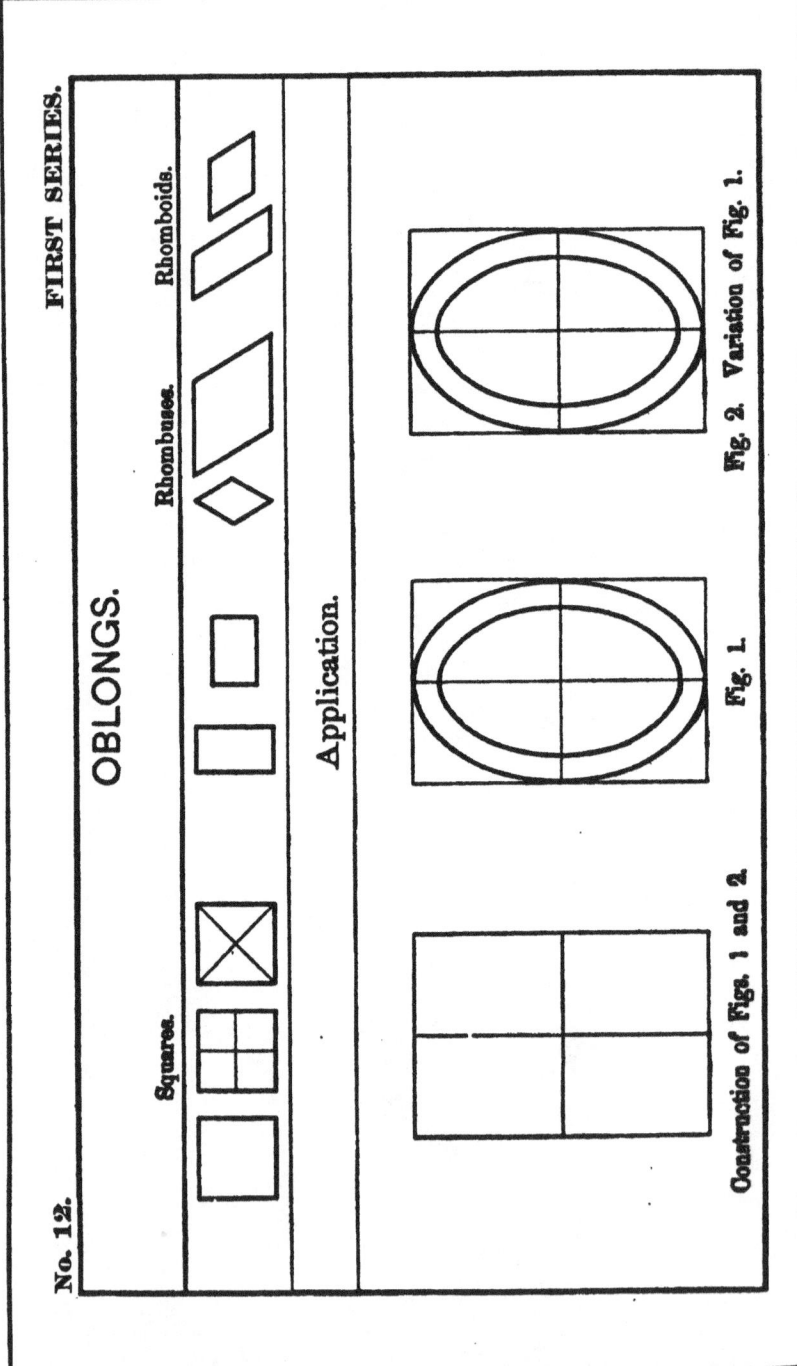

OBLONG.

verticals to the corresponding points on the lower side. — Mark off, from the upper and lower ends of the vertical sides of the oblong, a space equal to one-sixth the horizontal, which has been already obtained by trisection. — Connect these points by drawing horizontals. — Draw the diagonals of the squares at the corners of the oblong. — Strengthen the ends of the diameters, as seen on the card.

DRILL FOR THE WEEK. — The drill for this week should be mainly on proportion, drawing oblongs the proportion of whose sides is stated, and judging of the proportion of the sides of paper oblongs or of oblongs in objects.

Additional Work.

Elliptical Frame. ENLARGEMENT FROM CARD No. 12, FIG. 2. — Induce the children to observe the curve, and lead them to discover that it differs from the curves that they have had heretofore.

DIRECTIONS FOR THE TEACHER. — Place points for a vertical oblong two-thirds as wide as it is high, and sketch the oblong. — Bisect its sides, and sketch its diameters. — Trisect each horizontal semi-diameter. — Mark off from each end of the vertical diameter a space equal to one-sixth the horizontal diameter. — Through the ends of the diameters, **draw** an ellipse, imitating the curve of the copy. — Through the points nearest the ends of the diameters, **draw a** second ellipse, imitating the copy.

Rhombuses and Rhomboids. ENLARGEMENT FROM THE CARD. — A lesson may be given on these figures from the card, and from the board, if the teacher desires.

A rhombus has four sides.
A rhombus has four equal sides.
A rhombus has no right angles.

A rhomboid has four sides.
A rhomboid has two long sides and two short sides.
A rhomboid has only its opposite sides equal.
A rhomboid has no right angles.

WEDNESDAY.

Lesson of Tuesday. Card No. 12, Fig. 1. Oblong Frame. FROM MEMORY.

THURSDAY.

Two Oblique Oblongs crossing Each Other. FROM DICTATION.

DIRECTIONS. — (Give directions for **sketching** a square and dividing it into nine small squares by trisecting its sides, and **sketching** horizontals and verticals to connect the points of trisection.) — Find the upper left square. **Draw** the diagonal of this square from the upper right corner to the

lower left corner. — Find the lower right square. — **Draw** the diagonal from the upper right corner to the lower left corner. — Connect the upper ends of these diagonals by **drawing** an oblique. — Connect the lower ends of these diagonals by **drawing** an oblique. — (Give similar directions for the other oblong.)

Additional Work.

Original arrangements by the children, based on the construction given on Card No. 11, to be dictated to them by the teacher.

FRIDAY.

Slate. FROM THE OBJECT. — The slate with its frame may be drawn, the proportion between the width of the frame and the width of the slate being carefully observed.

Additional Work.

The children discover objects illustrating the subject of the week, and the teacher selects one suitable for the class. (See p. 233, Fig. 2.)

CHAPTER III.

CIRCLE AND ITS DIAMETERS. — CIRCLE INSCRIBED IN A SQUARE. — UNION OF LINES. — ELLIPSES. — ELLIPSES AND CIRCLES. — OVALS.

Remember that the whole week's work on a subject should be studied before any lesson is given on the subject.

SUBJECT. — **Circle and its Diameters.**

Card No. 1, Second Series.

MONDAY.	TUESDAY.	WEDNESDAY.	THURSDAY.	FRIDAY.
Geometric.	Enlargement.	Memory.	Dictation.	Object.
		Lesson of Tuesday.		Plate.

A circle is perfectly round.
The outline of a circle is called a circumference.
Every part of a circumference is equally distant from the centre of the circle.
A diameter of a circle passes from any point in the circumference through the centre of the circle to the opposite point in the circumference.
A circle has many diameters.
The diameters of a circle are all equal.
The diameters of a circle may be drawn first, and the circumference afterward.
When the diameters are drawn first and the circumference afterward, the circle is said to be drawn on its diameters.
A radius is a straight line from the centre to the circumference of a circle.
A radius is half a diameter.
When more than one radius is spoken of, the word "radii" is used.
A circle has many radii.

NOTE. — Sentences like the above, which are directly below the scheme for a subject, are not given as a set form to be used by the teacher or children, but are given as "leading sentences," embodying the ideas to be developed or recalled in the minds of the children.

MONDAY.

Circle and its Diameters. GEOMETRIC NAMES. — From the cylinder and hemisphere and from objects. From a large circle of pasteboard, having a string through the centre, knotted at the end to prevent its slipping through, by which the distance from centre to circumference may be measured at various parts of the circumference. From a large circle of pasteboard, having the centre marked so that the children may rule diameters through it, and measure them. From the blackboard, and by drawing.

Remember the order of the lesson, — Review, Observation, Term, Drill, Application, Drawing.

Busy Work for the Week.

Large circles cut from paper or cardboard may now be given to the children in addition to the splints. A design may be formed by laying the splints on the paper circle. The teacher is recommended to look over the suggestions for Busy Work given in previous chapters.

TUESDAY.

Concentric Circles. ENLARGEMENT FROM CARD NO. 1, FIG. 1. — Circles which have a common centre are called concentric circles. The curves of concentric circles are always parallel to each other. The construction given on the card shows that the circles of Fig. 1 are to be drawn on their diameters.

DIRECTIONS FOR THE TEACHER. — Place points for a horizontal and a vertical equal in length, and intersecting at their centres, and sketch them. — Draw a circle through the ends of these lines. — Bisect each semi-diameter. — Through the points of bisection, draw a circle.

DRILL FOR THE WEEK. — Concentric circles.

Additional Work.

Clock-Face. FROM CARD NO. 1, FIG. 2. — Lead the children to observe that the numerals all point toward the centre.

DIRECTIONS FOR THE TEACHER. — Place points for the horizontal and vertical diameters of a circle, and sketch them. — Draw a circle through the ends of the diameters. — Bisect each semi-diameter. — Bisect the outer half of each semi-diameter. — Through the outer points of bisection, draw a circle. — Trisect each quarter of the outer circumference. — From each point on one-half of the circumference, sketch a diameter to the opposite point. — Imitate the hands and numerals.

In addition to the above, semicircle and quadrant, as shown on the upper line of illustrations on the card, may be given.

A semicircle is half a circle.
A quadrant is a quarter of a circle.

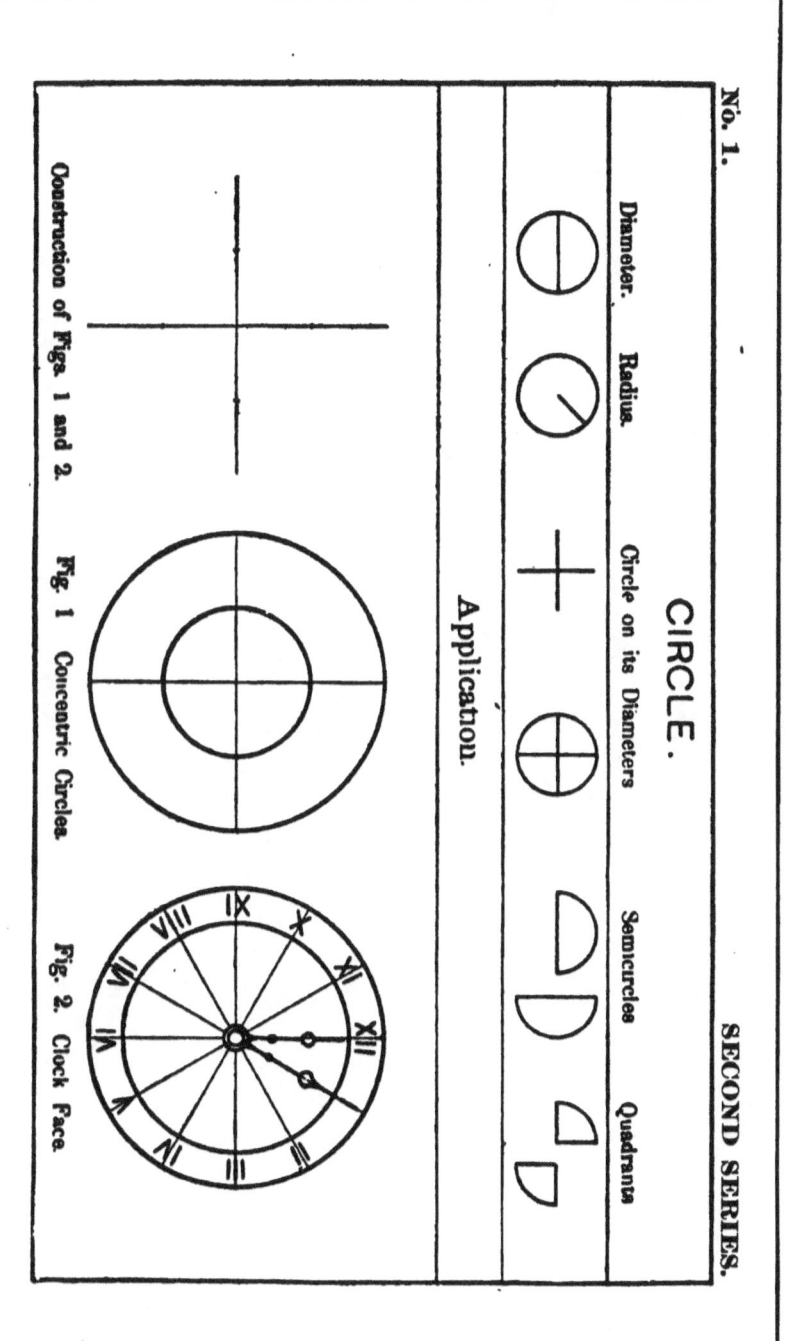

WEDNESDAY.

Lesson of Tuesday. Card No. 1, Fig. 1. Concentric Circles. FROM MEMORY.

THURSDAY.

Four-pointed Star and Squares in a Circle. FROM DICTATION AND THE BLACKBOARD. — This exercise gives an opportunity for constructing a square on its diameters. The figure should be given according to the first method of dictation, p. 15.

DIRECTIONS. — Place a point an inch to the right of the centre of the left side of the slate. Four inches to the right of this, place a point. Sketch a horizontal to connect the points. — Bisect the horizontal. As far above the centre as half the horizontal, place a point. As far below the centre as half the horizontal, place a point. Sketch a vertical to connect the points. — These lines are to be used as the diameters of a circle. — Draw the circle through the ends of the diameters. — Bisect each semi-diameter. — The two inner fourths of each diameter are to be used as the diameters of a square. — Who can tell what to do? — Place a point for the upper left corner of the square. Place a point for the lower left corner of the square. Connect the points by drawing a vertical. — (Give similar directions for the other sides of the square.) — Trisect the upper side of the square. — Draw an oblique from the upper end of the vertical diameter of the circle to each point of trisection. — What kind of a triangle have you? — (Give similar directions for the other isosceles triangles.)

Additional Work.

Original arrangements by the children, based on the construction given on Card No. 1; the construction to be dictated to the children.

FRIDAY.

Plate. FROM THE OBJECT. — The rim of a plate furnishes two concentric circles. A plate may perhaps be chosen which has a third circle in color. Lead the children to discover the proportion between the diameters of the different circles.

Additional Work.

Children discover objects in the room which illustrate the subject of the week, and the teacher selects one suitable for the class.

SUBJECT. — **Circles inscribed in a Square.**

Card No. 2, Second Series.

MONDAY.	TUESDAY.	WEDNESDAY.	THURSDAY.	FRIDAY.
Geometric.	Enlargement.	Memory.	Dictation.	Object.
		Lesson of Tuesday, horizontal border.		Clock face.

A circle may be within a square, and not touch it.
A circle may be within a square, and touch it at one point.
A circle may be within a square, and touch it at two points.
A circle may be within a square, and touch it at four points.
When a circle is within a square, and touches it at four points (at the ends of the diameters of the square), the circle is said to be inscribed in the square.
When a circle is inscribed in a square, the diameters of the square are also diameters of the circle.

MONDAY.

Circle Inscribed in a Square. GEOMETRIC TERM. — From the cube or the square prism, and circles of pasteboard of various sizes to show that circles may be within the square and touch it at only one or two points. Such circles are not said to be inscribed in the square. From the cube and square prism, and circles of pasteboard whose diameters are equal in length to the diameters of the faces of the cube, and to those of the bases of the square prism; the circles being applied to the faces of the cube and the bases of the square prism to show a circle inscribed in a square. From the blackboard. By laying sticks and circles, and by drawing.

Busy Work for the Week.

A square must first be laid with splints, which are of the same length as the diameters of the paper or pasteboard circle. The circle may then be laid within the square, the red splints added for construction-lines, and white splints used to complete a design.

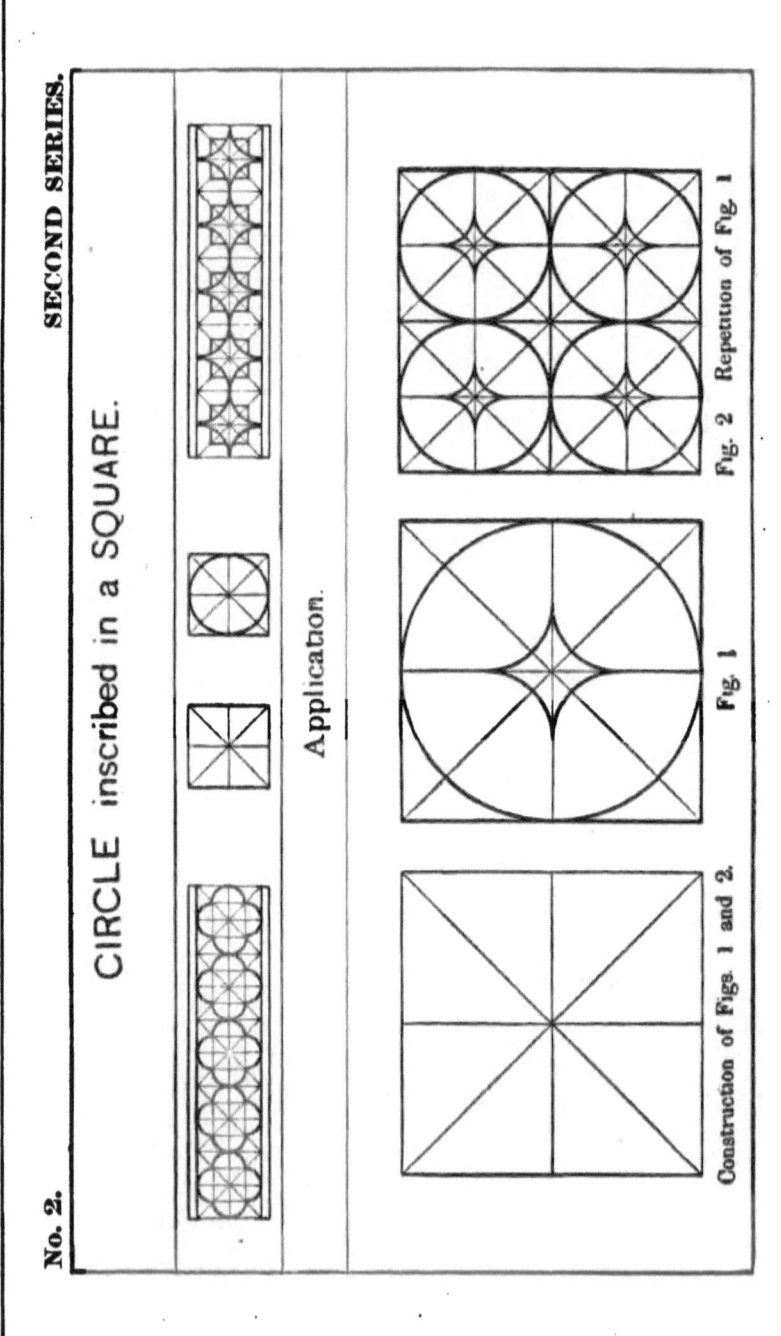

TUESDAY.

Design in a Square. ENLARGEMENT FROM CARD NO. 2, FIG. 1.

DIRECTIONS FOR THE TEACHER. — Place points for a square, and draw it. — Sketch its diagonals. — Bisect its sides, and sketch its diameters. — Mark upon each semi-diagonal the length of a semi-diameter from the centre. — Through the ends of the diameters, and through the points on the semi-diagonals, draw a circle. — Bisect each semi-diagonal. — Connect the points of bisection by drawing quadrants curving inward.

DRILL FOR THE WEEK. — Circles inscribed in squares.

Additional Work.

Design to cover a Surface. ENLARGEMENT FROM CARD NO. 2, FIG. 2. — As this is simply a repetition of Fig. 1, to cover four squares, no directions will be needed.

Horizontal Borders. ENLARGEMENT FROM CARD NO. 2. — The unit used in the first border is the design of Fig. 2, Card No. 5, First Series. (See p. 130.) The unit used in the second border has not been given before.

DIRECTIONS FOR THE TEACHER FOR THE UNIT OF THE SECOND BORDER. — Sketch a square, its diagonals and diameters. — Bisect each semi-diagonal. — Connect the points of bisection by sketching straight lines. — Connect the ends of the diameters by drawing quadrants curving inward. — Strengthen the corners of the inner square which are outside the quadrant.

WEDNESDAY.

Lesson of Tuesday in a Horizontal Border. FROM DICTATION AND MEMORY. — The outline of the border may be dictated, and the unit of design repeated from memory; or the outline of a horizontal border may be drawn from memory, and the unit then repeated within it from memory.

THURSDAY.

Quatrefoil Form. FROM DICTATION.

DIRECTIONS. — (Give directions for sketching a square, bisecting its sides, and sketching its diameters.) — Bisect each half of the upper side of the square. — Extend the vertical diameter upward and downward as far as one-fourth the side of the square. — Extend the horizontal diameter as far to the left and right as one-fourth the side of the square. — Connect the points on each half the upper side by a semicircle curving upward, and passing through the end of the extended diameter. — (Give similar directions for the other semicircles.)

Additional Work.

Original arrangements by the children, based on the construction given on Card No. 2; the construction to be dictated to the children.

FRIDAY.

Clock-Face. FROM THE OBJECT. — A clock-face was given on Card 1, to be drawn from the card. It is now to be drawn from the object, from observation of which the proportions are to be obtained by the children led by the teacher.

Additional Work.

The children discover objects illustrating the subject of the week, and the teacher selects one suitable for the class.

SUBJECT. — **Union of Lines.**

Card No. 3, Second Series.

MONDAY.	TUESDAY.	WEDNESDAY.	THURSDAY.	FRIDAY.
Geometric.	Enlargement.	Memory.	Dictation.	Object.
		Lessons of Monday and Tuesday.		Leaves.

A curved line may meet another line in such a way, that, if continued, the lines would cross each other.
A curved line may meet another line in such a way, that, if continued, the lines would make one line.
When two lines meet so that, if continued, they would cross each other, there is a secant union of lines.
When two lines meet in such a way that, if continued, they would make one line, there is a tangential union of two lines.

MONDAY.

Union of Lines. GEOMETRIC TERM. With cks and curved wire, and from the blackboard. — A branch of leaves is used by the teacher to illustrate tangential union from the union of the leaf-stems with the branch. The children seek for examples, both of secant and tangential union in design on the wall-paper or elsewhere in the room, and tell which is the more pleasing.

Busy Work for the Week.

Among other exercises, the children may try to draw from a branch of leaves. The plants found in nearly all primary schoolrooms will furnish illustrations of tangential union.

TUESDAY.

Abstract Curves. ENLARGEMENT FROM CARD NO. 3, FIG. 1.

DIRECTIONS FOR THE TEACHER. — Place points for a vertical, and draw it. — Trisect it. — Place points for a horizontal as far to the left and right of the lower point of trisection as one-third the vertical, and sketch the horizontal.

—From the upper end of the vertical, draw a curve to each end of the horizontal, imitating the curves of the copy. — Through the upper point of trisection, sketch a horizontal terminating at each end at the curves. — Trisect the upper third of the vertical. — Through the upper point of trisection, sketch a horizontal terminating at each end at the curves. — From each end of each horizontal, draw a curve curving inward to meet the vertical at the points shown in the copy, being very careful to have the curves unite tangentially with the vertical.

DRILL FOR THE WEEK. — Curves and straight lines uniting tangentially.

Additional Work.

Conventionalized Leaf. ENLARGEMENT FROM CARD NO. 3, FIG. 2. — This must be drawn by the children mainly from imitation.

DIRECTIONS FOR THE TEACHER. — Place points for a vertical, and sketch it. — Bisect it, and through the point of bisection sketch an indefinite horizontal. — On the horizontal mark the width of the leaf a little less than half the vertical. — Trisect each half of the vertical. — Draw the curve of each side of the leaf, reversing it near the lowest point of trisection to make the stem. — Draw the lines of the midrib. — Draw the veins, starting near the three inner points of trisection.

WEDNESDAY.

Lessons of Monday and Tuesday. Card No. 3. FROM MEMORY.

THURSDAY.

Rosette of Ovoid Forms. FROM DICTATION AND THE BLACKBOARD. — When an arrangement of units about a centre is made, the design is called a rosette, or little rose, from its analogy to the flower-forms in which the parts are arranged about a centre. The units here are ovoid forms, having an outline somewhat like that of an egg.

DIRECTIONS. — (Give directions for sketching a square, its diagonals and diameters.) — Mark on each semi-diagonal a distance equal to the length of a semi-diameter from the centre of the square. — Through the ends of the diameters, and through the points just made, draw a circle. — Trisect each radius. Through the inner points of trisection draw a circle. — Each circle is divided into eight equal parts. — Bisect each part of each circle. — From each point on the outer circle sketch a line toward the centre, to meet one of the points just made on the inner circle. — Bisect the lines just sketched. — Strengthen the inner half of the line that is just at the left of the vertical diameter. — Strengthen the inner half of the line that is just at the right of the vertical diameter. — Connect the outer ends of the strengthened lines by drawing a semicircle curving upward, and passing through the upper end of the vertical diameter. — (Give similar directions for the other units.)

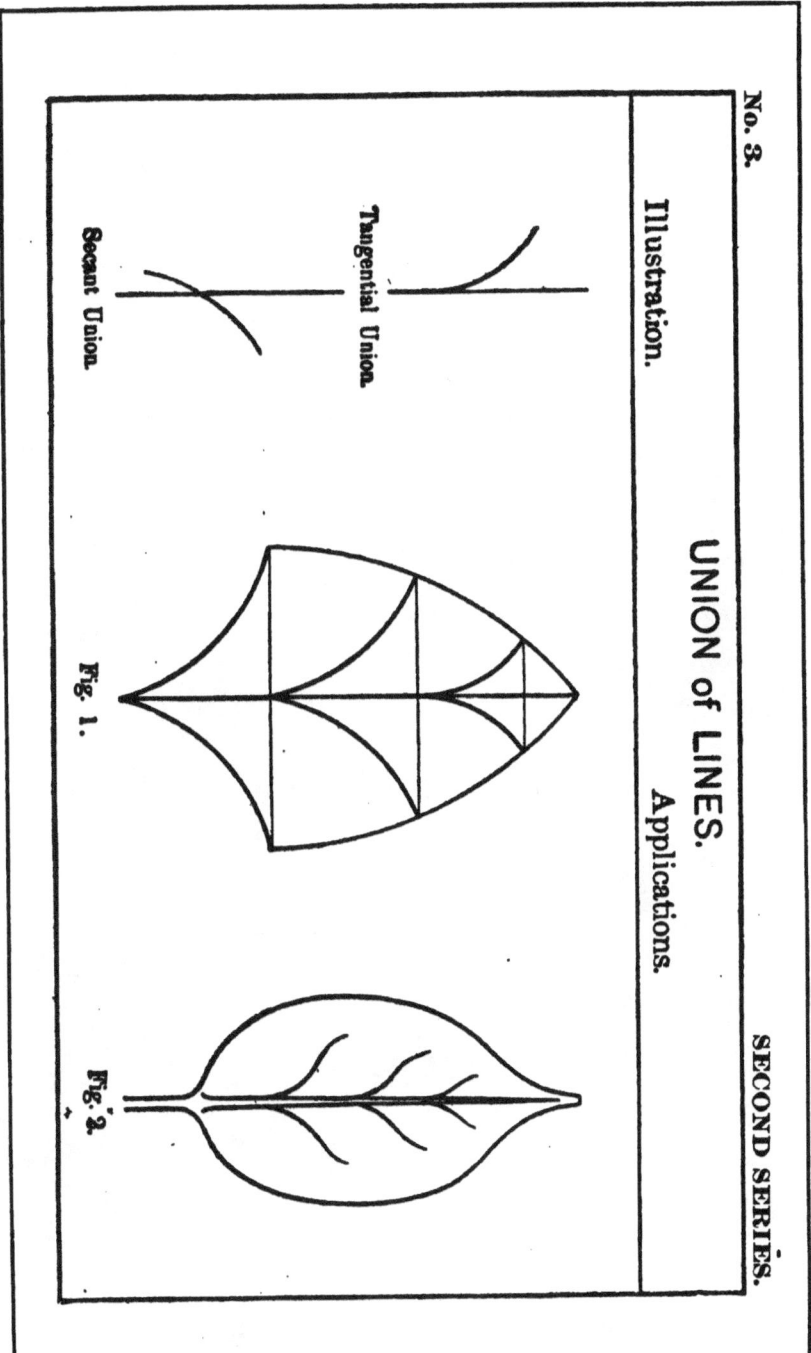

UNION OF LINES.

Additional Work.

Abstract Curves. FROM DICTATION AND THE BLACKBOARD.

DIRECTIONS. — An inch from the upper, and two inches from the left, side of the slate, place a point. Three inches below the point just made, place a point. **Draw** a vertical to connect the points. — Trisect the vertical. — Place points as far to the left and right of the lower point of trisection as one-third the vertical. — **Sketch** a horizontal to connect the points. — From a point a little below and to the left of the upper end of the vertical, **draw** a reversed curve like that on the board to the lower point of trisection. — **Draw** a similar curve on the right of the vertical. — Connect the ends of the horizontal by **drawing** a semicircle curving upward, and passing through the upper point of trisection. — From the left end of the horizontal, **draw** a quadrant curving inward to the lower end of the vertical. — From the right end of the horizontal, **draw** a quadrant curving inward to the lower end of the vertical.

FRIDAY.

Leaf. FROM THE OBJECT. — A very simple leaf should be chosen, and one of which a number can be readily obtained, so that each child may have one. The children should examine their leaves, learning about the midrib and the veins.

Additional Work.

The children bring leaves to school, and the teacher selects those suitable to be drawn.

SUBJECT. — **Ellipse.**

Card No. 4, Second Series.

MONDAY.	TUESDAY.	WEDNESDAY.	THURSDAY.	FRIDAY.
Geometric.	Enlargement.	Memory.	Dictation.	Object.
		Lesson of Tuesday		Frame.

The outline of a circle is curved.
The outline of an ellipse is curved.

A circle has many diameters, which are all equal.
An ellipse has two diameters, — a long and a short diameter.

An ellipse is more rounding at the ends of the long diameter than at the ends of the short diameter.
An ellipse is not pointed nor square at the ends of the long diameter.

MONDAY.

Ellipse. GEOMETRIC NAME. From curvilinear figures of pasteboard, — circles, ellipses (the diameters of the ellipses having different proportions to each other), and ovals. — The children select all the circles; then all the curvilinear figures which have both ends alike; that is, the ellipses.

From oblongs of cardboard, on which the children can draw ellipses. — The ellipses are drawn on these oblongs by means of a thread drawn through the oblong at two points on its long diameter; the thread being knotted at both ends on the under side of the oblong, and left in a loop on the upper side. The child puts the point of a lead-pencil in the loop, and, holding the thread taut, draws an ellipse.

Also from the blackboard, and by drawing.

Busy Work for the Week.

The picture of a fish drawn on the board may be copied by the children as one exercise in Busy Work.

TUESDAY.

Locket. ENLARGEMENT FROM CARD No. 4, FIG. 2. — The ellipse is given in Fig. 1, that children may have before them a good example of an ellipse. Fig. 2 is the regular lesson for the day.

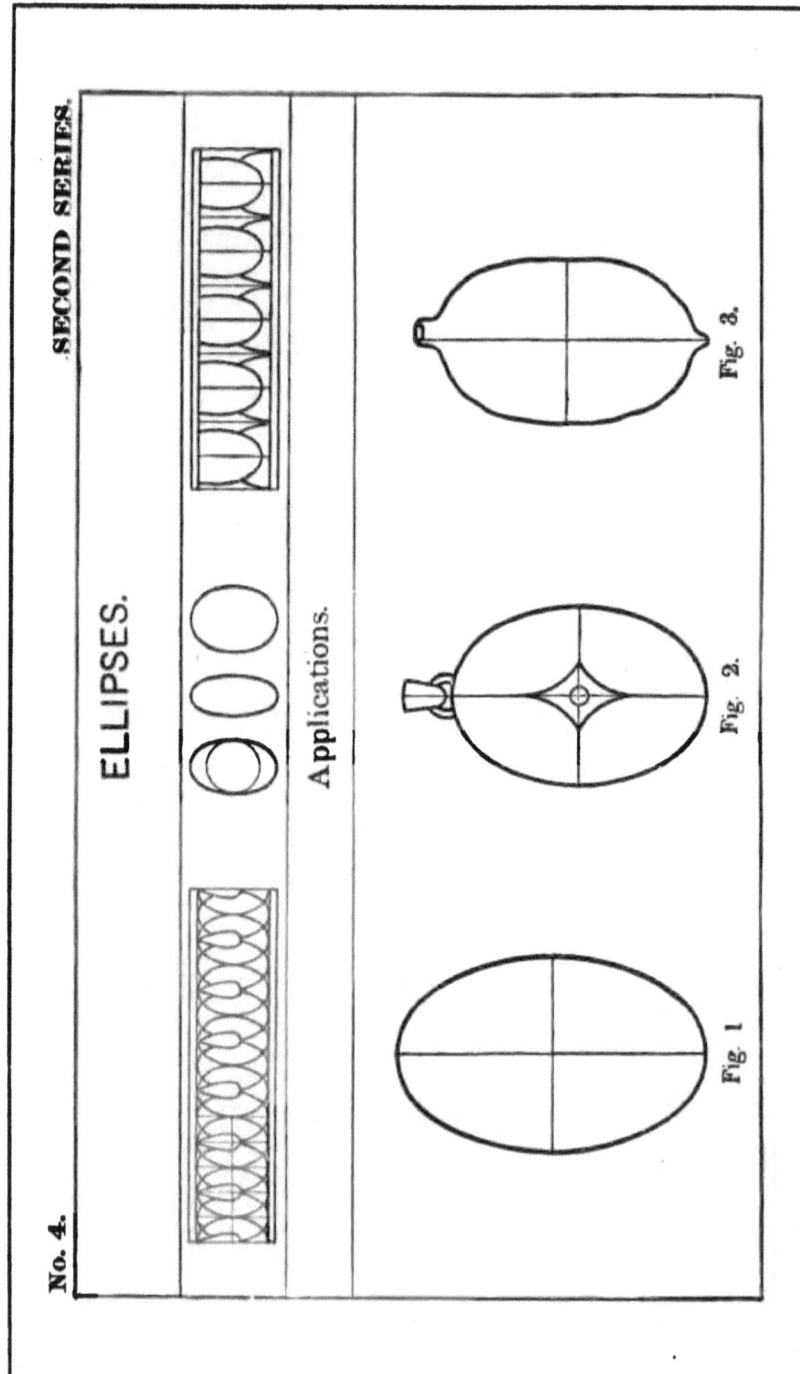

ELLIPSE.

DIRECTIONS. — **Sketch** the diameters of an ellipse having the proportion of two to three. — **Draw** the ellipse. — Bisect each semi-diameter. — Connect the points of bisection by **drawing** curves curving inward. — Draw a small circle at the centre of the ellipse. — Add the rings at the top, imitating the copy.

DRILL FOR THE WEEK. — Ellipses of various proportions.

Additional Work.

Lemon. ENLARGEMENT FROM CARD No. 4, FIG. 3.

DIRECTIONS. — **Sketch** the diameters of an ellipse having the proportion of two to three. — **Sketch** the ellipse. — **Draw** the outline of the lemon, varying from the ellipse, as seen in the copy.

Horizontal Borders. ENLARGEMENT FROM THE CARD. — These borders are both Greek. The first is from a painted border. The second is from the echinus moulding: the familiar name, the egg and dart moulding, will please the children.

Suggest to the children to look for such borders on the outside of buildings or in the decoration of rooms.

DIRECTIONS FOR THE TEACHER. *First Border.* — **Sketch** two indefinite horizontals. **Sketch** a vertical to connect the left ends of the horizontals. — Trisect the vertical. — Mark off on the horizontals distances equal to two-thirds of the vertical. — Connect the opposite points by **sketching** verticals. — Erase what may remain of the horizontals beyond the verticals. — There is now a series of vertical oblongs. — **Sketch** the diameters of each oblong. The horizontal diameters may be **sketched** in one continuous line. — Using the left vertical as a long diameter, **sketch** the right half of a vertical ellipse. — Using every alternate vertical as a long diameter, **sketch** a series of vertical ellipses. — On the upper part of each vertical used as a long diameter, sketch the ovoid form like a bud seen in the copy. — Using the second and thence each alternate vertical as a long diameter, **sketch** that part of an ellipse not concealed by the bud. — Strengthen the upper and lower horizontals, and add the marginal horizontals.

Second Border. — **Sketch** two indefinite horizontals. **Sketch** a vertical to connect the left ends of the horizontals. — **Sketch** verticals dividing the space into squares. — **Sketch** the vertical diameter of each square. — On each vertical diameter, draw a part of an ellipse, as seen in the copy. — **Draw** curved lines, curving inward, from the lower part of each ellipse to the lower end of each vertical side of a square. — Strengthen the horizontals, and add the marginal horizontals.

WEDNESDAY.

Lesson of Tuesday. Card No. 4, Fig. 1. **Locket.** FROM MEMORY.

THURSDAY.

Picture-Frame. FROM DICTATION.

DIRECTIONS. — Place a point an inch from the left and upper sides of the slate. Place a point an inch from the left and lower sides of the slate. Draw a vertical to connect the points. — This is for the left vertical of an oblong. — Trisect the vertical. — Place a point as far to the right of the upper end of the vertical as two-thirds the vertical. — Place a point directly below the point just made, and directly opposite the lower end of the vertical. — These points are for the right corners of an oblong. — Draw the remaining lines of the oblong. — Bisect the vertical sides. Sketch the horizontal diameter. — Bisect the horizontal sides. Sketch the vertical diameter. — Trisect each horizontal semi-diameter. — Set off from each end of the vertical diameter a distance equal to one of the parts just obtained by trisection. — Through the points on the vertical diameter, and through the outer points on the horizonal diameter, draw an ellipse.

Additional Work.

Ellipses. FROM DICTATION. An ellipse having its short diameter two-thirds its long diameter; an ellipse having its short diameter one-half its long diameter; an ellipse having its short diameter one-third its long diameter. — These ellipses can be easily dictated, and furnish admirable practice in drawing.

FRIDAY.

Picture-Frame. FROM THE OBJECT. — Remember that the shortest and easiest way to draw any figure is by the use of construction-lines.

Additional Work.

Children discover objects in the room illustrating the subject of the week; and the teacher selects one suitable for the class, from which the children draw.

ELLIPSES AND CIRCLES. 187

SUBJECT. — **Ellipses and Circles.**

Card No. 5, Second Series.

MONDAY.	TUESDAY.	WEDNESDAY.	THURSDAY.	FRIDAY
Geometric.	Enlargement.	Memory.	Dictation.	Object.
		Lessons of Monday and Tuesday.		Lemon.

The outline of a circle is curved.
The outline of an ellipse is curved.
The curve of an ellipse is not like the curve of a circle in any part.
All parts of the curve of a circle curve alike.
All parts of the curve of an ellipse do not curve alike.
Any part of the curve of a circle is called a circular curve.
Any part of the curve of an ellipse is called an elliptical curve.

MONDAY.

Ellipses and Circles; Circular and Elliptical Curves. GEOMETRIC NAMES. From circles and ellipses of pasteboard of such size that the diameters of the circles equal either the long or short diameters of the ellipses. — The children place circles on ellipses, or *vice versa*, and discover that the curve of an ellipse is never like that of a circle.

Also from the blackboard.

The teacher holds a circle vertically, and asks the children to look at the upper part; then revolves it around its centre, still keeping it vertical, and asks the children to look at the upper part, and tell how it compares with the part just observed. The teacher holds and revolves an ellipse in the same way, the children observing the difference in the curves of different parts of the outline. The children discover that all parts of the curve of a circle are alike; that the two halves into which each diameter divides an ellipse are alike; that the four quarters made by the crossing of the diameters of an ellipse are alike, but that all parts of the curve of an ellipse are not alike.

Busy Work for the Week.

Ellipses and circles may be laid with kernels of corn. The annexed page of letters furnishes good material for Busy Work. The letters may be given separately, or may be combined to form words.

TUESDAY.

Letter O. ENLARGEMENT FROM CARD No. 5, FIG. 1.

DIRECTIONS FOR THE TEACHER. — Place points for, and sketch, the diameters of a circle. — Draw the circle. — Bisect the horizontal diameter. — Draw an ellipse passing through the ends of the vertical diameter, and through the points of bisection on the horizontal diameter.

DRILL FOR THE WEEK. — Circles and ellipses.

Additional Work.

Letters C and D. ENLARGEMENT FROM CARD No. 5, FIGS. 2 AND 3. — These letters are so similar in construction to the letter O that no directions are necessary for the teacher. It will be noted that the width between the vertical lines of the D is equal to half the semi-diameter: it is obtained by quadrisecting the semi-diameter, and drawing the verticals through the two outer points of division.

Horizontal Border. ENLARGEMENT FROM THE CARD. — This is a Greek border from the astragal moulding familiarly known as the bead and button moulding. It is also sometimes called a chaplet or string of pearls.

DIRECTIONS FOR THE TEACHER. — Sketch two indefinite horizontals. Sketch a vertical connecting the left ends of the horizontals. — Mark off distances on the horizontals equal to twice the vertical. Connect the points by sketching verticals. — Erase what may remain of the horizontals beyond the verticals. — The space is now divided into oblongs. Sketch the diameters of each oblong. — Trisect each horizontal semi-diameter, and quadrisect each vertical semi-diameter. — Through the outer points of division draw an ellipse. — Bisect each outer third of the horizontal diameter of the oblong, and through the centre of each sketch a vertical as long as the vertical diameter of the ellipse. — From each end of each vertical just sketched, draw an oblique to the nearest end of the horizontal diameter of the oblong. — From each end of each vertical just sketched, draw an oblique to the nearest end of the horizontal diameter of the ellipse. — Strengthen the upper and lower horizontals, and add the marginal horizontals.

WEDNESDAY.

Lessons of Monday and Tuesday. Card No. 6. Circle and Ellipse. Fig. 1. Letter O. FROM MEMORY.

THURSDAY.

Barrel. FROM DICTATION AND THE BLACKBOARD. — There are several divisions necessary in the construction of this figure; but children can readily follow them from the blackboard.

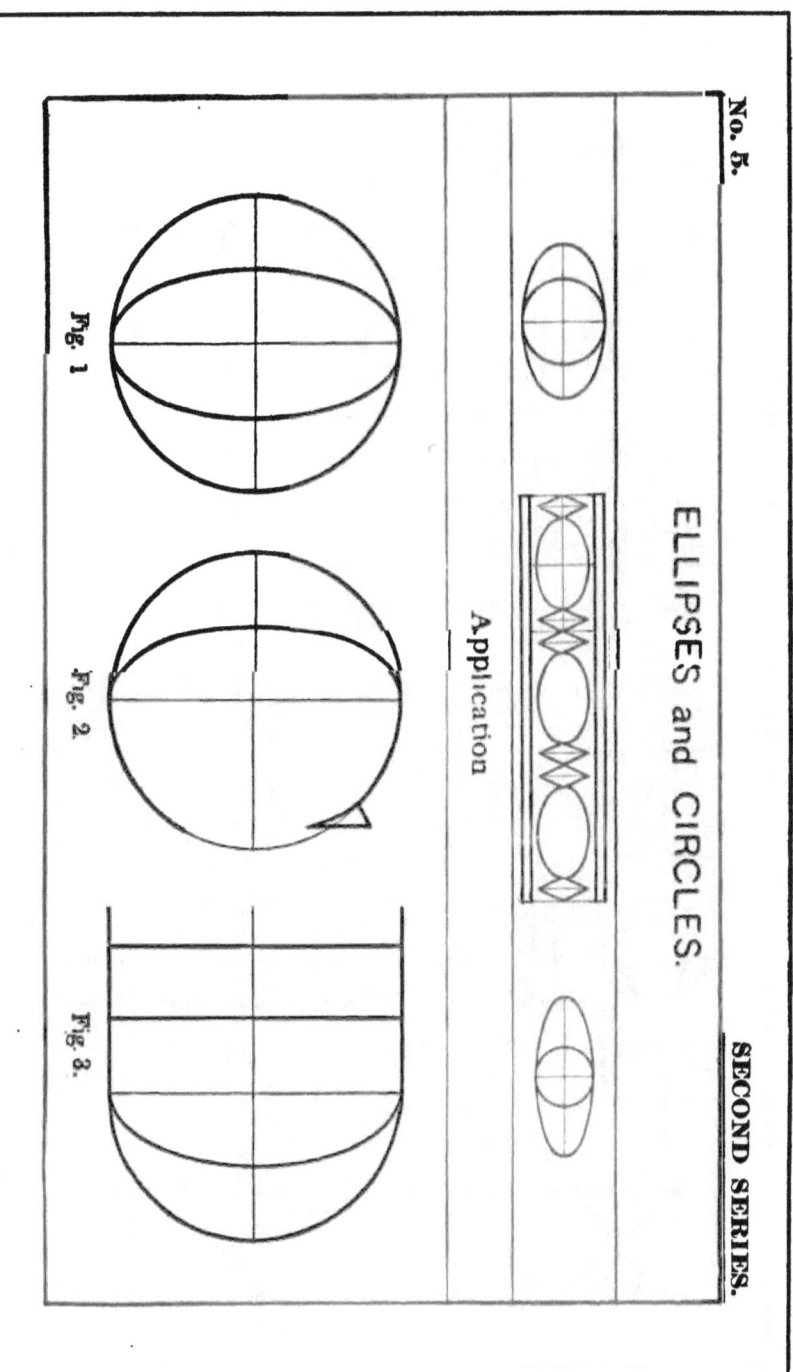

ELLIPSES AND CIRCLES.

DIRECTIONS. — An inch from the centre of the left side of the slate, place a point. Four inches to the right of this, place a point. **Sketch** a horizontal connecting the points. — Trisect the horizontal. — Bisect its central third. — Place a point as far above the centre of the horizontal as one-third the line. Place a point as far below the centre of the horizontal as one-third the line. **Sketch** a vertical to connect the points. — **Sketch** an ellipse through the ends of the vertical and horizontal. — Bisect the outer thirds of the horizontal. — Bisect the outer half of each outer third. — Through the last points of bisection made, **draw** verticals for the heads of a barrel. — Bisect the space between each vertical just drawn and the next point within. — Through the points of bisection just made, **draw** verticals for the end hoops. — **Draw** the small circle in the centre for the bung. — **Draw** the verticals for the two remaining hoops, making the hoops as wide as the end hoops, placing them like those on the board. — Continue all the verticals a little beyond the ellipse to indicate the thickness of the hoops. — Finish each hoop by connecting the ends of the verticals by **drawing** curved lines parallel to the curve of the ellipse. — Strengthen the ellipse between the hoops.

Additional Work.

Letters. FROM DICTATION. — A page of letters is given here for occasional use in Busy Work or otherwise. A number of the letters are based on the same construction as the letters O, C, and D, given on Card No. 5. Dictate one or more of these letters for the *Additional Work.*

FRIDAY.

Lemon. FROM THE OBJECT. — Lead the children to examine the lemon carefully, discovering its proportions, and the differences between its outlines and that of an ellipse.

Additional Work.

The children discover objects in the room illustrating the subject of the week, and the teacher selects one suitable for the class.

SUBJECT. — **Oval.**

Card No. 6, Second Series.

MONDAY.	TUESDAY.	WEDNESDAY.	THURSDAY.	FRIDAY.
Geometric.	Enlargement.	Memory.	Dictation.	Object.
		Lessons of Monday and Tuesday.		Pear.

The outline of a circle is curved.
The outline of an ellipse is curved.
The outline of an oval is curved.

A circle is perfectly round.
An ellipse is longer one way than the other, but has both ends alike.
An oval is egg-shaped, and has one end rounder than the other.

The curve of an ellipse is never circular in any part.
A part of the curve of an oval may be circular.
A part of the curve of an oval may be elliptical.
The curve of an oval may be neither circular nor elliptical in any part.
The curve of an oval may be circular at the rounder end of the oval, and elliptical at the more pointed end of the oval.

MONDAY.

Oval. GEOMETRIC NAME. From straight and curved line figures of pasteboard. — The children select circles, ellipses, and the curvilinear figures whose ends are not alike. They find also the straight-line figures, which are respectively the most like the circle, the ellipse, and the oval.

From eggs, and from the blackboard. — An oval is easily constructed by sketching a vertical, trisecting it, sketching through the upper point of trisection a horizontal equal to two-thirds the vertical, and drawing through the ends of the lines the outline of an oval. The curve above the horizontal may be circular, and below the horizontal may be elliptical. An illustration is given on Card No. 6, Fig. 1.

Busy Work for the Week.

Horizontal ovals may be made the foundation-figures of hens, ducks, etc. Faces may be made in vertical ovals. Borders may be made introducing the circle, the ellipse, the oval. (See p. 231, Figs. F.)

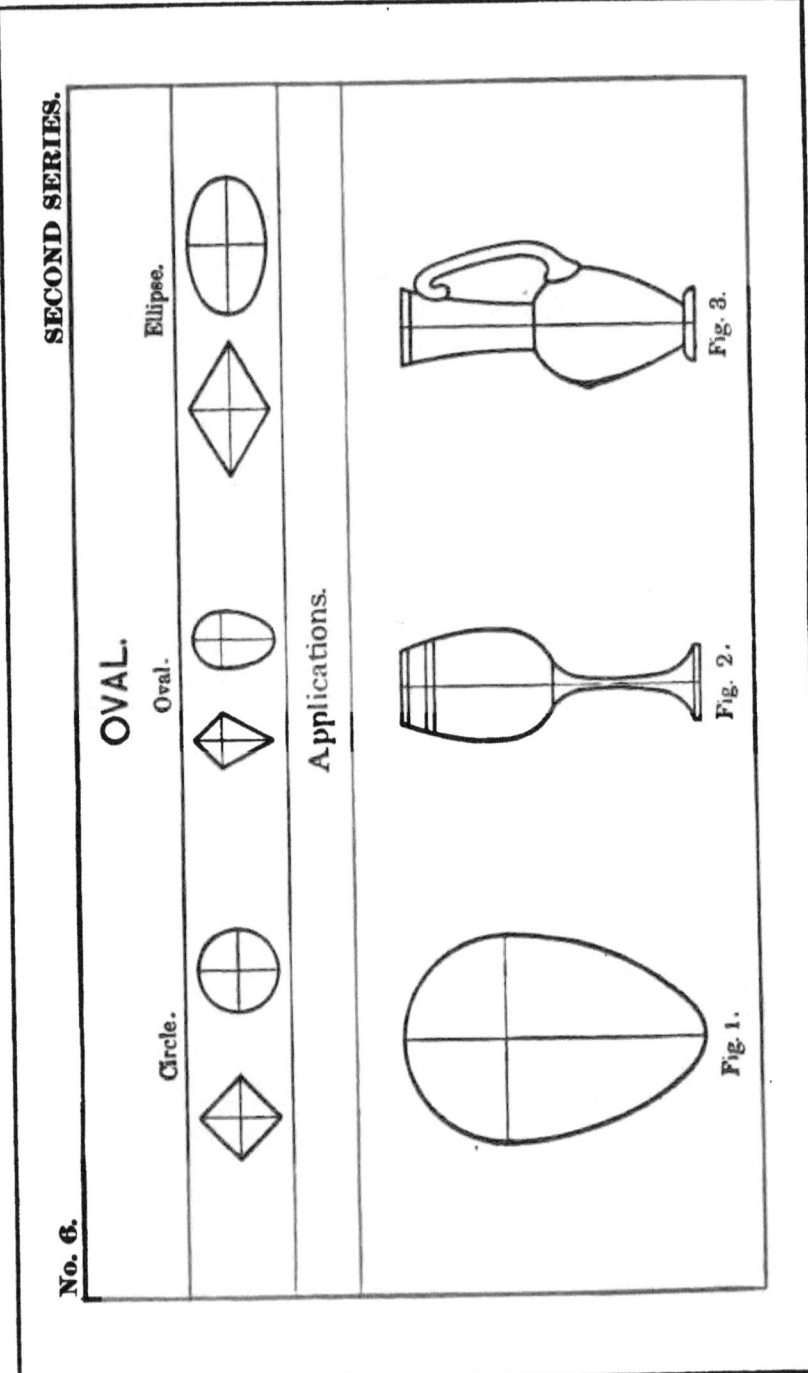

TUESDAY.

Flower-Glass. ENLARGEMENT FROM CARD No. 6, FIG. 2.

DIRECTIONS FOR THE TEACHER. — Place points for a vertical, and sketch it. — Quadrisect it. — Through each end of the vertical, draw a horizontal as long as one-fourth the vertical. — Draw the bowl from imitation, noting that it is egg-shaped, and is broader at the lower than at the upper part. — Bisect the upper fourth of the vertical. — Through the point of bisection, draw a horizontal. — Quadrisect the space between the upper horizontals, and through the first and third points of quadrisection draw horizontals. — Draw the upper horizontal line of the base, making the space between the horizontals not quite as great as the width of the bands at the top. — Draw short verticals to connect the ends of the horizontals of the base. — Draw the curves of the stem, imitating the copy.

DRILL FOR THE WEEK. — Ovals.

Additional Work.

Vase. ENLARGEMENT FROM CARD No. 6, FIG. 3.

DIRECTIONS FOR THE TEACHER. — Place points for a vertical, and sketch it. — Quadrisect it. — Through each end of the vertical, draw a horizontal as long as one-fourth the vertical. — A little above the centre of the vertical, draw a horizontal a little shorter than those just drawn. — Draw the base, the curves of the top, bowl, and handle from imitation, noting the ovoid character of the bowl, and also that the line of the handle overlaps the outline of the vase. — Add the horizontal near the top.

WEDNESDAY.

Lessons of Monday and Tuesday. Card No. 6, Fig. 1. Oval. Fig. 2. Flower-Glass. FROM MEMORY.

THURSDAY.

Mug. FROM DICTATION AND THE BLACKBOARD. — The mug should be drawn on the board by the teacher before the time for the lesson. The placing of the central line of the body of the mug (directions for which are given below) should be dictated to the children. They should then draw the mug by imitating the work on the board without further directions.

DIRECTIONS. — Place a point in the centre of the slate. Two inches above the centre, place a point. — Two inches below the centre, place a point. — Sketch a vertical to connect the upper and lower points. — This vertical is for the construction-line of the mug on the board. — Draw the mug.

Additional Work.

Upright and Reversed Oval. FROM DICTATION. — These can readily be dictated from the suggestions given for the construction of an oval under Monday's lesson.

FRIDAY.

Egg. FROM THE OBJECT. — Lead the children to note wherein the outline of the egg resembles, and wherein it differs from, the oval given on Card No. 6, Fig. 1.

Additional Work.

Children discover objects in the room illustrating the subject of the week; and the teacher selects one suitable for the class, from which the children draw. (See p. 233, Fig. 6.)

CHAPTER IV.

AXIS OF SYMMETRY. — AXES OF SYMMETRY. — REVERSED CURVES. — UNITS OF DESIGN. — CONVENTIONALIZATION OF LEAVES. — CONVENTIONALIZED FORMS IN DESIGN.

Remember that the whole week's work on a subject should be studied before any lesson is given on the subject.

SUBJECT. — **Axis of Symmetry.**

Card No. 7, Second Series.

MONDAY.	TUESDAY.	WEDNESDAY.	THURSDAY.	FRIDAY.
Geometric.	Enlargement.	Memory.	Dictation.	Object.
		Lessons of Monday and Tuesday.		Fan.

A line which divides a figure into two parts so that, if the figure were folded together along the line, the parts would be just alike, is called an **axis of symmetry**.

Any figure which can be folded along a line so that the two parts will be just alike, has an axis of symmetry.

An axis of symmetry need not always be drawn: it can be imagined.

NOTE. — Sentences like the above, which are directly below the scheme for a subject, are not given as a set form to be used by the teacher or children, but are given as "leading sentences," embodying the ideas to be developed or recalled in the minds of the children.

MONDAY.

Axis of Symmetry. GEOMETRIC TERM. From figures cut from paper. — The teacher folds a square so that the two parts exactly coincide. The children discover other figures which will fold so that the two parts will coincide. The fold made in the paper is an axis of symmetry.

From the blackboard. — The teacher illustrates axis of symmetry from the first line of illustrations on Card No. 7, and also from Fig. 1 on the same card, which is a unit of design suitable for repeating in an arrangement around a centre.

Remember the order of the lesson, — Observation by sight and by touch, Term, Drill, Application, Drawing.

DIRECTIONS FOR THE TEACHER. CARD No. 7, FIG. 1. — Place points for a vertical, and sketch it. — Quadrisect it. — Place points as far to the left and right of the centre as one-fourth the vertical, and sketch a horizontal connecting the points. — Bisect each half of the horizontal. — Draw an oblique from the upper end of the vertical to each point of bisection. — Strengthen the outer fourths of the horizontal. — Draw an oblique from each end of the horizontal to the lower end of the vertical.

Busy Work for the Week.

The children may invent figures having an axis of symmetry. If a figure is made of splints, its axis of symmetry should be a red splint.

As a general thing, but one exercise is suggested for Busy Work. It is expected, however, that teachers will devise other exercises, or apply previous suggestions for Busy Work to the subject of the week.

TUESDAY.

Water-Bottle. ENLARGEMENT FROM CARD No. 7, FIG. 2.

DIRECTIONS FOR THE TEACHER. — Place points for a vertical, and sketch it. — Bisect it. — Trisect the upper half. — Through each end and through the centre of the vertical, draw horizontals as long as one-sixth the vertical. — Sketch verticals connecting the upper and lower horizontals. — Quadrisect the upper sixth of the vertical. — One of the fourths thus obtained gives the width of the bands and the thickness of the base. — Draw the horizontals for the bands and the base. — Strengthen the upper half of each outer vertical. — Draw a semicircle curving outward from the lower end of each strengthened line to meet the upper line of the base. — Complete the base by lengthening the lowest horizontal, and adding short verticals.

DRILL FOR THE WEEK. — Vertical and horizontal lines.

Additional Work.

Goblet. ENLARGEMENT FROM CARD No. 7, FIG. 3.

DIRECTIONS FOR THE TEACHER. — Place points for a vertical, and sketch it. — Bisect it. — Through each end, draw a horizontal equal to one-half the vertical. — From each end of the upper horizontal, sketch an oblique to the lower end of the vertical. — Through the centre of the vertical, draw a horizontal ending in the obliques just drawn. — Strengthen the upper half of each oblique. — Draw the reversed curve of the stem, imitating the copy. — Add the horizontals making the band at the top.

Unit of Design. ENLARGEMENT FROM CARD No. 7, FIG. 4. — The construction is so simple that directions are not needed.

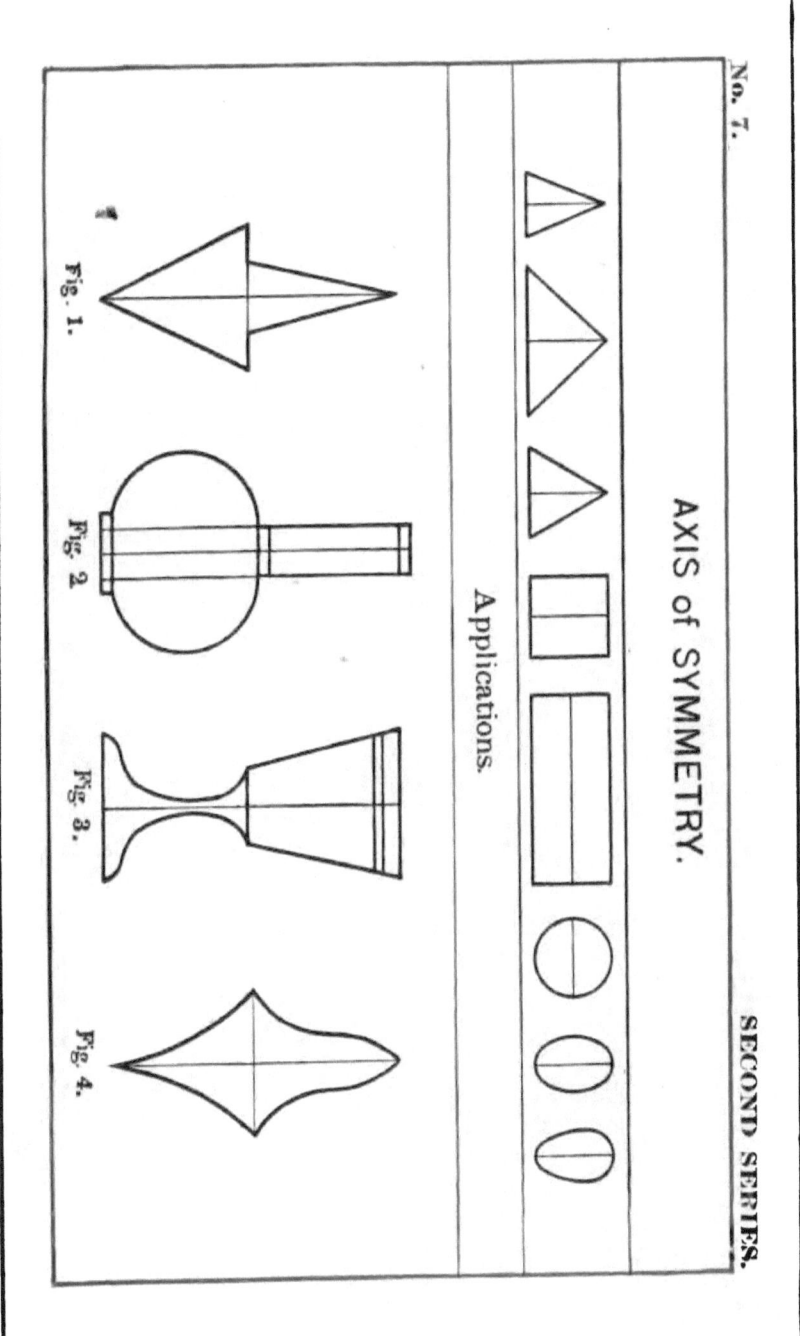

WEDNESDAY.

Lessons of Monday and Tuesday. Card No. 7, Fig. 1. **Unit of Design.** Fig. 2. **Water-Bottle.** FROM MEMORY.

THURSDAY.

Unit of Design. FROM DICTATION AND THE BLACKBOARD.

DIRECTIONS. — An inch from the upper side, and two inches from the left side, of the slate, place a point. Three inches below this, place a point. **Sketch** a vertical connecting the points. — Trisect the vertical. — An inch to the left of the upper point of trisection, place a point. An inch to the right of the upper point of trisection, place a point. **Sketch** a horizontal connecting the points. — Trisect the horizontal. — From the upper end of the vertical to the left point of trisection, **draw** a circular curve curving outward. — From the left end of the horizontal to the left point of trisection, **draw** a circular curve curving upward. — From the left end of the horizontal to the lower end of the vertical, **draw** a circular curve curving inward. — Repeat these curves on the right.

Additional Work.

The children draw original units of design, each unit having an axis of symmetry, the construction-lines of the unit being dictated by the teacher.

FRIDAY.

Fan with Handle. FROM THE OBJECT. — The fan should be drawn with reference to its axis of symmetry. (See p. 233, Fig. 3.)

Additional Work.

The children discover objects in the room illustrating the subject of the week, and the teacher selects one suitable for the class.

SUBJECT. — **Axes of Symmetry.**

Card No. 8, Second Series.

MONDAY.	TUESDAY.	WEDNESDAY.	THURSDAY.	FRIDAY.
Geometric.	Enlargement.	Memory.	Dictation.	Object.
		Lessons of Monday and Tuesday.		Toy wheel.

A figure may have more than one axis of symmetry.
An equilateral triangle has three axes of symmetry.
A square has four axes of symmetry.
An oblong has two axes of symmetry.
A circle has many axes of symmetry.
An ellipse has two axes of symmetry.
An oval has one axis of symmetry.
If the axes of symmetry are drawn in a figure, a symmetrical design can be easily placed in the figure.

MONDAY.

Axes of Symmetry. GEOMETRIC TERM. From geometric figures cut from paper. — The children fold the figures, and discover the axes of symmetry.

From the blackboard. — The teacher illustrates axes of symmetry from the first line of illustrations on Card No. 8, and from Fig. 1, a trefoil form. This figure was given as a dictation lesson in the early part of the year. It will now be an exercise in reduction, as the children are to draw it from the board.

DIRECTIONS FOR THE TEACHER. CARD No. 8, FIG. 1. — Construct a light equilateral triangle. —Quadrisect its sides. — From each angle, sketch a line through the centre of the opposite side, extending as far beyond the side as one-fourth of a side. — On each side of the triangle, draw a semicircle curving outward, connecting the two outer points of quadrisection, and passing through the end of an extended axis of symmetry.

Busy Work for the Week.

The children may lay the various figures on the first line of illustrations on Card No. 8 with splints and kernels of corn, and add to the figures their axes of symmetry.

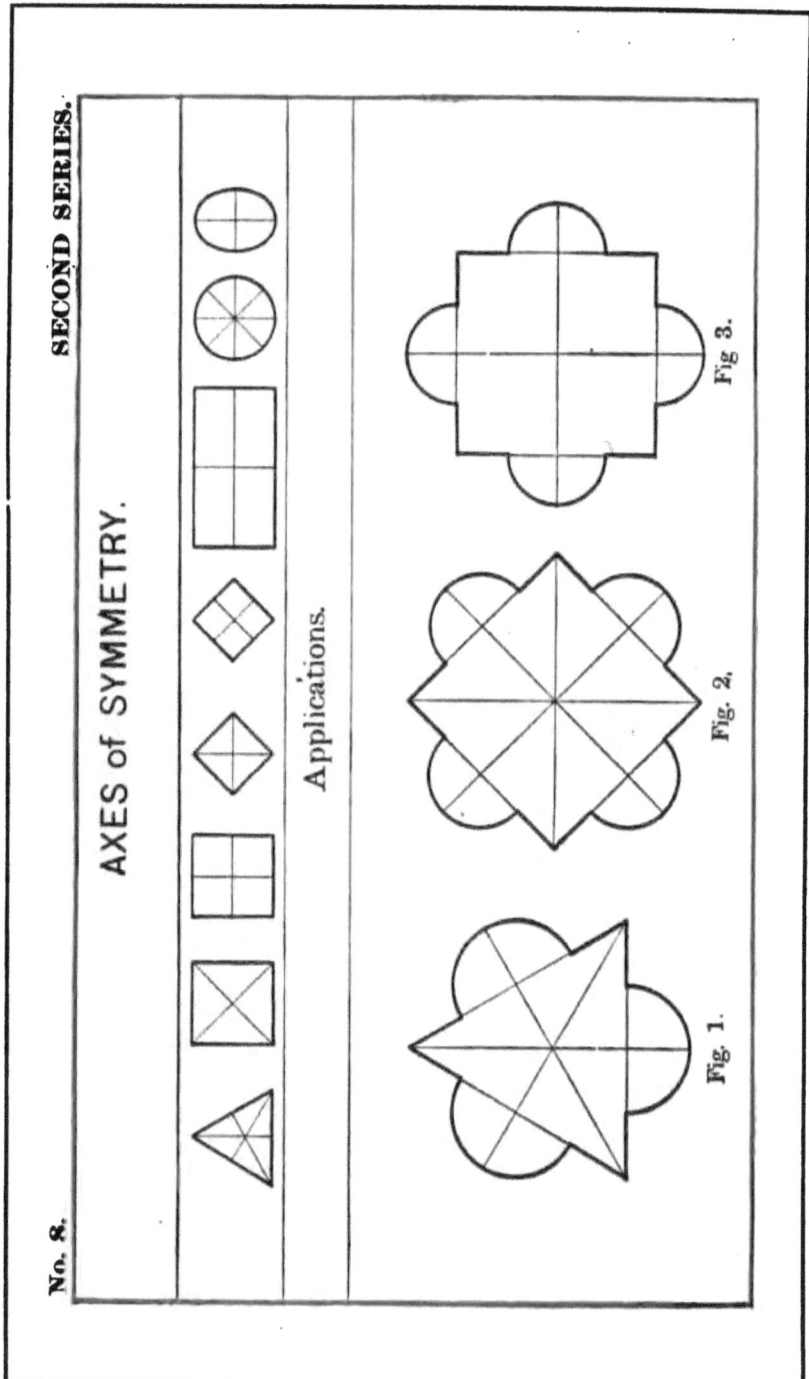

TUESDAY.

Quatrefoil Form. ENLARGEMENT FROM CARD NO. 8, FIG. 2.

DIRECTIONS FOR THE TEACHER. — Sketch a square on its diagonals. — Quadrisect its sides. — Sketch its diameters, extending them at each end a distance beyond the sides of the square equal to one-fourth their length. — On each side of the square, draw a semicircle curving outward, connecting the outer points of quadrisection, and passing through an end of an extended diameter. — Strengthen the corners of the square between the semicircles.

DRILL FOR THE WEEK. — Semicircles.

Additional Work.

Quatrefoil Form. ENLARGEMENT FROM CARD NO. 8, FIG. 3. — The construction of this figure is so similar to that of Fig. 2 that no directions are needed.

WEDNESDAY.

Lessons of Monday and Tuesday. Card No. 8, Fig. 1. Trefoil Form. Fig. 2. Quatrefoil Form. FROM MEMORY.

THURSDAY.

Wheel. FROM DICTATION.

DIRECTIONS. — (Give directions for sketching a square, its diagonals and diameters, and for inscribing a circle in the square.) — Quadrisect each radius of the circle. — Draw a circle through the outer points of quadrisection. — Draw a circle through the inner points of quadrisection. — Strengthen that part of each radius that is between the two inner circles.

Additional Work.

Original arrangements by the children, based on the construction of any figure on Card No. 8, the construction to be dictated by the teacher.

FRIDAY.

Wheel. FROM THE OBJECT. — A wheel from a child's carriage or from a toy wagon would answer well for this lesson.

Additional Work.

The children discover objects in the room illustrating the subject of the week, and the teacher selects one suitable for the class.

SUBJECT. — **Reversed Curves.**

Card No. 9, Second Series.

MONDAY.	TUESDAY.	WEDNESDAY.	THURSDAY.	FRIDAY.
Geometric	Enlargement.	Memory	Dictation.	Object.
		Lessons of Monday and Tuesday.		Vase.

A curve which curves in one direction, and then turns and curves in another direction, is called a reversed curve.
A reversed curve may be circular in its parts.
A reversed curve may be elliptical in its parts.
A reversed curve may be ovoid in its parts.
A reversed curve crosses its construction-line without a break or a sudden bend.

MONDAY.

Reversed Curves. GEOMETRIC NAME. With wire, and from the blackboard. — The teacher sketches a vertical on the board, and bisects it; then applies a circle of pasteboard (whose diameter is greater than half the vertical) to the vertical, so that the circumference will touch the vertical at its upper end and at its centre, and draws, by the pasteboard circle, from the upper end to the centre of the vertical; applies the circle in the same way to the lower half of the vertical, but so that the curve drawn will be on the other side of the vertical; and draws by the pasteboard circle from the centre of the vertical to the lower end of the vertical; then having these two circular curves as a guide, draws the whole reversed curve from the upper to the lower end, that the children may see that a reversed curve is a continuous unbroken line through its entire length. Thus a reversed curve, circular in its parts, and like the Curve 1 on Card No. 9, is formed. In a similar way the teacher forms reversed curves elliptical and ovoid in their parts. The children do the same. The teacher draws on the board the reversed curves given on Card No. 9, and the children imitate them. The Curves 1, 2, 3, are based on a vertical bisected; the Curves 4, 5, 6, are based on a vertical trisected.

Busy Work for the Week.

The children may use the red splints for construction-lines, and lay reversed curves on the construction-lines with twine. Having laid the curves, the children may draw them.

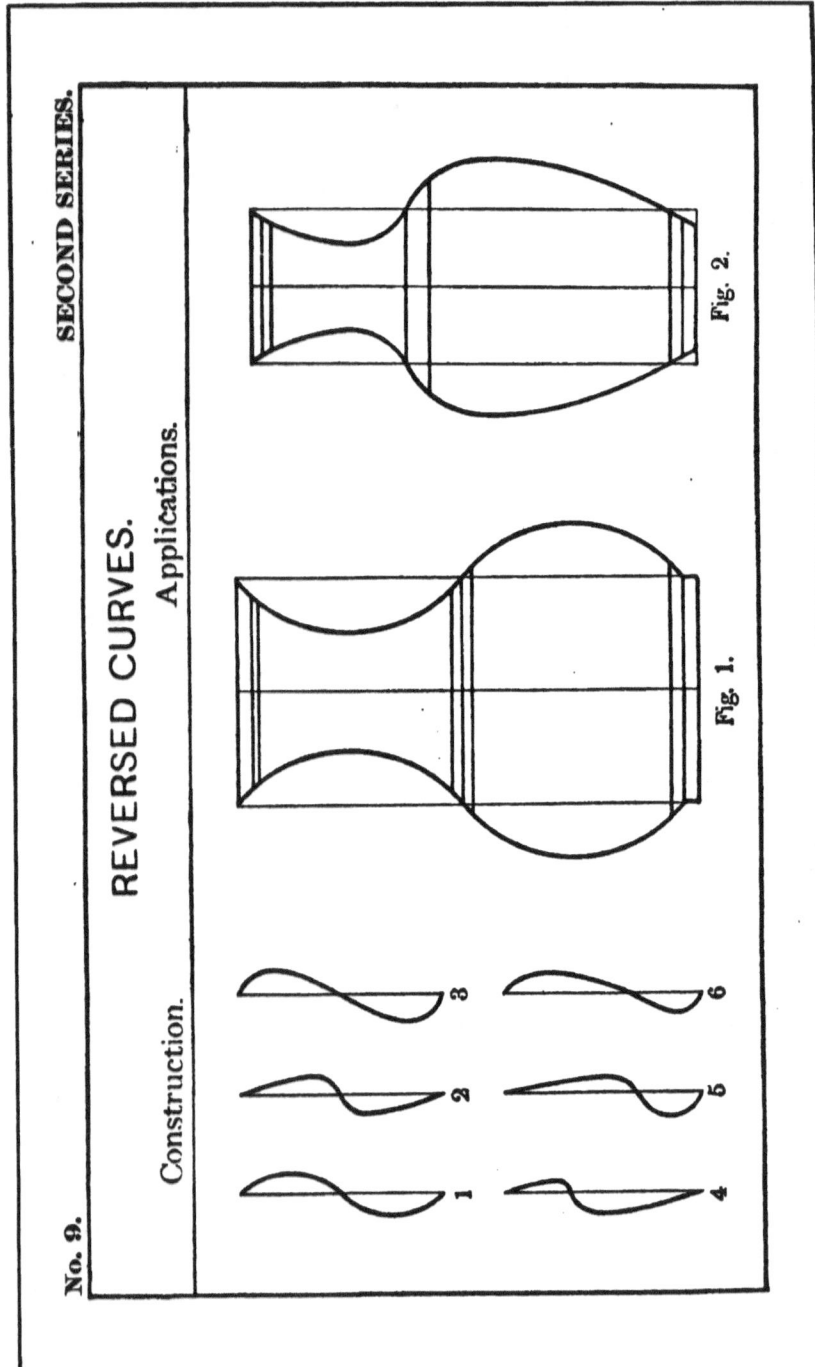

TUESDAY.

Vase. ENLARGEMENT FROM CARD No. 9, FIG. 1.

DIRECTIONS FOR THE TEACHER. — **Sketch** a vertical, and quadrisect it. — Through each end, **draw** a horizontal equal to one-half the vertical. — **Sketch** verticals to connect the ends of the horizontals. — Bisect these verticals, and connect the points of bisection by **drawing a** horizontal. — From the upper end of the left vertical, **draw** a reversed curve, circular in its parts, curving inward in the upper part, crossing the vertical at its centre, curving outward in the lower part, and ending at the lower end of the vertical. — Repeat the curve on the right vertical, reversing it. — Add the base and the horizontal markings.

DRILL FOR THE WEEK. — Reversed curves.

Additional Work.

Vase. ENLARGEMENT FROM CARD No. 9, FIG. 2.

DIRECTIONS FOR THE TEACHER. — **Sketch** a vertical, and trisect it. — Bisect the upper third. — Through each end of the vertical, **sketch** a horizontal equal to one-third the vertical. — Connect the ends of the horizontals by **sketching** verticals. — Trisect the verticals. — Connect the upper points of trisection by **drawing a** horizontal. — On the left vertical, beginning at the upper end, **draw** a reversed curve like that of the copy, passing through the upper point of trisection, and ending at the lower horizontal a little to the right of the left vertical. — Repeat the curve on the right, reversing it. — Add the horizontal markings.

WEDNESDAY.

Lessons of Monday and Tuesday. Card No. 9. **Reversed Curves** 1, 2, 3, 4, 5, 6. Fig. 1. Vase. FROM MEMORY.

THURSDAY.

Vase. FROM DICTATION AND THE BLACKBOARD. — The teacher should draw upon the board the reversed Curve 5 from Card No. 9, and should then dictate to the children the construction-lines given above for Fig. 2, Card No. 9. The children having the construction-lines should draw a vase upon them, using the Reversed Curve 5, which has been drawn upon the board.

Additional Work.

The teacher may select other reversed curves from Card No. 9, and use them as Reversed Curve 5 was used in the exercise just given.

FRIDAY.

Vase. FROM THE OBJECT. — Care should be taken to select for this exercise a vase whose proportions and curves are simple.

Additional Work.

The children discover objects in the room illustrating the subject of the week, and the teacher selects one suitable for the class. (See p. 233, Fig. 5.)

SUBJECT. — **Unit of Design.**

Card No. 10, Second Series.

MONDAY.	TUESDAY.	WEDNESDAY	THURSDAY.	FRIDAY.
Geometric.	Enlargement.	Memory	Dictation.	Object.
		Lesson of Tuesday.		Units from good designs.

A unit of design is a form intended to be repeated for decoration.
A unit of design may be repeated horizontally to make a horizontal border.
A unit of design may be repeated vertically to make a vertical border.
A unit of design may be repeated horizontally and vertically to cover a surface.
A unit of design may be repeated around a centre to make a rosette.
When a unit of design is repeated around a centre, there must be a central form large enough to hold the units together, so that the rosette will not look as if it would easily fall to pieces.
A unit of design may be modified to suit the place it is to fill.

MONDAY.

Unit of Design. TERM IN DESIGN. From examples of design. — The teacher shows manufactured articles, such as wall-paper, and various woven fabrics, in the decoration of which the several kinds of repetition are used. The children discover that forms are repeated in the designs, and that they are repeated in various ways.

From the blackboard. — The teacher illustrates the various kinds of repetition on the board, selecting from the examples given throughout the Primary Manual. Examples of horizontal repetition will be found on pp. 52, 78, 99, 122, 140, 145; of vertical repetition, on pp. 85, 99, 121; of repetition to cover a surface, on pp. 83, 100; and of repetition around a centre with a strong central form, on pp. 177, 217. The units of design given on the first line of illustrations on Card No. 10 are intended to be used for repetition around a centre. Various arrangements of these units will be found on p. 217.

NOTE. — Teachers can obtain from dealers and manufacturers sample books of goods sold in previous years, in which examples of design can be found to illustrate the lessons on design.

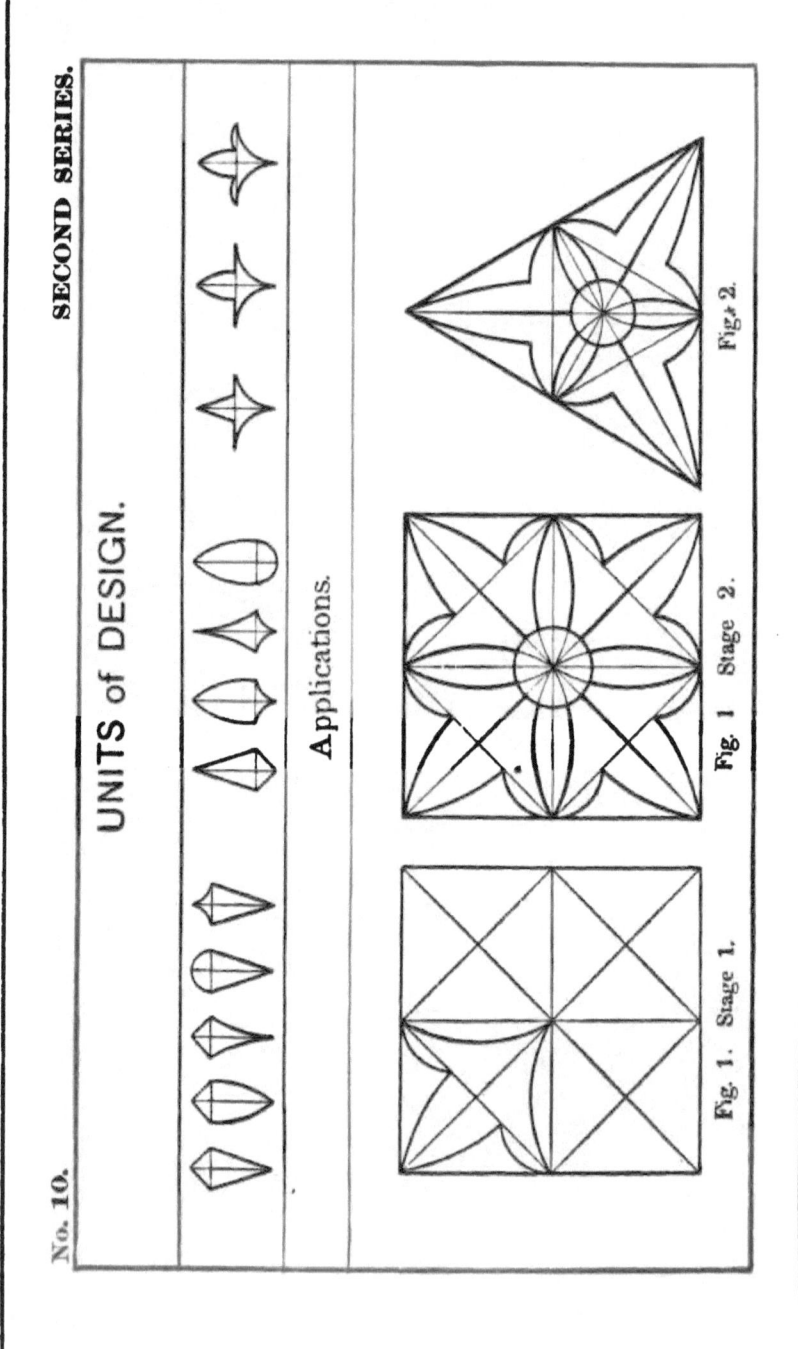

UNIT OF DESIGN. 215

Busy Work for the Week.

The children may draw the units from the first line of illustrations on Card No. 10. They may draw squares and triangles with their axes of symmetry, and make designs within the squares and triangles, using the units given on Card No. 10.

TUESDAY.

Design in a Square. ENLARGEMENT FROM CARD NO. 10, FIG. 1. — The last unit in the upper line of illustrations on the card is used here for repetition in a square. The axes of symmetry of the square are drawn, and the unit is so placed that its axis of symmetry coincides with half an axis of symmetry of the square. It will be remembered that both the diagonals and diameters of a square are axes of symmetry. In this case the units are placed on the diagonals. The units having been drawn on the four semi-diagonals, a central circle is added to hold the units together.

DIRECTIONS FOR THE TEACHER. *Stage 1.* — Draw a square, and sketch its diameters and diagonals. — Connect the ends of the diameters by obliques, thus making a square on its diagonals. — Trisect the upper left side of this square. — Sketch the curves of the unit as shown in Stage 1 on the card.

Stage 2. — Repeat the unit on the other semi-diagonals. — Quadrisect each semi-diameter. — Through the inner points of quadrisection, draw a circle. — Strengthen the curves of the units outside the circle; also that part of each semi-diagonal outside the circle, remembering that it should be stronger as it approaches the circle, as in the copy.

DRILL FOR THE WEEK. — Circles, ellipses, and ovals.

Additional Work.

Design in an Equilateral Triangle. ENLARGEMENT FROM CARD NO. 10, FIG. 2. — In this design the same unit is used as in Fig. 1; but the unit is modified to suit the place which it occupies.

DIRECTIONS FOR THE TEACHER. — Draw an equilateral triangle. — Bisect its sides, and sketch its axes of symmetry. — Connect the ends of the axes by sketching lines to form a second equilateral triangle. — On the long part of the vertical axis of symmetry as an axis, sketch the unit. A horizontal crosses this vertical axis. Trisect this horizontal. The points where the curves of the upper part of the unit meet are directly above the points of trisection. — Sketch similar units on the long parts of the other axes of symmetry. — Trisect the short part of each axis of symmetry. **Draw a circle through the points of trisection.** — Strengthen the curves of the units outside the circle; also that part of the axis of each unit outside the circle, remembering to make it stronger toward the circle, as in the copy.

WEDNESDAY.

Lesson of Tuesday. Card No. 10, Fig. 1. Design in a Square. From Memory.

THURSDAY.

Original Design. Enclosing Form from Dictation. — Fifteen designs are given on p. 217 for the use of the teacher in illustrating upon the board the manner in which the units on Card No. 10 may be used in design in various enclosing forms. In some cases the units have the same proportions as those on the card; in other cases the shape of the unit is modified to suit the space in which it is placed. Figs. 1, 3, and 13 are based on the equilateral triangle; Figs. 2, 4, 5, 6, 11, 14, on a square on its diameters; Figs. 7, 8, 9, 15, on a square on its diagonals; and Figs. 10 and 12, on a circle.

The designs in a trefoil, Fig. 13, and the quatrefoils, Figs. 14 and 15, illustrate the use of two units.

The teacher may select a triangle, square, circle, trefoil, or quatrefoil, and dictate it with its axes of symmetry to the children. The teacher should then draw on the board one or two illustrations from p. 217 (not taking, however, any having the same enclosing form as that dictated to the children), to show how the units on Card No. 10 can be used in a design.

The construction of these units is very simple. The units of the first group are constructed by sketching a vertical, quadrisecting it, sketching through the upper point of quadrisection a horizontal equal to one-half the vertical, and then connecting the ends of these lines by drawing straight or curved lines. In the units of the second group the horizontal is sketched through the lower point of quadrisection. In the units of the third group the vertical is bisected, and a horizontal of the same length is sketched through the centre of the vertical, and trisected.

The work for Thursday in the illustration, p. 212, shows one way in which the unit may be used.

Additional Work.

The *Additional Work* should be of the same nature as the work just given.

FRIDAY.

Units from Good Designs. From the Object. — The designs from which the children draw units may be drawn upon the board by the teacher; but it will be much better if they are given from some manufactured article.

Additional Work.

The *Additional Work* should be a variation of that just given.

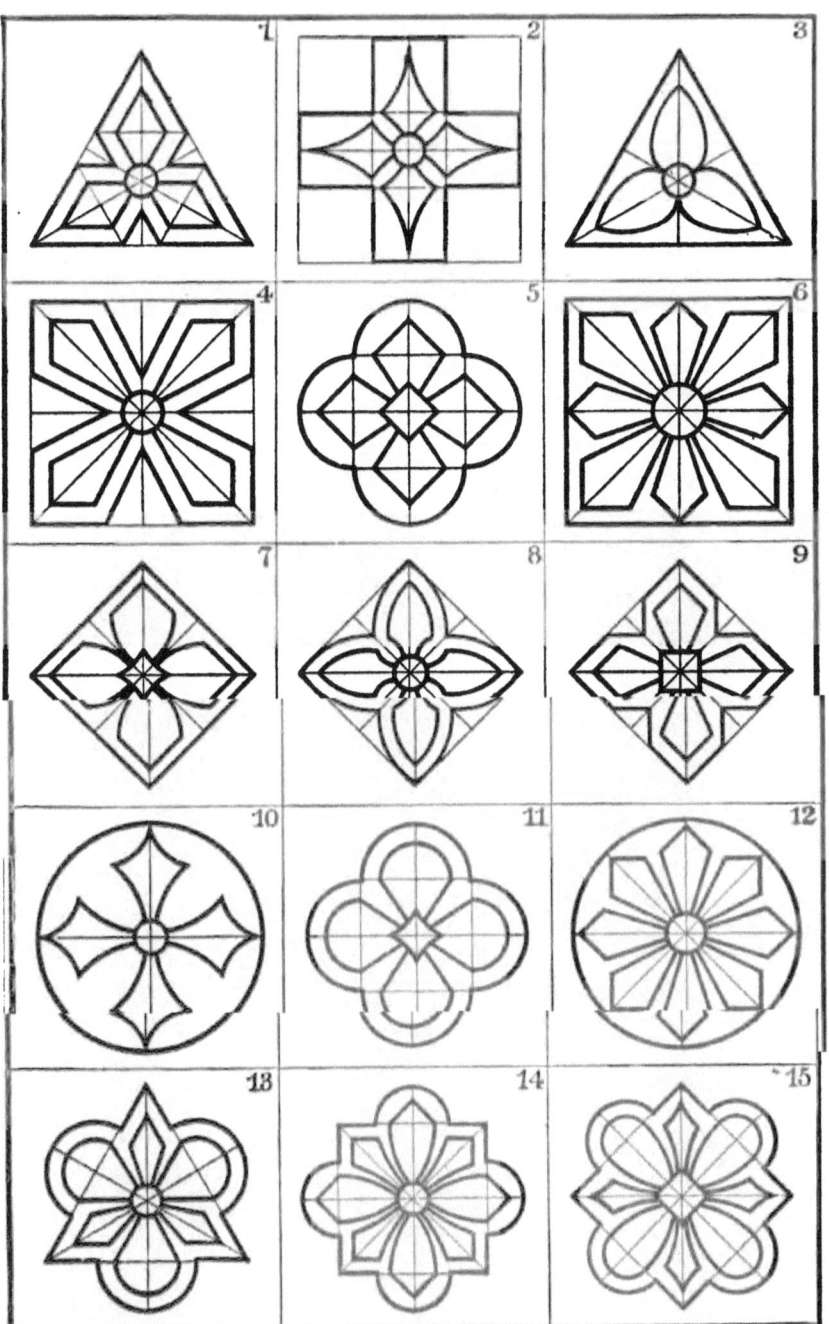

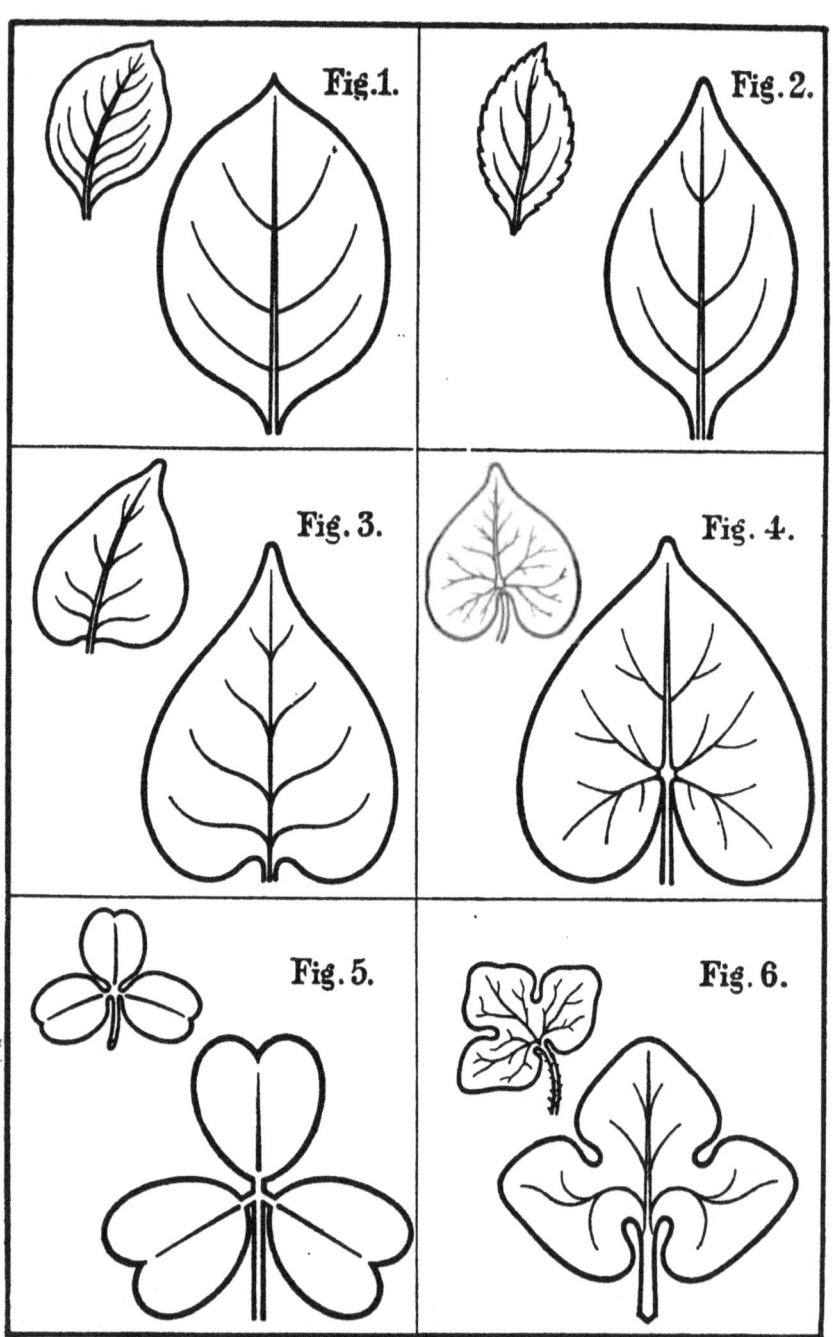

CONVENTIONALIZATION OF LEAVES.

SUBJECT. — **Conventionalization of Leaves.**

Card No. 11, Second Series.

MONDAY	TUESDAY	WEDNESDAY.	THURSDAY.	FRIDAY.	
Geometric.	Enlargement.	Memory	Dictation.	Object.	
			Lessons of Monday and Tuesday.		Leaves.

The two sides of a natural leaf are not often alike.
The edges of a natural leaf are often notched.
The midrib of a natural leaf is often curved.
The veins of a natural leaf are often irregular.

In conventionalizing a leaf the sides are generally made alike.
In conventionalizing a leaf the edges are generally drawn entire; that is, without notches.
In conventionalizing a leaf the midrib is generally made straight.
In conventionalizing a leaf the veins are generally made regular.
In a conventionalized leaf all irregularities and little details are left out.

MONDAY.

Conventionalization of Leaves. TERM IN DESIGN. From leaves and from the blackboard. — The teacher has a large number of leaves of one kind. The children search for those which have the two sides alike, and lay aside those which have the sides most nearly alike. They search for those leaves which have a straight midrib, and lay aside those which have the midrib the most nearly straight. They search for those leaves which have the veins regular, and lay aside those which have the veins the most nearly regular. The teacher takes a leaf which is the most nearly regular in all respects, and, drawing a vertical on the board, places the leaf so that the midrib will be over the vertical, and draws around the leaf (without following the notches in and out, if the edge is notched), then takes the leaf away, corrects any lack of symmetry, and adds the veins, placing them regularly. The drawing thus produced is that of a conventionalized leaf; for it retains the general form and characteristics of the natural leaf. The teacher then draws any one or all of the natural leaves on the upper line of illustrations on Card No. 11, with their conventionalizations.

A page of conventionalized leaves, with the natural forms from which they are derived, is given here to aid the teacher. Fig. 1 is the quince-leaf; Fig. 2, the syringa; Fig 3, the lilac; Fig. 4, the morning-glory; Fig. 5, the clover; Fig. 6, the hepatica.

Busy Work for the Week.

The children may draw from natural leaves.

TUESDAY.

Natural and Conventionalized Rose-Leaf. ENLARGEMENT FROM CARD No. 11, FIGS. 1 AND 2. — Both these forms are to be drawn mainly by imitation. The midrib should be drawn first, and then the greatest width of the leaf marked each side of the midrib.

DRILL FOR THE WEEK. — Straight and curved lines.

Additional Work.

Two Natural Ivy-Leaves, and Conventionalized Ivy-Leaf. ENLARGEMENT FROM CARD No. 11, FIGS. 3 AND 4. — Two natural ivy-leaves are given, differing in shape: the conventionalized leaf combines the forms of the two. These must also be drawn mainly from imitation. The midrib must be drawn first. In the conventionalized leaf the vertical construction-line can be trisected, and the greatest width of the leaf marked opposite the lower point of trisection. The points where the upper lobe joins the two side lobes may be placed nearly opposite the centre of the vertical; the points where the side lobes join the lower lobes are almost directly below those just placed. The veins are drawn toward the points of the lobes.

WEDNESDAY.

Lessons of Monday and Tuesday. Card No. 11. Natural and Conventionalized Leaves. FROM MEMORY. — One of the natural leaves from the first line of illustrations on the card, together with its conventionalizations, may be drawn; also the natural and conventionalized rose-leaf, Figs. 1 and 2.

THURSDAY.

Conventionalized Leaf. FROM DICTATION. — The teacher should hold before the children a natural leaf, simple in its shape, and ask the children how to conventionalize it, taking first the midrib, then the shape of the leaf, then the veins. In this case the shape should be drawn by imitating the form of the leaf, and not by drawing around the leaf. The teacher should then give to the children directions for drawing the conventionalized leaf on their slates.

It must be remembered that there are leaves in which the midrib is

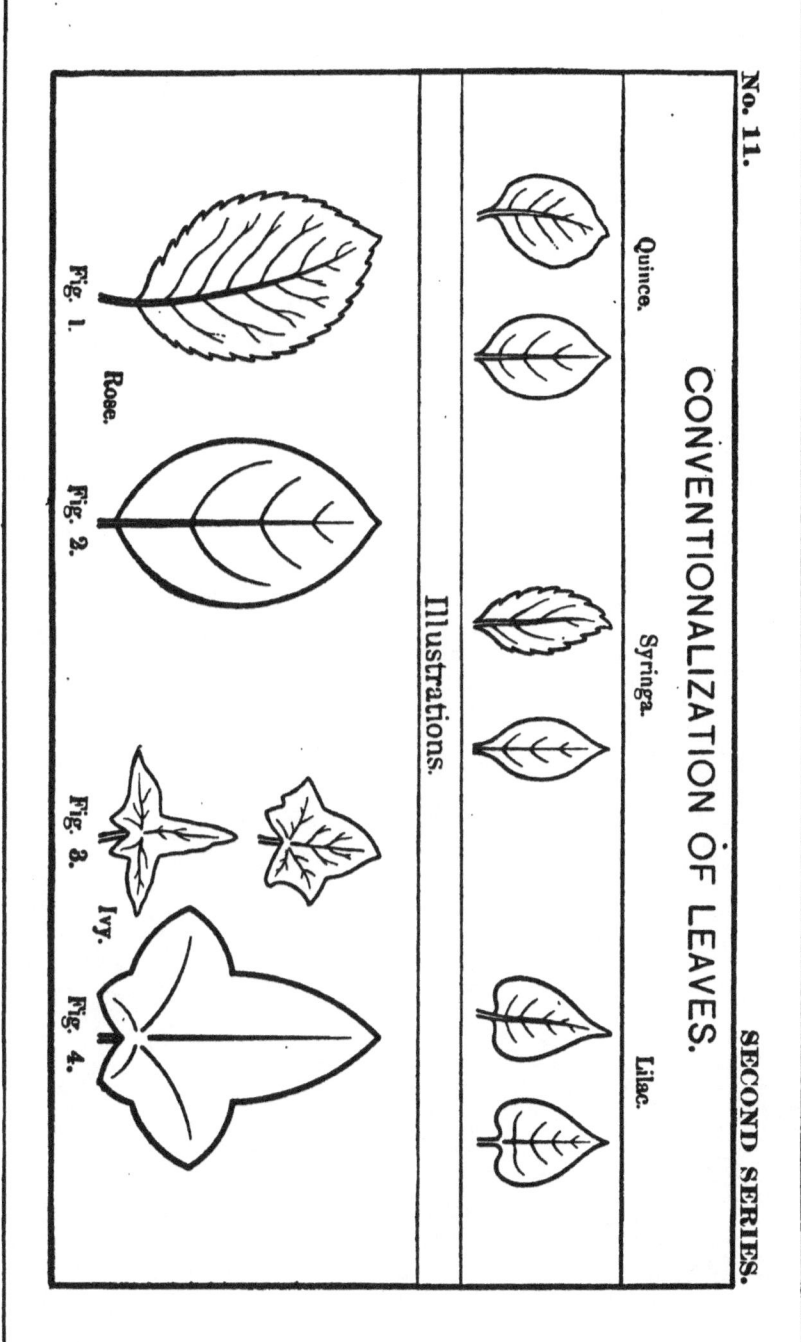

always curved: in such a case the midrib of the conventionalized leaf should be curved. There are also leaves, like the elm, which never have the two sides alike: in such a case the two sides of the conventionalized leaf should not be alike.

Additional Work.

The teacher takes another leaf, and gives a similar lesson.

FRIDAY.

Natural Leaves. FROM THE OBJECT.

Additional Work.

The work should be similar to that just given.

SUBJECT. — **Conventionalized Forms.**

Card No. 12, Second Series.

MONDAY	TUESDAY	WEDNESDAY	THURSDAY	FRIDAY.	
Geometric	Enlargement.	Memory	Dictation.	Object.	
			Lessons of Monday and Tuesday.		Design.

Conventionalized forms are more suitable for decorative purposes than natural forms; for —
1. It is necessary in decoration that forms should be repeated.
2. Symmetrical forms with few details are more pleasing for decoration when repeated, than natural forms without symmetry and with many confusing details.

A conventionalized form omits more or less of the details of the natural form from which it is derived.

Several conventionalized forms may be obtained from one natural form.

MONDAY.

Conventionalized Forms. TERM IN DESIGN. From examples of design in manufactured articles. — The teacher shows manufactured articles, wall-paper, textile fabrics, pottery, etc., which furnish examples of designs made from natural forms, and also from conventionalized forms. The children find the designs made from natural forms, and those made from conventionalized forms.

From the blackboard. The teacher has morning-glory leaves. The children examine them, and find the most regular leaves. The teacher draws a conventionalized leaf from them, putting in the veins; then draws the various forms shown in the designs on Card No. 12, all derived from the morning-glory leaf. The children draw the natural leaf and the various conventionalized forms.

Busy Work for the Week.

The children may draw from Card No. 12, and may design.

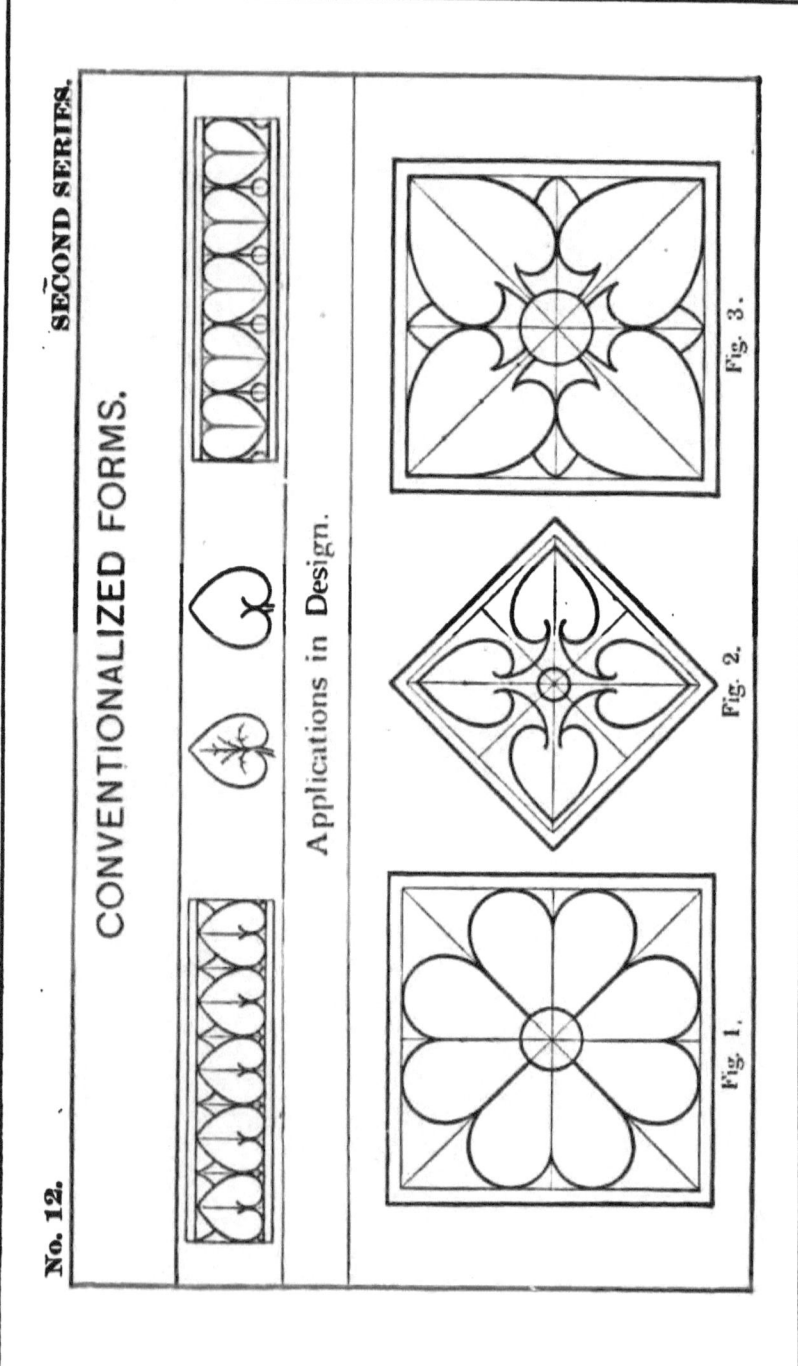

CONVENTIONALIZED FORMS.

TUESDAY.

Design in a Square. ENLARGEMENT FROM CARD No. 12, FIG. 1.

DIRECTIONS FOR THE TEACHER. — Sketch a square, its diagonals and diameters. — Bisect each semi-diagonal, trisect each half side of the square, and quadrisect each semi-diameter. — Connect each outer point of quadrisection with the two nearest points of bisection by **drawing** curves curving outward, each of which should touch a half side of the square at the inner point of trisection. — Through the inner points of quadrisection, **draw** a circle. — Strengthen that part of the inner half of each semi-diagonal that is outside the circle. — Extend the diagonals each way lightly, and **draw** an enclosing square.

DRILL FOR THE WEEK. — Straight and curved lines.

Additional Work.

Design in a Square. ENLARGEMENT FROM CARD No. 12, FIG. 2.

DIRECTIONS FOR THE TEACHER. — Sketch a square on its diagonals. — Bisect its sides, and sketch its diameters. — Trisect each semi-diagonal. — **Draw** the conventionalized form used as a unit on the vertical semi-diagonal, noting the distances of the curves from the corner of the square and from the semi-diameters, and that the lower part of each curve is opposite the lowest point of trisection. — Repeat the unit on the other semi-diagonals. — **Draw** curves connecting them. — **Draw** the central circle. — Extend the diagonals lightly each way, and **draw** the enclosing square.

Design in a Square. ENLARGEMENT FROM CARD No. 12, FIG. 3.

DIRECTIONS FOR THE TEACHER. — Sketch a square, its diagonals and diameters. — Quadrisect the sides of the square, its semi-diagonals and semi-diameters. — **Draw** the conventionalized leaf, used as a unit, on each semi-diagonal. — Through the inner points on the semi-diameters **draw** a circle. — **Draw** the points of leaves that are seen on the semi-diameters. — Extend the diagonals each way lightly, and **draw** an enclosing square.

WEDNESDAY.

Lessons of Monday and Tuesday. Card No. 12. Conventionalized Forms from the Morning-Glory Leaf. Fig. 1. Design in a Square. FROM MEMORY.

THURSDAY.

Original Design. ENCLOSING FORM FROM DICTATION.

DIRECTIONS FOR THE TEACHER. — (Give directions for sketching a square on its diagonals.) — Bisect the sides of the square. — Sketch its diameters. — Bisect each semi-diameter. — Quadrisect each side. — Find the upper left

side of the square. — From the upper point of quadrisection to the point on the nearest semi-diameter, draw a vertical. — Find the upper right side of the square. — From the upper point of quadrisection to the point on the nearest semi-diameter, **draw** a vertical. — Strengthen the corner of the square between the verticals. — (Give similar directions for the other parts of the figure.)

After the enclosing **form has** been dictated, the children may draw within it an original design.

The teacher may vary the exercise by giving different enclosing forms to different rows of children.

Additional Work.

A similar exercise in original design.

FRIDAY.

Design. FROM A MANUFACTURED ARTICLE. — This design should be selected to illustrate symmetry, repetition, a strong central form if the repetition is around a centre, conventionalization. The children should be led to discover these principles in the design before drawing it.

Additional Work.

A similar exercise in drawing a design from a manufactured article.

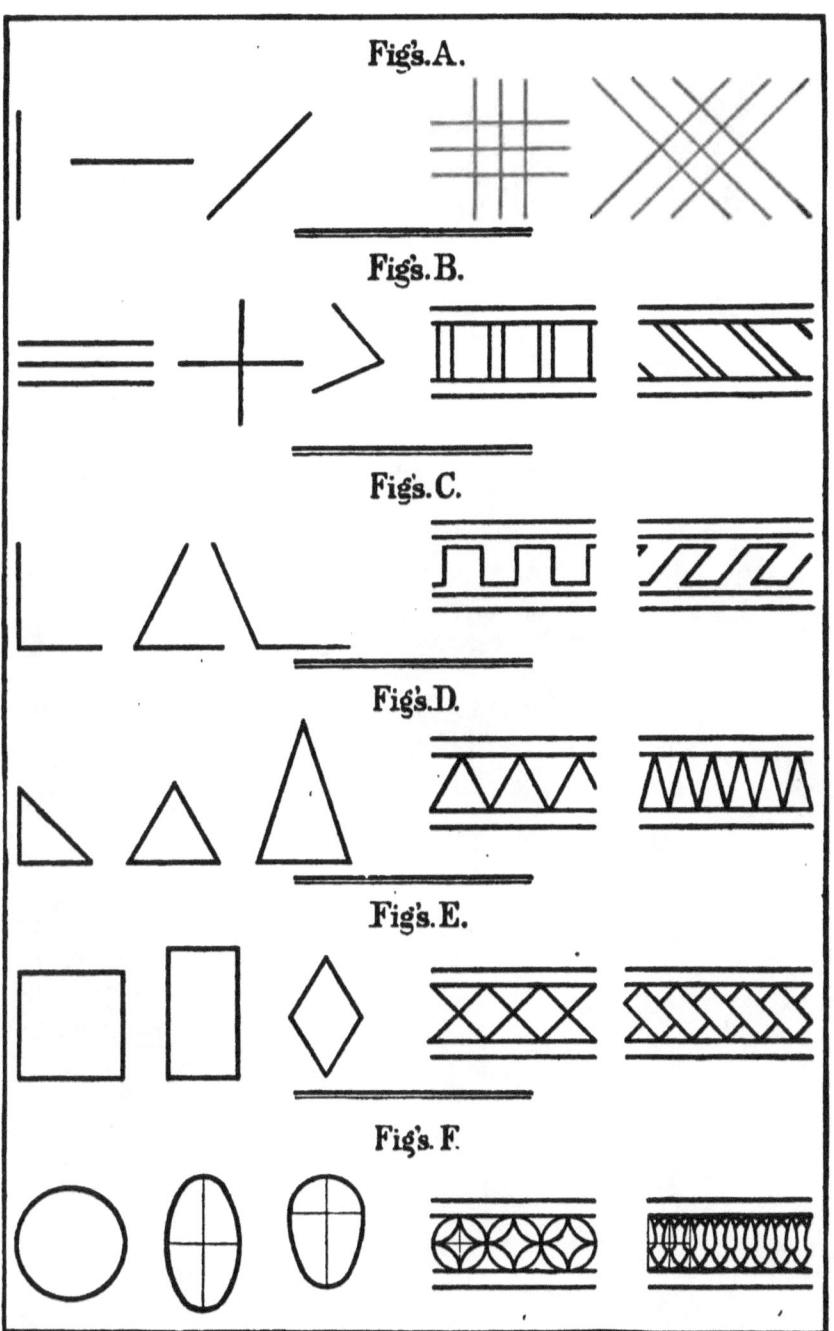

www.ingramcontent.com/pod-product-compliance
Lightning Source LLC
Chambersburg PA
CBHW021547200526
45163CB00016B/2573